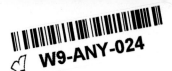

THE RIGHT PICTURE

BY KEN HEYMAN
AND JOHN DURNIAK

AMPHOTO
AN IMPRINT OF WATSON-GUPTILL PUBLICATIONS/NEW YORK

First published 1986 in New York by AMPHOTO,
an imprint of Watson-Guptill Publications,
a division of Billboard Publications, Inc.,
1515 Broadway, New York, NY 10036

Library of Congress Cataloging in Publication Data
Heyman, Ken.
 The right picture.
 Includes index.
 1. Photography, Documentary. 2. Photography,
Artistic, 3. Heyman, Ken. 4. Durniak, John.
I. Durniak, John. II. Title.
TR820.5.H49 1986 778.9'07 86-3422
ISBN 0-8174-5725-9
ISBN 0-8174-5726-7 (pbk.)

Manufactured in Japan

1 2 3 4 5 6 7 8 9/91 90 89 88 87 86

Editorial concept by Glorya Hale
Edited by Marisa Bulzone and Robin Simmen
Graphic production by Ellen Greene

THE RIGHT PICTURE

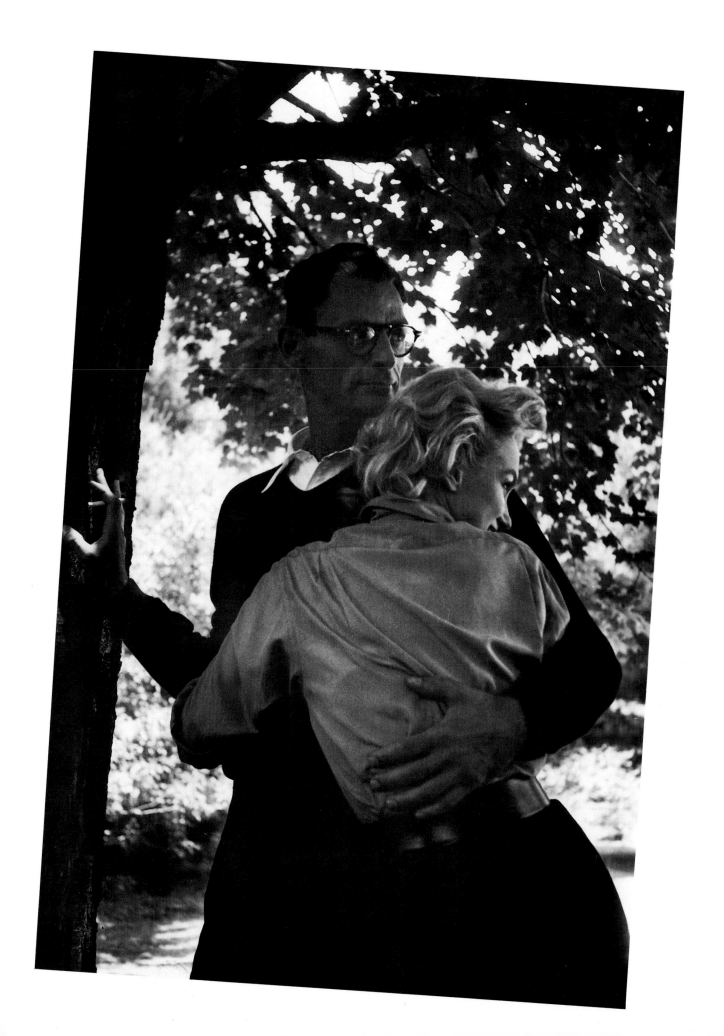

CONTENTS

INTRODUCTION

Photography encourages us to observe human relationships. Pictures display love, hate, humor, disgust, eroticism, hope, and fantasy, and these in turn spark every conceivable emotion in the viewer. Multiply this idea by thirty-six, the number of wristwatch-size images on a contact sheet, and you have an insight into the complexity of picking the right picture out of all of the visual experience recorded on a roll of 35mm film.

There are not many places a photographer can go to learn how to read and evaluate contact sheets. Most learn from other photographers. Some of our greatest photographers are excellent teachers. All photographers stop to listen when a master photographer like Ansel Adams says, "A great photograph is one that fully expresses what one feels, in the deepest sense, about what is being photographed, and is thereby a true manifestation of what one feels about life in its entirety."

Such a statement should ring in a photographer's mind when he looks at his own contact sheet. What deep questions does he feel should be raised by the pictures he chooses? Which of the images represents the truth? Which is a reflection of who he is and what he thinks? Do any reveal the event better because of his vision? Are these pictures what his life is all about? Questions such as these are doors to a lifetime of inquiry.

Photographs are never complete. There is no mountain high enough for photographing the whole earth. Photography offers us some meaning, but demands that we look for the rest of it in ourselves. A great photograph asks as much from us as it gives to us.

The contact sheet is an incredible instrument for measuring the breadth of a photographer's vision, but it is only as good as the mind that uses it creatively. Poor judgment of its images destroys and diminishes a photographer's efforts. Ingenious editing, on the other hand, can upgrade mediocrity and disguise failure as success.

Some photographers say picture editors shouldn't be trusted with the awesome responsibility of deciding which image deserves to be published for millions of people to see. Like Supreme Court Justices, picture editors believe they make careful, thoroughly thought-out decisions based on a wealth of experience and knowledge. The picture editor's eye has traveled mile after mile over images on contact sheets. His experience empowers him to select the most outstanding examples of a photographer's work, which protects everyone—the photographer, the publication, and the viewer.

Most photographers, including Ken Heyman, never show their contact sheets to other people. Ask Heyman why and he'll tell you, "They show too much." A contact sheet discloses not only how a photographer works technically, but also intellectually and spontaneously.

Publications pay photographers for the right to have their editors—editors like John Durniak—see contact sheets first, so they are the first decision makers. They see pictures before the photographer and make judgments without consulting him. But the photographer's caption notes and the background information he supplies can influence selection. Sometimes on hot stories, the photographer is debriefed and the resulting information goes into the story. Remember, these photographs were made to accompany words. Writers file stories, and pictures illustrate them.

In journalism, stories do not keep. To be a day late is to belong in yesterday's newspaper, or last week's magazine. Some photojournalists shoot for a year without ever seeing a picture. Newspapers can't afford the time or money necessary to bring these photographers back from distant locations along with each roll of film shot. If newspapers waited for them to come into the office to edit their contact sheets, deadlines would be missed and few pictures would be published.

Photography has an impact on the mind, and pictures must travel through many psyches before they are published. The vari-

ous tastes, thought processes, predjudices, and emotional conditions of photographers, picture editors, and editors can affect a photograph's outcome during its journey toward the public eye, and determine whether or not it appears in a magazine, a newspaper, a book or on a wall. Time—a day, a week, months, years—changes what we see on contact sheets by creating distance between the immediate needs of the hour and the timelessness of an image. Pictures tend to change when they are judged without deadline pressures. Time can turn a simple image into a priceless, irreplaceable visual fact. Can the photographer and picture editor wear historians' hats as well? The good ones do.

Ken Heyman is constantly assessing the differences between his color and his black-and-white photography. This issue also concerned Ansel Adams, as well as most photographers working today. "Color photography usually takes advantage of the obvious," wrote Adams. Black-and-white photography fares better, as its inherent abstraction takes the viewer out of the morass of manifest appearance and encourages inspection of shapes, textures, and qualities of light. The picture editor also must have access to im-

The photographer's input, however, is essential to good journalism. How can the eyewitness to a story be excluded? How can all the nonvisual information he has collected be ignored? At some magazines like the *National Geographic*, photographers now ask to be part of the editing and layout process. New electronic technologies offer photogra-

phers hope of getting more involved in the editing act. Someday photographers will be able to make pictures directly on tapes in their cameras. These electronic pictures won't need any processing, but will be available instantly in a still video format for photographers to edit on the spot before sending them to newspapers. Perhaps in the future the picture editor will have to insist, "Send them all!" For some time now, great news articles have been referred to as "literature under pressure." In the future, will great news photographs rate being called "art under pressure?"

Contact sheets mirror the photographer's mind. They are filled with far more information than most of us ever realize. Edited contact sheets reflect the quality of the editor, too. An inexperienced editor will reveal himself by the pictures he doesn't choose. A great editor goes to the heart of what is on the contact sheet by pulling out the best frames, then selecting subtle, intriguing images to augment and enhance the blockbuster photographs.

A great editor, like a great photographer, goes into the contact sheet and tests potential images for certain criteria. John Durniak first considers whether a good print can be produced from the negative. He decides whether part of the image is greater than the whole and if cropping will enhance communication. Sometimes an image has to be enlarged before a decision can be made. When a single picture can't tell the whole story, Durniak looks for a series of pictures that can. He never discounts images that raise

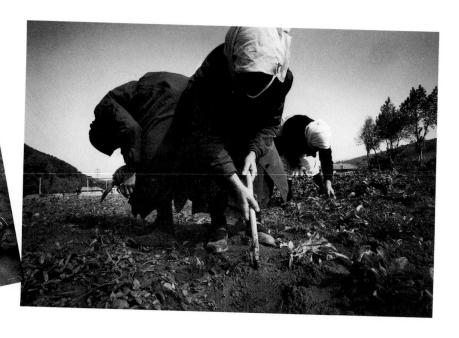

questions; he knows they are just as important as those that provide answers.
portant ideas, questions, and debates about photography, or he or she cannot be a good editor.

In a broad sense, this book is autobiographical. Ansel Adams was right—when the photographer tells us about his pictures, he is also telling us about his life. Picture by picture, contact sheet by contact sheet, in this book Ken Heyman shows us the life he has led. Underneath Heyman's images lies the story of his own becoming, which includes some surprises. To hear from Heyman that Cartier-Bresson likes to look at contact sheets upside down tells us more than usual about the French photographer. Heyman has touched and been touched by some of the most interesting personalities of our time, including other photographers and the famous subjects of some of his pictures. His ability to make conversation and explore important ideas in art, communications and anthropology keeps people on their toes, listening and absorbing.

The authors have often disagreed, which is not unusual for an editor and a photographer. It is good for both of them that they do. Without debate, truth dies of boredom. To be of any value, every contact sheet should be the beginning of an argument. This book describes some of the influences that surround a photograph as it is being passed from person to person. Hopefully, like a good photograph, this book will raise as many questions as it answers.

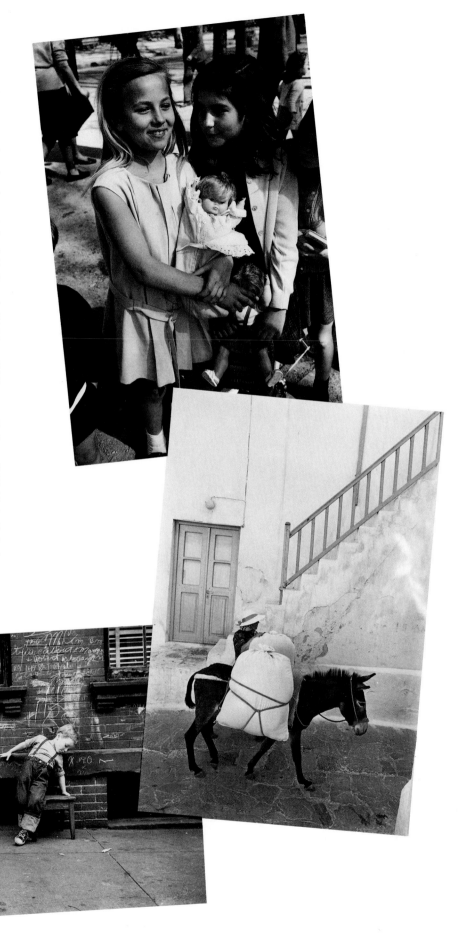
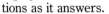

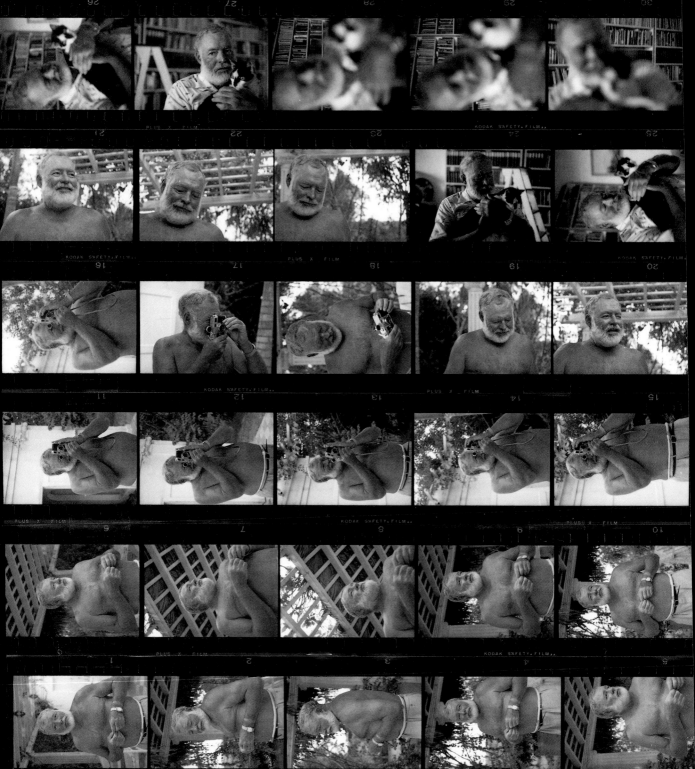

THE OLD MAN AND THE CAMERA

You dream about it, you hope for it, and then it happens—you stand face to face with one of the most famous personalities in the world. With camera in hand, what do you think about, what do you do?

Ken Heyman encountered his subject, novelist Ernest Hemingway, at his country hideaway in Cuba.

The initial shock of seeing such a recognizable face in person can throw a photographer off base and intimidate one to distraction from the most important purpose—getting photographs.

If you are lucky, as Heyman was, you make the connection, talk to your subject, and agree upon the next step for taking pictures. Heyman left his initial meeting with Hemingway on a high—and with an appointment to photograph the writer the next day. Little did he know that everything would go wrong, that he wouldn't find the town where he was supposed to meet his famous subject.

KEN HEYMAN
"Why should I pose for you when LOOK magazine pays me 10,000 dollars to do it?" I was stunned, and couldn't say a word. Luckily he continued talking, not knowing he had knocked all the wind out of me.

JOHN DURNIAK
The author dropped his guard. He probably thought Heyman was not a threat, Heyman didn't want to spar with "the old man," so Hemingway decided not to take him on.

KEN HEYMAN

A college friend invited me to go to Cuba with him. We had both just graduated, and pre-Castro Cuba was synonymous with wine, women, and song.

Shortly before I left, I had dinner with my brother. We started talking about Hemingway, who was living in Cuba, and he made me a ten-dollar bet that I couldn't photograph the famous author. I took the bet, and managed to get a letter of introduction from a friend who was a book reviewer for a newspaper.

On my second day in Cuba, I headed alone in a rented car for Hemingway's villa. The place was easy to find; everybody knew him. I remember there were three or four big signs in English and Spanish on his gate, reading "Beware of Dogs" and "Keep Out." I gave my letter to the gatekeeper. After about an hour, a man in a white shirt and white pants came down the driveway. He asked me to follow him in my car. The driveway was junglelike with orchids and heavy vegetation. I drove slowly up the hill, following the man in white.

At the top in front of the villa, the vegetation was so thick that it cut off the breeze; the 98-degree temperature felt like 150 degrees. The humidity was terrible. I took my camera and gadget bag from the car and followed my guide into the house.

I had heard about Hemingway's love of cats. They were all around the place. We walked through his trophy room, out the door and down another path to the pool, where I did a double take. Three naked men were swimming.

I tried not to look shocked, and focused my eyes straight ahead until I got to the far end of the pool. There sat Hemingway, on a raised platform under an arbor with latticework over his head—like a king on a throne. Near him was a pitcher filled with what looked like ice water. It turned out to be vodka. The only thing he wore was a pair of walking shorts. I was struck by the hairiness of his massive body. When you see a super-celebrity like Hemingway, you realize how much he looks like his pictures.

My letter was on the table at Hemingway's elbow. He looked up at me. "Why should I pose for you when *LOOK* magazine pays me $10,000 to do it."

I was stunned, and couldn't say a word. Luckily he continued talking, not knowing he had knocked all the wind out of me. Disregarding his blockbuster statement, he began to tell me about the trouble he was having with the movie company currently filming his novel *The Old Man and the Sea*, in Cuba. He had been out to sea every day with the camera crew trying to find the great fish. No great fish appeared. After weeks, they gave up and shot the fighting-fish scene in a Hollywood sound studio, using a cooperative mechanical fish. Hemingway mistakenly thought I wanted to go in the boat on the next trip out. He did not want me to go with him.

I told him I would be satisfied taking pictures in and around the house. He seemed agreeable, but he didn't want to do it at that moment. I was facing Hemingway as we talked, concentrating on what he had to say. When I turned around, the three naked men had disappeared.

Hemingway agreed to meet me the following afternoon at a small fishing port after his boat came in, sometime about five o'clock. I thought I could remember the port's name, so I didn't write it down.

The next day, I started out about two o'clock. I didn't know a word in Spanish, and searched for the port until it was dark. I never found it or Hemingway. I blew it, I thought. What an opportunity and what a mess.

The following morning, I started out at seven o'clock, and went back to Hemingway's villa. It was a hot Sunday. I had decided to camp at the gate until I saw him again. I told myself, "You can't give up."

At nine-thirty, much to my surprise, a Rolls Royce came down the drive, and there was Hemingway in the front seat with his trainer. He was going out to do roadwork. He looked at me through the car window, recognized me, but did not acknowledge me. They drove off. I continued sitting there. It was the hottest day I had ever known.

Two hours later, the Rolls Royce came up the road toward the gate. The trainer, who was driving, rolled down the window and I asked him if I could follow the car up to the house. He nodded yes. By the time I got to the top of the hill, the Rolls was parked and no one was in sight.

Before leaving the United States I had bought a compact, six-inch-long, portable radio. It was tiny—it could fit in my pocket—and produced incredible sound for that time. I took it out and turned the volume on full blast, hoping someone would hear it and come along to tell me to turn it down. I was alone, and wondered if I would ever see Hemingway again.

After what seemed like hours, a servant came by and said, "Follow me." We got on the path leading to the trophy room, but instead went by it and down to the pool. Hemingway was in his spot, with the pitcher at one elbow and his trainer on the other. The trainer behaved as if Hemingway were

getting ready for a championship fight. Everybody called Hemingway "Papa," except the trainer; he called him "Ernie."

Hemingway began the conversation by telling me I was persistent and he liked that in a person. Then, he asked me where I had been the day before. Instead of being annoyed, he was amused. My tale about trying to find the port made him laugh. When I finished the story he said I could take my pictures, but first he wanted pictures of himself and his trainer. They threw their arms around each other's shoulders and posed for me. I shot a roll and gave it to the trainer because I had the feeling that Hemingway wanted me to leave the film. He appreciated my gesture and said so.

Hemingway said he had heard loud music coming from where I was waiting, and asked how I did it. I fumbled around looking for the radio in my pockets and couldn't find it. Then I realized that in my rush to follow the servant I had packed it in my camera bag. I took out the portable and showed it to him. He was impressed. He had never seen one like it. After all, it was the newest and smallest of its kind.

All at once it hit me. "I can't give you 10,000 dollars for a picture like *LOOK* magazine," I said to him, "but I would like to give you this radio for the opportunity." He beamed.

"Where do you want to take my picture?" he asked.

"In your trophy room with your cats." Waiting at the gatehouse that morning, I had decided the cats were important to him. Something about the cats and something about the trophies were important.

"Why don't you get some here—start here." he said. But after twenty-three frames I saw that he was impatient. What was important was the situation in the trophy room. I didn't want to make a big thing out of shooting by the pool.

At that point I was dripping with perspiration. The day was incredibly hot. Hemingway looked at the sweat pouring out of me.

"Hey, kid, why don't you go for a swim."

"I didn't bring a bathing suit," I told him.

"Nobody swims here with a suit," he said.

Because I had seen three naked swimmers in the pool before, I took his word as the truth. I went into the bathhouse, took off my clothes and ran toward the pool as fast as I could. Diving in, I swam underwater to the far end. I hadn't been in the pool for more than a minute when suddenly, a gong sounded loudly. Hemingway got up immediately and started walking toward the house.

"When Mama rings that bell," he called to me, "I have to get up there."

"What about my pictures?"

"We'll do that before lunch," he said and disappeared up the path.

There was no towel and I remember trying to get my clothes onto my wet body. My shoes refused to slide over my feet. Finally, I won the battle. By the time I arrived at the trophy room, Hemingway had changed into a striped sports shirt. I attached a Stroboflash II to the camera and made a few frames.

No sooner had I started than a woman's voice came from the next room asking that he come in for lunch. In those years, Hemingway's wife Mary thought of herself as a photographer and she did not willingly permit any other photographers to shoot him. Maybe my brother had known this when he made the bet. But Hemingway loved to have his picture taken.

"I'll be right in," said Hemingway. "The kid shoots fast."

Then I knew I had only a minute or two to work, and I managed to shoot two-and-a-half rolls of black-and-white film, besides the roll from the pool area.

I stopped photographing around the pool at frame 23. The second series begins in the trophy room with frame 24. My synchronization cord wasn't connected properly and Hemingway had already picked up a cat. In my rush to try to finish shooting before he disappeared for lunch, I forgot to focus. I knew I had seconds to work, and was standing there shooting still dripping wet from my swim and perspiring from the heat.

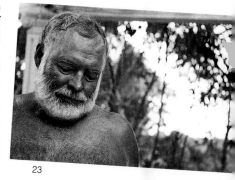
23

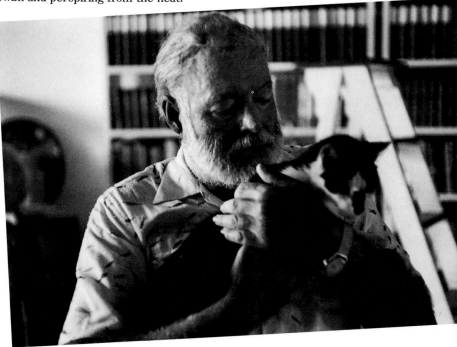
24

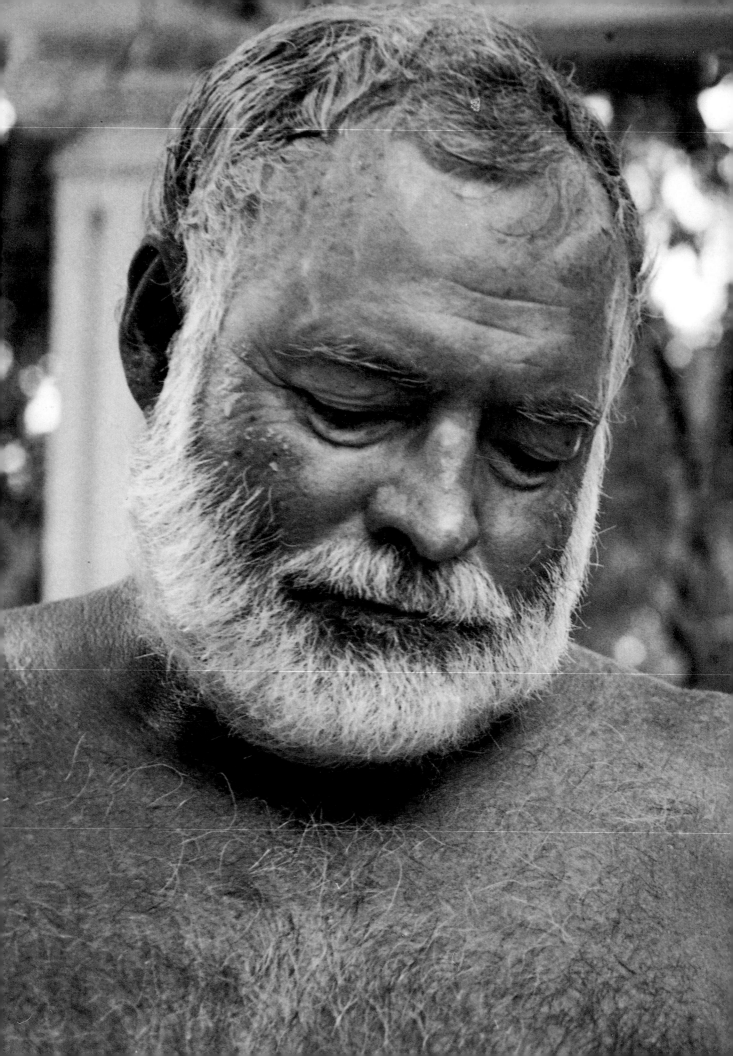

I like frame 23 best. A print of this frame hangs on my office wall. I cropped it vertically from a horizontal. It's Hemingway. Here is an image of one of the great writers of his generation, and in it he is unassuming, he's holding my Leica camera and looking at it. Hemingway is so great that he doesn't have to broadcast his strength. The right word I guess is *understatement*. This picture is an understated image of the man's greatness.

The room had insufficient light to make a decent portrait. I attached my Stroboflash II and bounced its light off the ceiling as I exposed a few frames. I wouldn't think of using a bounced strobe outdoors although I use it indoors in addition to the available light. Light in my photographs is so important. One should know how to build up light until the clearest and best photograph can be taken. You shouldn't see light in the final picture—you should see the subject.

Later that year in New York, I joined the Rapho-Guilleumette photo agency. Charles Rado, a founder of the agency, always took this picture of Hemingway and put it on the front page of my portfolio, because there were virtually no pictures of Hemingway available. The picture was a door opener. Every editor who opened my portfolio had a story about Hemingway and would tell it to me. I didn't need to worry about breaking the ice by saying something clever, and usually these meetings were successful.

My second favorite is frame 27, where I focused the camera and got an interesting expression. The cat seems to be part of the picture. But the ladder in the background was intrusive, so when I made the final print, I cropped it out and kept the horizontal format.

My third pick is frame 9 where Hemingway had just told me a story about himself as a boxer. Because I had just arrived from the United States, he wanted to know who had won a recent championship fight. As he talked to me about boxing, he seemed to take a boxer's stance. I did not print this picture at that time because although it said something, it was not what I wanted to say about the greatness of Hemingway.

It is interesting that I took three pictures in a row without focusing. My heart was pounding so. In all my years of photography I don't remember shooting a series of three pictures out of focus like that—unless, of course, there was something wrong with my equipment. But the confrontation with this man, the pressure under which I was shooting while his wife waited with his lunch—well, those are enough excuses. I can live with these pictures and the mistakes. I was probably close to hysteria.

When I got out of there I was flying. "My God, I did it!" I yelled.

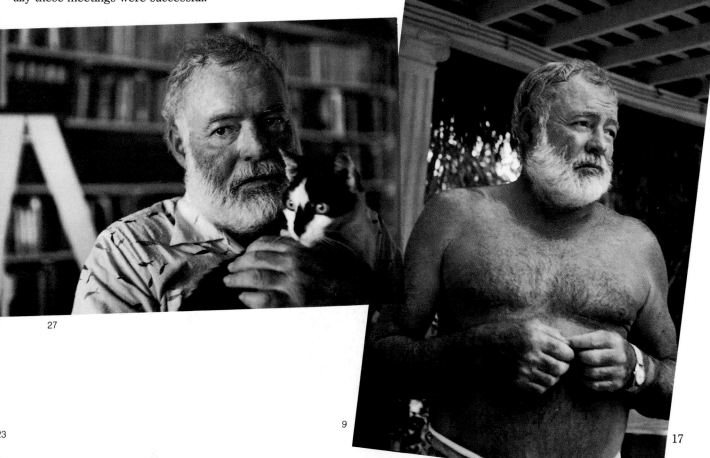

27

9

JOHN DURNIAK

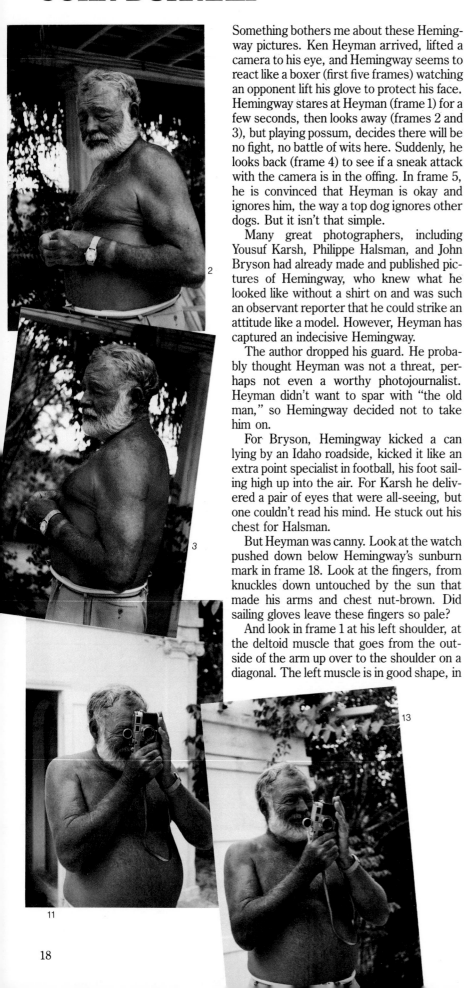

2

3

13

11

Something bothers me about these Hemingway pictures. Ken Heyman arrived, lifted a camera to his eye, and Hemingway seems to react like a boxer (first five frames) watching an opponent lift his glove to protect his face. Hemingway stares at Heyman (frame 1) for a few seconds, then looks away (frames 2 and 3), but playing possum, decides there will be no fight, no battle of wits here. Suddenly, he looks back (frame 4) to see if a sneak attack with the camera is in the offing. In frame 5, he is convinced that Heyman is okay and ignores him, the way a top dog ignores other dogs. But it isn't that simple.

Many great photographers, including Yousuf Karsh, Philippe Halsman, and John Bryson had already made and published pictures of Hemingway, who knew what he looked like without a shirt on and was such an observant reporter that he could strike an attitude like a model. However, Heyman has captured an indecisive Hemingway.

The author dropped his guard. He probably thought Heyman was not a threat, perhaps not even a worthy photojournalist. Heyman didn't want to spar with "the old man," so Hemingway decided not to take him on.

For Bryson, Hemingway kicked a can lying by an Idaho roadside, kicked it like an extra point specialist in football, his foot sailing high up into the air. For Karsh he delivered a pair of eyes that were all-seeing, but one couldn't read his mind. He stuck out his chest for Halsman.

But Heyman was canny. Look at the watch pushed down below Hemingway's sunburn mark in frame 18. Look at the fingers, from knuckles down untouched by the sun that made his arms and chest nut-brown. Did sailing gloves leave these fingers so pale?

And look in frame 1 at his left shoulder, at the deltoid muscle that goes from the outside of the arm up over to the shoulder on a diagonal. The left muscle is in good shape, in

workout shape. In frame 5 the left deltoid is flat, as if the arm were broken, and just out of a cast. That bothers me. Why would one arm look so much stronger than the other? Then it comes to me—fishing. Have you ever watched a man deep-sea fishing? His left hand holds the pole, sometimes gripping it for hours, sometimes holding on for dear life as the fish leaps from the water and attempts to break away. The left arm takes on the struggle while the right arm does the lighter job, the line work. If you use one arm more than another, there will be a muscular discrepancy. These pictures are proof that his stories about a love affair with fishing were more than just stories. He did it himself, again and again. And many of these pictures have never been published! Is there a sequence here for a double-truck layout?

Heyman is giving us the man, not the hero. But, wait, here comes the hero.

Heyman drops to one knee and shoots up (frame 6). He knows his craft, and makes a hero picture, hoping to sell it to an editor in New York, where they will make a print of frame 7 with a horizontal crop at the top of his head, and straight across from the pinky to above the elbow, turning Hemingway into Paul Bunyan with a mountainous chest. Hemingway knows the hero bit, and looks off into the sunset, not down at Heyman.

But the hands are still across his belly. After ten frames and three different shooting angles, Hemingway still has his hands across his belly. Does the old pro want us to look at his hands and not at the belly he is sucking in for the camera? When Hemingway reaches over to pick up one of Heyman's cameras, he drops his guard. He relaxes. Look at his stomach (frame 11). That's what he was trying to hide. Heyman notes how the belly pushes the top of his pants up over his belt so you see the inside lining. Heyman diplomatically crops out this roll of fat in some of the pictures, but finally returns to journalism and tells it like it is.

I like frame 13. Heyman must be telling him to keep one eye closed, or saying, "I can't see your face, push the camera off," or else Hemingway has asked a question such as "How can a man see better with one eye than with two?"

Heyman has been using a 50mm lens. Nothing exotic about a 50mm lens except it makes you get close to people. Most of these pictures are taken from about six feet away, some closer. Heyman, who looks like a guard on a professional football team, stands shooting six feet away from Hemingway, who looks like a fullback. Two big men, close enough to shake hands.

From frame 24 on, Heyman is in the house with Hemingway. Here the photographer discovers he has one hell of a situation going for him.

Hemingway has gentle hands. Look how he holds the camera in frame 18 with those big hands. And you see this gentleness in how he holds his cat in frame 24—a picture that I like a lot, although it will be a gargantuan task to print it well because of the backlighting. But look at the tender grip Hemingway has on the cat.

Frame 24 is sharp, then Heyman gets so excited with the scene that he fumbles the focus on frames 25 and 26. But here it is— the picture—frame 27, no doubt in my mind, the best picture of the set. Sharp, razor-edge sharp, and the image, that look from Hemingway! The mask is down and Heyman finds tenderness not only in his hands, but in the whole person. The eye contact between the subject and photographer is like a blast from a furnace. It stuns Heyman and he fumbles the focusing again, and again, and again, ending the roll shaken and out of focus. But he got his shot. Frame 27 is the best shot, standing alone like an island in a sea of out-of-focus.

I also want to see frame 22—a musing giant—enlarged, as well as frame 24. The latter is a mysterious picture that asks more questions than it answers. It implies that Hemingway is a lonely man. Writers are perhaps more lonely than other people because they live in a world on paper as well as the real world—two worlds to be lonely in.

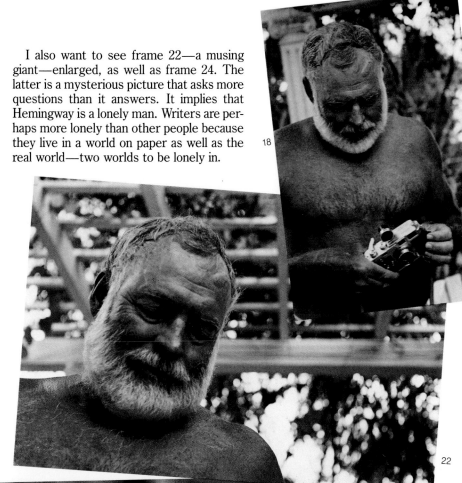

18

22

27

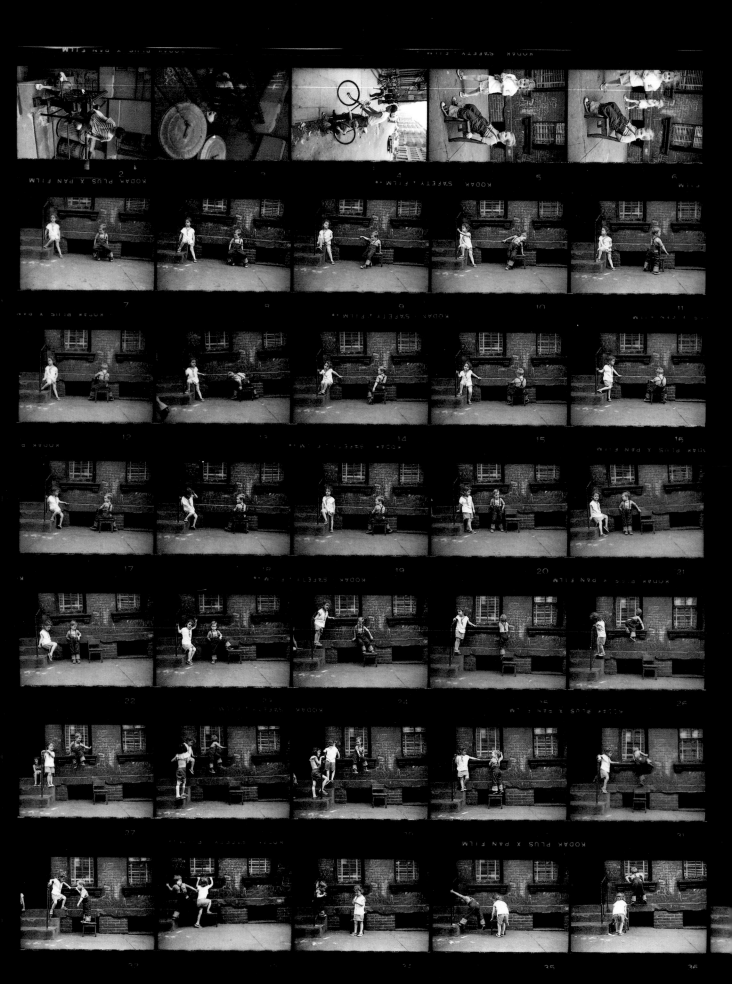

WILLIE'S WORLD

Sometimes photographic judgments have to be made in seconds. Driving down a street, Ken Heyman saw a subject. Was the subject worth stopping for? Did the subject have something to say? In the case of Willie, Heyman decided correctly in less time than it takes to say the subject's name.

He saw a boy hanging on a man, hugging a man on a city stoop. He stopped the car and began to photograph him. Before the first roll was finished, he knew he had someone special.

Heyman went back the next day and the one after that. In four days he had enough pictures to do a book on the boy. A photographer has to know when he has something good, and has to stay with it until he gets his story.

Willie, the book that resulted from the shooting, is now a collector's item, selling for as much as $100 a copy.

KEN HEYMAN
Being behind the car was important because it blocked their vision. If I had been standing on the sidewalk taking their picture, they would have seen all six feet of me, and I would have been intrusive. From behind the car only a part of me was visible, just my head. Even though they knew I was there, it didn't interrupt their play.

JOHN DURNIAK
The photographer likes and understands children. He touches their world without tampering with it. He became invisible to these two youngsters, an extraordinary feat.

KEN HEYMAN

This sheet was from the third day of photographing Willie, my subject for a picture story. He knew I was there and knew what I was doing. The little girl had seen me around with him, and probably thought of me as some kind of uncle-with-a-camera because Willie put up with me. She also knew I was making pictures but didn't know why.

The action was happening so well that I did not need to change my position. I could have placed the camera on a tripod and made the pictures with a cable release. Amazing! I cannot remember a contact sheet where I'm not going left, right, up, down, in and out. It was like a silent movie set—full of action, where action speaks.

I stayed with it, a 35mm lens on my Leica. I was behind a car and leaning over it. Being behind the car was important because it blocked their vision. If I had been standing on the sidewalk taking their picture, they would have seen all six feet of me, and I would have been intrusive. From behind the car, only a part of me was visible, just my head. Even though they knew I was there, it didn't interrupt their play.

Looking at these pictures today, I'm surprised I didn't move with the subjects. It is rare for me to stand in one place, at one level, and shoot an entire roll. In this case, the children were moving so well that I left them alone, even when they got up to the window in frames 25 and 26. They are fun pictures. I still think frame 14 is the right picture.

I overshot because their movements were so subtle. Both the girl and boy were animated, going through one continuous action. I almost couldn't miss. There was no motor drive on my camera. I don't use one because I want to select the right moments, and not leave it to the motor.

I did not think of Willie becoming the hero of a book when I photographed him. I had never before worked on a book. In the four days I shot more than fifty rolls, and a book emerged from them.

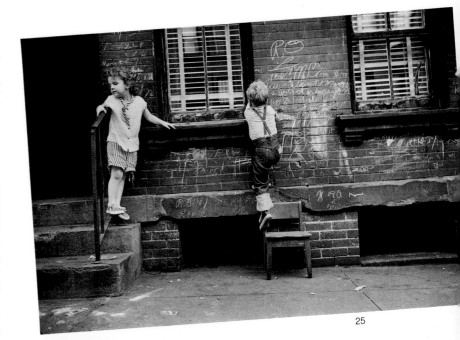

25

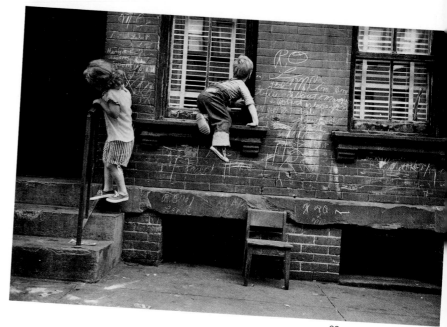

26

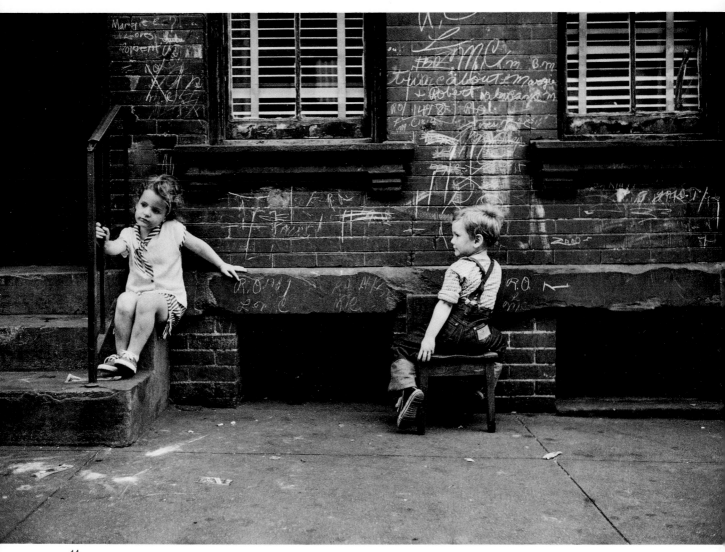

14

JOHN DURNIAK

Some people are born with a way of moving, a way of talking, a way of relating to others that is energetic, magnetic and compelling. Willie was one of those people. In his child's world, the photographer found him not only in control but enjoying his life fully. Nothing held back his imagination, his climbing, running, or playing. He was an actor and didn't know it. He could strike a pose and play a role without effort. Study these pictures, and you'll see a happy, unhappy, thoughtful, playful, startled Willie, whose body language never stopped communicating.

A game had started, one of those made-up games that kids get into. It may not have an ending. Part follow-the-leader, part king-of-the-mountain, part I-dare-you-to-do-what-I-do—Willie led the game. Frame 10 is one of the best pictures. Here are two children within a few feet of each other, yet worlds away. His body language says Willie is daydreaming. His playmate sits on the stairs, miles away in thought. Kids alone, yet together—I have seen moments like this, and so have most people.

The photographer likes and understands children. He touches their world without tampering with it. He became invisible to these two youngsters, an extraordinary feat.

The choice is between frames 10, 35, 32, and 36. How could I have picked four contenders? Are the pictures that good or am I getting sloppy?

I like frame 32 with the arm at the far left cropped out, and choose it as the right picture. Here, Willie encourages his playmate to try his route to the window. There is fear in the little girl's knees. Like a ballerina, she tells it with her movements. Confident Willie, having proven that he could climb and sit on the sill, shows off and tests his friend at the same time.

The last frame, 36, is one of those delicious moments when the viewer asks an unanswerable question, a mystery forever. How will Willie get down without the chair? Is his playmate taking it away or bringing it to him so he can climb. Is she a lady or a tiger?

It's a difficult decision, but I choose frame 32 as the right picture.

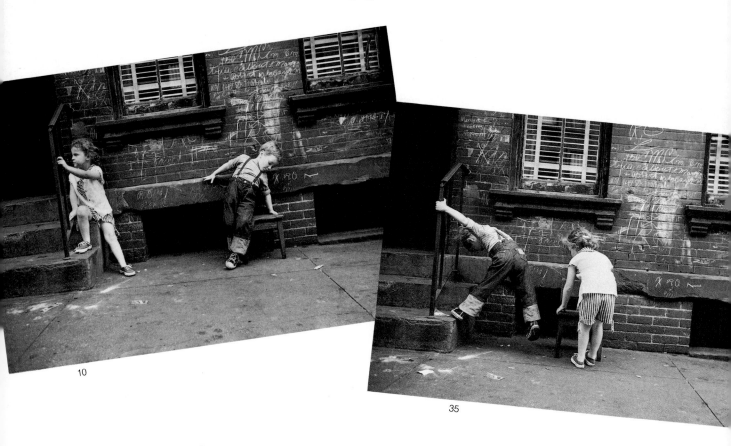

10

35

24

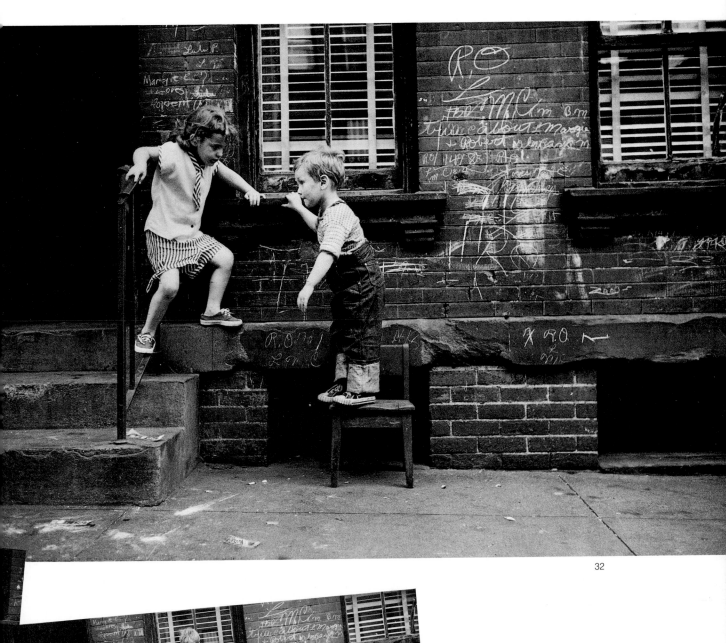

32

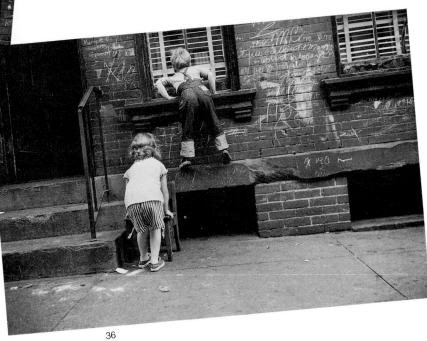

36

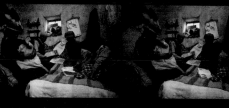

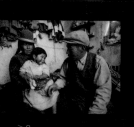
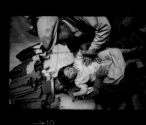
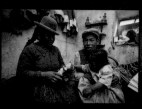
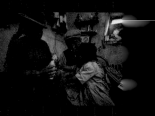
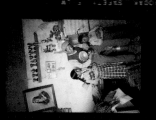

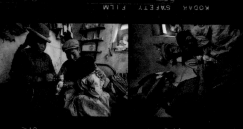

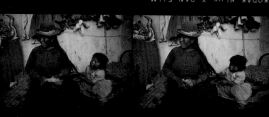

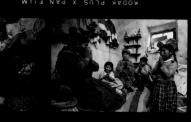
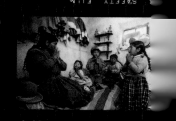

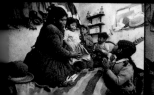
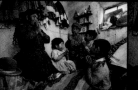
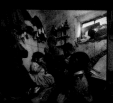
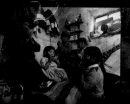

VISUAL ANTHROPOLOGY IN PERU

Ken Heyman's training was in anthropology, a field that values good, factual photography more than beautiful pictures. A moody shot of a mother holding her child will not work, whereas a picture of an entire family with all their belongings standing before a straw house has a great deal of information.

In many societies it is almost impossible to gain access to a family. One cannot walk into a home in Peru, for instance, and observe how a family lives. These people do not trust strangers—but in this case, they trusted Heyman.

As an artist, Heyman has various goals in mind when he photographs people. He accentuates special characteristics and plays with composition and graphic devices. As an anthropologist, he must capture visually readable, factual data. This contact sheet demonstrates both aspects of Heyman's photography.

KEN HEYMAN
Trying to understand people gives meaning to the world. I took these photographs to talk about and show these people as they were, getting as much information as I could without losing the viewer's interest. I composed my pictures carefully and waited for special, revealing moments.

JOHN DURNIAK
In spite of the shooting problems and the posing, one piece of information explodes from this sheet, which is the touching the family does. They hold, grasp, hug, rub against each other. There is love and closeness in this tiny room, care and protection, too.

KEN HEYMAN

I was in the city of Puno, on an assignment for Alliance for Progress to photograph a Peruvian family. In Peru, like many other countries, it is difficult to gain access to people's homes, but in the course of traveling the world, I have learned how to find the right kind of help.

I made inquiries to find out if there were any Americans in the vicinity. I was told that some Maryknoll Fathers lived in a village near Puno. I immediately headed there. One of my resources has always been the Maryknolls. These Catholic missionaries work in remote areas of the world and are truly dedicated, giving help and support in sound, sensible ways.

Once again, the Maryknolls came to my aid. They helped me to find a place to stay and, more important, they introduced me to a family that I could photograph. The father was the caretaker of the church and he, his wife and their four children lived in a small house behind it.

My introduction to the family was a ceremony in itself. The father smiled and bowed; then I was presented to each member of the family. They were all roly-poly and smiling. The mother had a ruddy, weatherbeaten face.

The interior of the house, I discovered, was a single dark room. And it was cold; the temperature inside was a few degrees below freezing.

Before starting to photograph, I sat the children on the bed and said to them, in Spanish, "Don't look at the camera." They tried not to look at me, but as I worked I could feel them struggling to keep their eyes away.

I used a 21mm lens because there was so much information to capture in that room, and I wanted to spread out their world so it could be examined. I liked the stucco walls, because they had no vertical lines, beams, or seams—nothing for the lens to bend out of shape. The ceiling was black from soot, which created great problems for the strobe that I used for bounce light. Throughout the shooting, I had trouble with the electronic flash, which went off sporadically.

In frame 6 you can see the distortion the lens is creating in the reflection in the window behind the child. Frame 6 is a good photograph of the children reading—well, not actually reading, because they didn't know how to read. The family was illiterate, but thought it important to be seen "reading," and had borrowed books and magazines from the church library.

There are four right pictures in this contact sheet—frames 6, 20, 25, and either 30

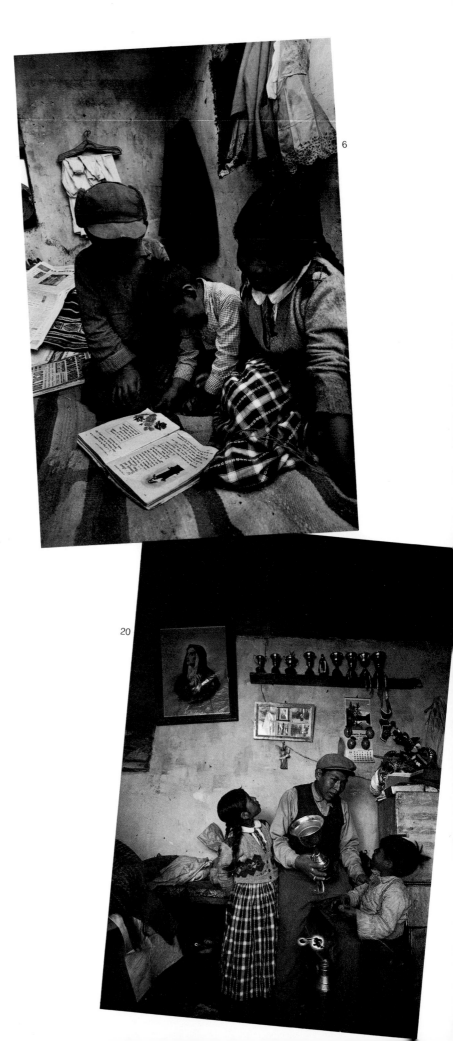

or 32. One of the latter is the best. I prefer frame 32. The older boy is not looking at the camera, and the mother is talking to the baby, elements which make this an interesting photograph, an anthropological picture where everything is meaningful, even the portable radio on the shelf in the background.

I also like frame 25, the little girl playing with her mother's long braids, and frames 20 and 21 of the father showing off his soccer trophies. Finally, I like frame 6 of the children looking at the books. They are happy and charming children.

Trying to understand people gives meaning to the world. I took these photographs to talk about and show these people as they were, getting as much information as I could without losing the viewer's interest. I composed my pictures carefully and waited for special, revealing moments.

These photographs are very marketable because there is something special about this family. I have been quite successful selling these pictures to the publishers of sociological books.

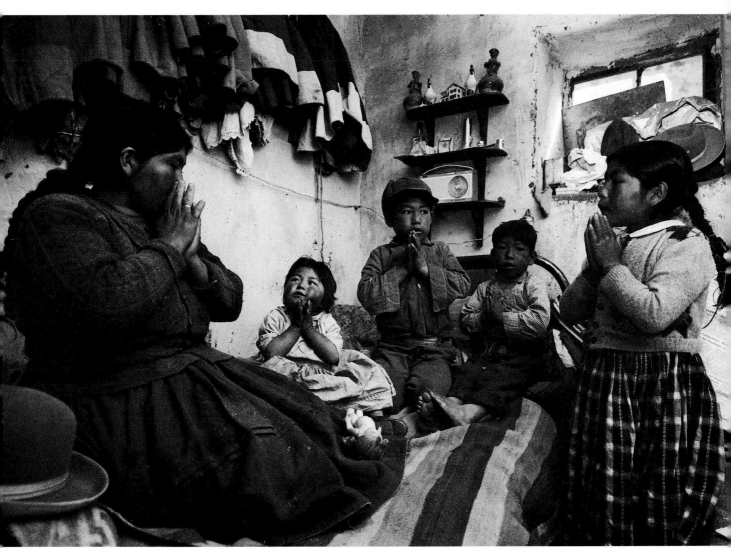

32

JOHN DURNIAK

There are five almost-blank frames on this sheet, which tells me that something was not happening right in the photographer's mind. The equipment functioned well for the other pictures, so the problem had to be in the photographer.

I can't prove it, but I feel Heyman might have been trying too hard in a difficult situation. Uncomfortable in the tiny space he had to work in, he probably would have preferred shooting with available light instead of bounce flash off a dark ceiling. (Take a look at the ceiling in frame 18.) It was catch-as-catch-can lighting—the photographer could only guess if the light was bouncing up into the faces of the children as they bent over.

A photographer's last resort at control is posing—when all else fails, become a director. Here, the photographer posed the father with his trophies—a self-conscious picture but one that makes a point. After suggesting a pose, Heyman shot it and looked for a new situation to spring from the pose. Success—frame 17 is that unexpected moment where the family members are more interested in one another than in the photographer.

In spite of the shooting problems and the posing, one piece of information explodes from this sheet, which is the touching the family does. They hold, grasp, hug, rub against each other. There is love and closeness in this tiny room, care and protection, too. The photographer went through photography's back door to bring us such pictures as frames 5, 8, 13, 16, and 25. These important moments tell me about the relationship between the parents and the children—that's why these pictures are successful.

The mother fascinated the photographer. She is the central figure on this contact sheet, and with her hat on (except in the prayer pictures) she dominates most of the activity. As in an average workday, in these pictures the father is around only part of the time but the mother is always there. These pictures reflect and emphasize that fact.

Frame 2 fascinates me—the mother and child, the father, alone but not alone, the three children together. These three elements are probably at work in this family all the time. The three children play together because they are close in age. The father goes to work, spending most of his time alone, away from the family. The mother and the infant are inseparable because the child needs the mother most. I am not aware of any posing here. If the photographer did pose them, I'm surprised.

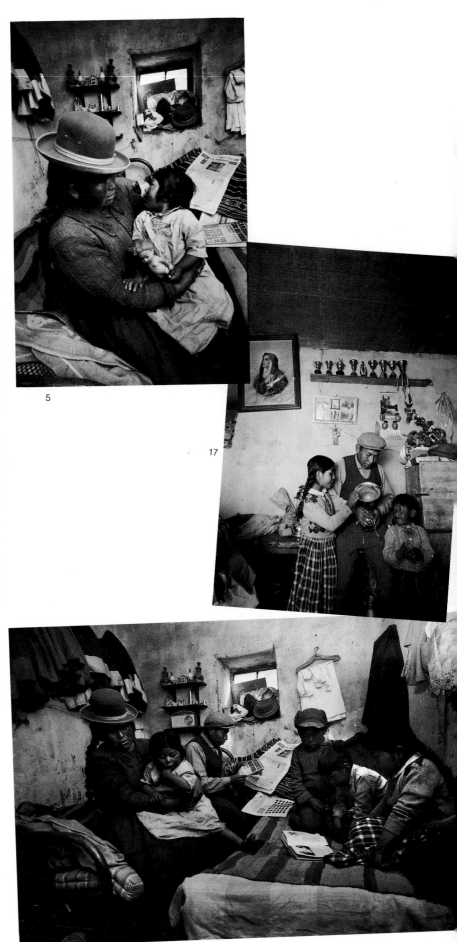

5

17

2

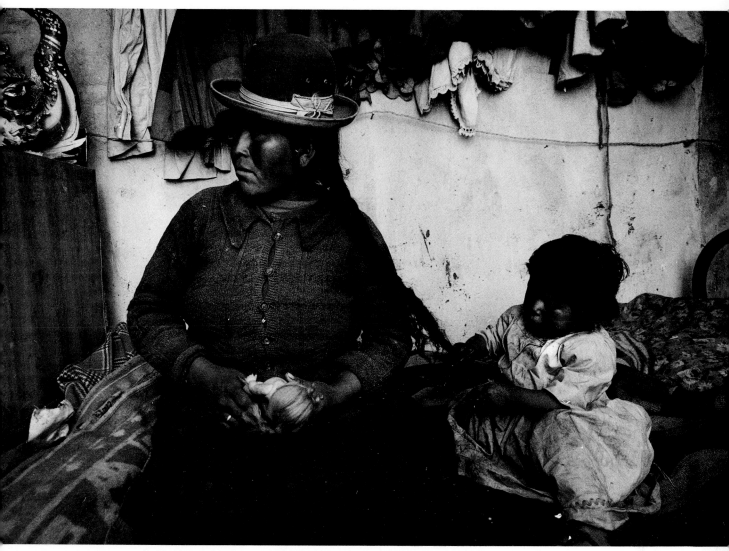

The right picture on this sheet is frame 25. It says to me: "One day she will sit having her child comb her hair, as I did for my mother." This is a picture of the chain of life. One generation replaces another, preserving a few customs and activities. I believe that this scene occurs when the photographer is not here, so it is a real picture. In this world of scarcity, a comb becomes a plaything and, at the same time, part of a ritual of affection.

The mother holds a plastic doll from the mysterious world where people make books and magazines with pictures that "talk." The expression on her face is placid, perhaps telling of the rewards in her small world—a husband, children, and a house. Having seen all their possessions, we can put together the pieces and make a whole picture of their lives.

The blanks on a contact sheet are always the most visible pictures, but counting them is a bad way to judge a contact sheet for quality. Sometimes, the limitations of a situa-

tion call the tune. Making these pictures, the photographer had much going against him— the cold, the dark, language barriers, lack of space, and lack of time. There is no quick way of making subjects comfortable with a man who points a magic machine at them, filling the room with lightning each time he touches a button.

The photographer waited for them to get bored with his presence and to return to their own interests. His patience was rewarded several times over. But during this mission, he ignored his equipment. He didn't wait for his flash to recharge fully, or he unconsciously unhooked the synch cord, and produced the blanks.

Tough situations make war on the photographer's senses. He needs to be thinking on several levels at the same time. His technical thinking should be on automatic. Heyman's ultra-simple technical methods were challenged by this small, dark room. Yes, he missed four or five shots, but he got the pictures that count.

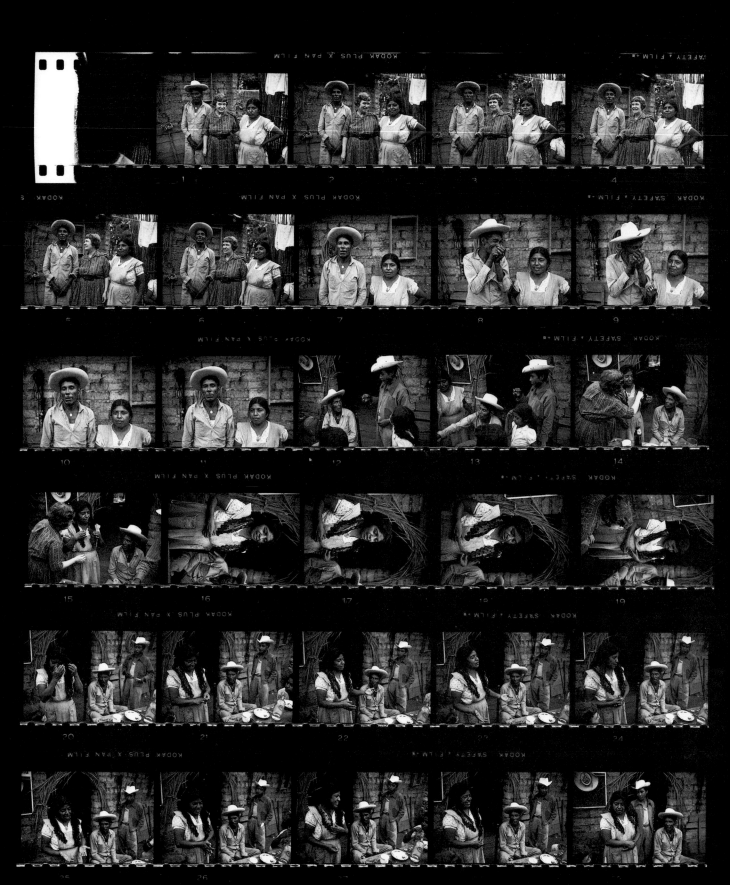

MARGARET MEAD IN MEXICO

On anthropological projects, a photographer must work closely with the director of the study. Ken Heyman and Dr. Margaret Mead worked out a system that enabled them to do a good project in one week. They travelled to a Mexican village, one they had carefully scouted beforehand, where they found a family and began their observations. Heyman was so attuned to Dr. Mead's methods of working that he began shooting immediately, and continued without hesitation throughout their visit.

In fact, Heyman extended the anthropological aspect of the shooting beyond coverage of the original subjects. Even as he and Dr. Mead were saying goodbye to the family, Heyman was able to capture a revealing glimpse of the great anthropologist herself.

KEN HEYMAN
Notice that I shot five pictures besides the one Dr. Mead wanted. That comes from the discipline of anthropology, and in response to suggestions from the subjects. I hadn't stopped fact hunting or searching for relationships.

JOHN DURNIAK
Heyman is tough, maybe tougher when his unconscious is turned on. Was he fully aware that he was making a movie of Dr. Mead's attempt to relate to both these people? In the span of eight frames, she visually admits that she is paying too much attention to the mother, and switches her body language and stance toward the father.

KEN HEYMAN

Margaret Mead asked me to go to Mexico with her to photograph a farm family. We had already documented four other families—a white family in Vermont, a black one in Georgia, one in Sicily and another in Bali—and all this material was to be published in a book. After finishing our Mexican project, Dr. Mead asked me to make some pictures of her with our study family so we could send prints back to the family. I took six group pictures. Why six pictures, when I could have shot only one?

The reason is conditioning. Being with Dr. Mead and shooting anthropological pictures meant getting as much information and as many pictures as possible. During my first twenty years in photography, my personal record for the most pictures taken in a single day was thirty-two rolls, made in Bali for Dr. Mead, who wanted just about everything photographed. Today, that's not considered a gigantic shoot, but at that time making 1,152 pictures was big shooting. In doing anthropological photography, one visual discovery leads to another, and more and more pictures are taken.

After a week of continuous shooting my finger was working rapidly. So when Dr. Mead said take a picture, it was automatic for me to take more than one—even if she was in the shot. Notice that I shot five pictures besides the one she wanted. That comes from the discipline of anthropology and in response to suggestions from the subjects. I hadn't stopped fact hunting or searching for relationships.

In frame 7 the couple asked for a portrait of themselves, alone. I call this kind of shot a passport picture. It is a kind of stand-up-to-the-camera-and-take-a-picture shot, simply a record. Sometimes you get a stark, interesting portrait; some photographers, such as Richard Avedon, use the passport situation as a style. Frame 7 is a good portrait of the couple—simple, direct, and unpretentious.

We sat down around the table for a meal. In frame 15, Dr. Mead gives the wife a mantilla, a present from us. She was thrilled with it, as you can see from her reaction in the next four frames. In frames 20 to 24, the father and the oldest son sit passively in the background as the mother tells a story with open gestures. In this family and culture, the woman is the stronger one.

The right picture is frame 26, because of its interesting composition—the arch of the doorway is used for strength. But frame 7 is an interesting portrait, even though it is a picture with little involvement on the photographer's part, a passport picture.

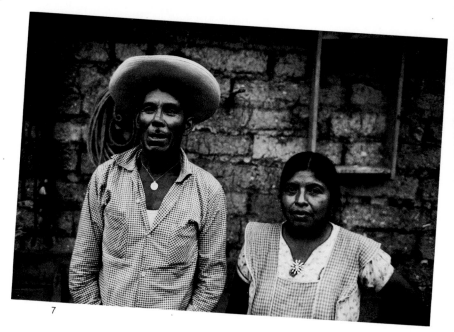

7

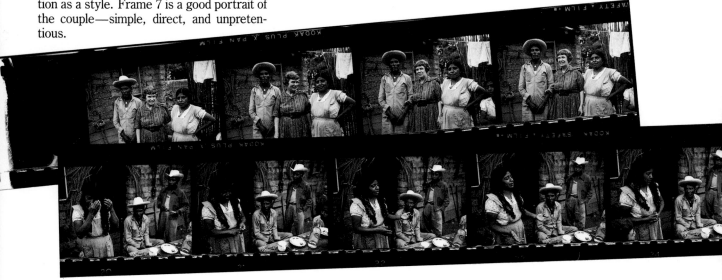

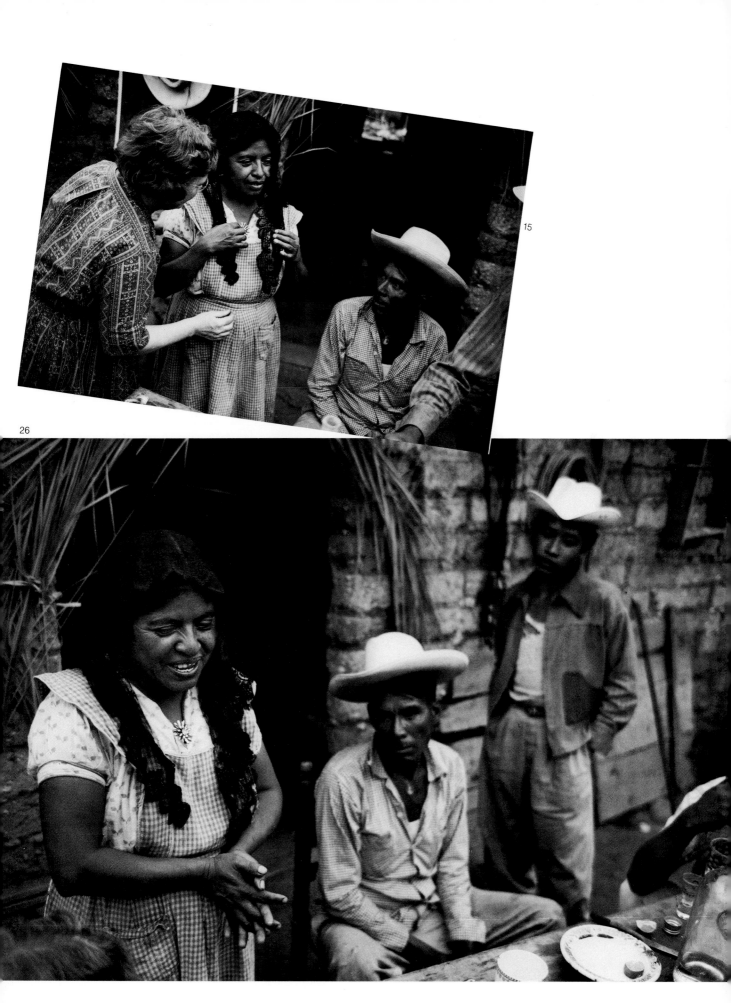

JOHN DURNIAK

The first picture and the last picture on this sheet are the best. In frame 1, Dr. Mead is relating to the mother. They touch, they are conscious of themselves as the center of the picture. The father might as well be out in the town square—he stands like a stick, not knowing what to do with his hands.

Sensing that he would learn something more about Dr. Mead, the photographer stayed with this scene. Watch Dr. Mead. In the span of eight frames, she visually admits that she is paying too much attention to the mother, and switches her body language and stance toward the father. In frame 5, she actually looks up at him, making him the center of attention in the picture.

Heyman is tough, maybe tougher when his unconscious is directing him. Was he fully aware that he was making a movie of Dr. Mead's attempt to relate to both these people? In frame 1 the anthropologist puts her arm around the mother, but nowhere does she touch the father. Perhaps Dr. Mead was following the society's code, which allows women to put their arms around each other, but keeps a wall between men and women.

Heyman was hair-trigger sharp on this shoot. He was in a no-win situation and could have settled for taking a few personal pictures, then joined the party. There shouldn't be a single picture worth publishing coming out of this take. But the photographer stayed with his subjects, and discovered relationships, feelings, ego, and a sense of honor in these direct, simple pictures.

The mother emotionally receives the mantilla. The gift surprises and greatly pleases her. Frame 15 establishes her feelings of delight and surprise, and is a warm picture of Dr. Mead and the father. I would crop out the arm at the right of the frame.

All stops have been pulled out for this going-away celebration. A bottle of tequila graces the table, and in frames 12 and 13, the older son has a "shot." The light in these pictures is fabulous. The shadows are open, and you can see the subjects' eyes. No New York studio could light the scene better. Soft, even illumination allowed the photographer to move freely and shoot from different angles. There are no harsh shadows, making the negatives easy to print.

I like frame 9. It's ambiguity makes me reach. What is the father doing? Perhaps he is hiding his open mouth that might reveal irregular teeth. In frame 7, he starts breaking up with laughter. By frame 11, he has gained his composure and poses with his wife for a double portrait, Avedon style, presenting himself to the camera.

I believe the best frame is 30. The mother runs the show in this family and frame 30 is the picture that says so. I would have liked the boy in the background to be a bit sharper, but I'm not that upset. The mother-as-superstar is in the picture, and that's what the week in Mexico and the day was all about—motherhood as the strength and bonding material in this Mexican family.

When I first picked up this sheet, I expected one of five frames, 16 to 20, to be the right frame. But frame 30 beats them in spite of the dark archway. For a bunch of party pictures, this was not a bad take, which shows that the follow-through can be as important in photography as in golf.

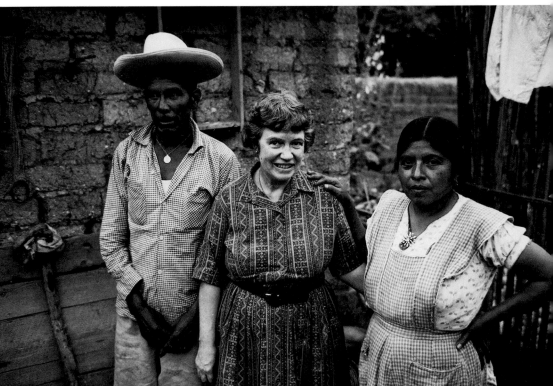

9

12

30

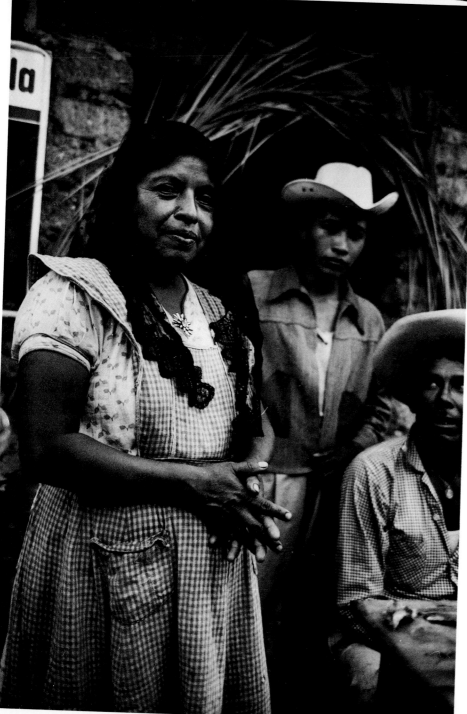

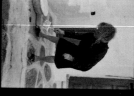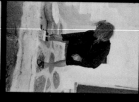
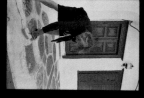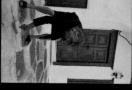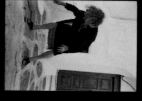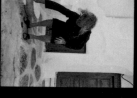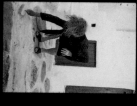
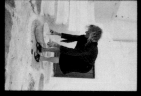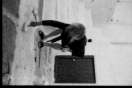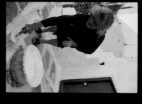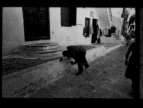
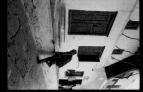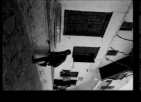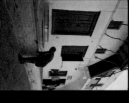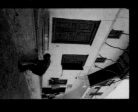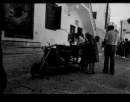
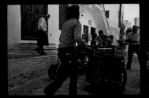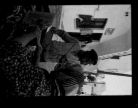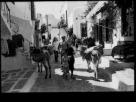
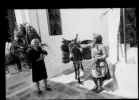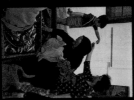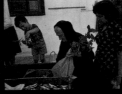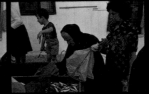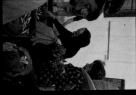

MYKONOS, A SELF-ASSIGNMENT

The practice of self-assignment can be one of a photographer's most useful exercises. It is a highly personal experience in which the photographer becomes his own audience—there is no client to please, no specific requirements by which the photographs will be judged. Many professionals use the self-assignment to break away from a specialized area in which they normally work; it is a tool that they use to keep from getting stale. For nonprofessionals, self-assignments may be more structured, serving as a way to test their abilities should they ever be offered that "dream" assignment. Whichever the case, this is an opportunity to make mistakes and learn from them. Some good images may be captured in the bargain, but the purpose behind any such practice should be to move beyond the ordinary, to break the photographic cliché.

The photographs shown here were taken on the island of Mykonos, off the coast of Greece, but they could have been taken anywhere in the world. The photographer's premise was merely to be open to any subject that passed in front of his lens, to see the patterns and shapes that existed, and to be aware of the people's movements and their interaction with the surroundings.

KEN HEYMAN
I feel like I've walked the world. People will never know the miles and miles and miles a photographer has to walk for interesting picture results. But this day in Mykonos I felt fortunate. Everywhere I turned there was the whiteness of the village and people at every corner. It was like a studio created for my photography—black against white.

JOHN DURNIAK
Is there an astonishing picture here? Is there one that will live for generations on a museum wall? I am not astonished, but I am impressed with the effort. There are several close calls.

KEN HEYMAN

I had no assignment. I was on vacation. That day I had a choice of sunning myself at the beach or taking pictures. I hate the idea of sitting in the sun doing nothing. Under these circumstances what I do is wander, wander with my camera. Actually, I usually wander with two cameras, one with a 28mm lens, and the other with either a 90mm or 135mm lens. If I have a third camera, the 50mm lens goes on it. My cameras are on my shoulder and I try to keep them as inconspicuous as I can. It's hard, but flashing a lot of equipment is often a bad way to be introduced to a subject. I try to remain low-key and invisible, if that's possible.

I ask if it's market day, and if it is I head for the market because a community's way of life springs from the market. It's also a place where you can tell the driver to go without knowing the address. I usually start shooting there, and then go out into the town or countryside.

But Mykonos had another thing going for it: its white-washed buildings. Everything was white. The alleys, sidewalks—everything. And the buildings had rounded edges. The fence posts were round and white. Ours is a rectangular world but Mykonos is round.

I feel like I've walked the world. People will never know the miles and miles and miles a photographer has to walk for interesting picture results. But this day in Mykonos I felt fortunate. Everywhere I turned there was the whiteness of the village and people at every corner. It was like a studio created for my photography—black against white.

I turned a corner and saw a woman painting the sidewalk in front of her house. She was wearing a black dress and using white-wash.

The first question I ask myself is always the same: How long will I have to photograph the subject? Would it be only a few frames before this woman became aware of me and started posing? Would I have to move immediately into the situation to get one or two frames, or would it last?

In this case, I felt safe because I saw that her bucket of whitewash was full and she would be a long time using all of it up. I could take my time and didn't have to panic.

As I moved in to shoot her, she communicated in some way—this is hard to explain—that I could do my thing and she would do her thing. (I have traveled around the world taking pictures, and people have a way of telling me nonverbally that it's okay to shoot.)

She kept working. She didn't give a damn about my being there or taking her picture. This is the best situation for my kind of photography—when the subject ignores

me. Most women in the world would brush back their hair or do something cosmetic to make themselves look a little better; this one did not.

In the first three frames I used the doors as part of the design. Then I dropped to a low angle. Then back up to my usual shooting position—at the subject's shoulder. I should explain that I have a rule for using a wide-angle lens (and that's about three-quarters of the time). If I'm photographing correctly my camera should be at the level of the person's face. If my subject is a child, I get low to the ground. The reason is that the least distortion occurs when I work on the same level. I pride myself on making pictures without much distortion. This rule prevents it automatically.

By frame 6 I was more interested in the woman than in the design. I tried anticipating her movements. Frame 15 is the best of the group. In retrospect, I don't like my designs, but frame 8 is fair.

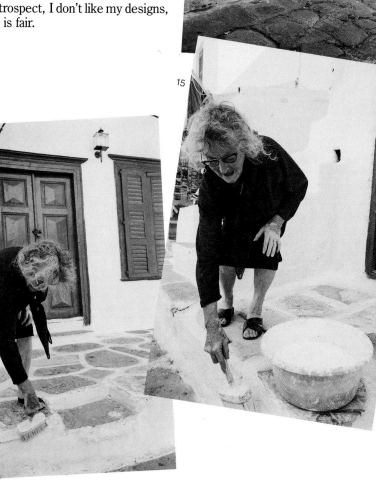

18

15

8

Farther down the street I discovered a drunk having trouble with a shoe, but on this morning I was more interested in getting designs than in concentrating on the man and his problem. Instead of telling his story, I tried using him as an element in the design. I prefer frame 18. It has more than design, it has energy—the line of the leg adds zing.

A three-wheeled vehicle pulled up, and I became fascinated with the market situation that developed around it. Frame 22 is my reaction to it.

Frame 27 is a bad picture, but it gives you a feeling of the place. I made the shot quickly and went back to the three-wheeler where the driver was selling small, sardinelike fish. I was distracted again by a man coming down the street pushing a cart. I tried to capture his energy in frame 23, but I missed the decisive moment, so I returned to the fish peddler. I moved in to make frame 31, the market-type shot that I have done all over the world showing the arms of the buyer and seller in contrasting poses.

On this day I wasn't interested in talking about people, but in the design and atmosphere of the town. The alleyways fascinated me as much as the people did. I was working well on this day, but not well enough—I really didn't get a picture on this sheet. When you wander, your mind should be a blank. The photographer should be open to anything. In this shoot I was not hungry. I must have had a big contented smile on my face. I have to be hungry to do good work.

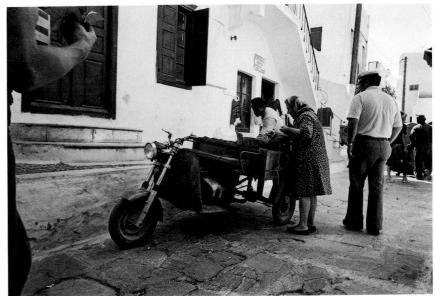

22

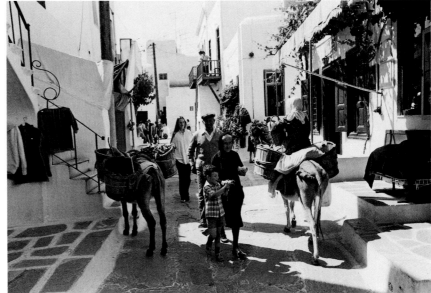

27

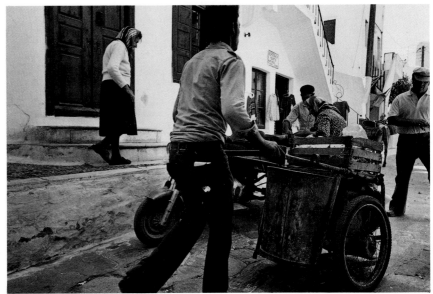

23

JOHN DURNIAK

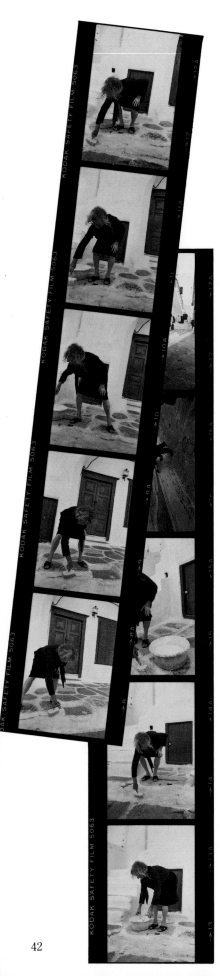

Freedom is the condition under which these pictures were made. The photographer stopped wherever he pleased, shot whatever he wanted, and had only himself to face. In Ken Heyman's case, however, self-criticism may be the toughest criticism dealt to him. He doesn't allow himself much room for error, misjudgment, or sloppy work. Photography is always serious work for Heyman. He doesn't bring the camera up to his eye unless he is seriously pursuing a picture. While some photographers can sketch with a camera or play with ideas, Heyman never plays at photography—he is after *the* picture.

I had a chance some time ago, while doing an article for *Popular Photography* magazine, to spend time with Heyman while he "looked." We walked the streets and he talked about what he was seeing. It was an impressive exercise because he saw relationships between people, their emotional conditions as individuals, and graphic possibilities that some photographers might have overlooked. For Heyman, daily life is dramatic and no individual is immune from his scrutiny. His mechanism for analysis is never turned off. It was on in Mykonos.

Is there an astonishing picture here? Is there one that will live for generations on a museum wall? I am not astonished, but I am impressed with the effort. There are several close calls.

In frames 3 to 15, Heyman photographed a woman painting the seams in the sidewalk in front of her house. She's not young, but her movements are graceful and limber. I have seen photographs of Jackson Pollack and other artists who paint canvases on the ground, and have been impressed by their body language while they paint. There are some dance elements in their movements when brushing and dripping paint. In these frames, Heyman has made arms, legs,

clothing and head elements of the composition. At first glance, I thought I had possibly found a sequence of Pollack-like movements in these images. I jumped into the contact sheet looking for three or four pictures that would work together. But Heyman did not see sequences in the situation. Instead, he worked for single shots, causing the door and the windows in the background to move around like a yo-yo. Had he held the camera in one position, keeping the background fixed, I could have worked out a sequence. But with the background so dissimilar in each frame, I had no such chance. He missed an opportunity here.

Of this series, I like frame 5 best. The stance in the legs, the triangle shape of the body, the position of the head and the brush—all the elements work together, including the random pattern of the sidewalk stones against the symmetry of the doors and shutter in the wall.

Frame 18 is my next choice. It is surreal. Again, the situation is a find: an intoxicated man trying to put on his shoe. It's a scene worthy of a Charlie Chaplin film. Yet no sequence can be made from the surrounding shots because again, Heyman was thinking of single pictures. Had he shot the drunk with a telephoto to bring him in closer, a sequence might have been possible, but as it stands, the subject was too far away.

Frame 27 is a nice image—balanced, flowing, and well composed. If the boy and the old woman were not centered I'd like the frame better, but in the final print, the right side should be cropped out. (Note that there is only one frame of this image. Did the scene come and go so quickly that there was no time to shoot other frames, or did Heyman get the right shot, know it, and then move on to other work? I believe the latter is true.)

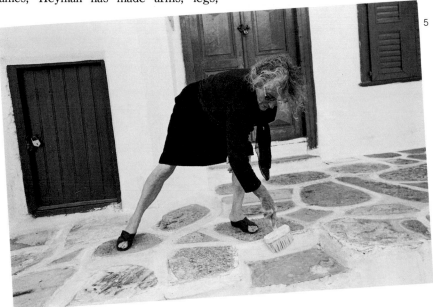

5

The boy taking a small fish from his mother—frame 29—is my next choice. This is a complicated, interesting picture, with action in the background and counteraction in the old woman's movement. Each subject has a different expression. The large shape of the fish peddler's shirt in the lower left might have to be printed darker. If it isn't it will control the whole picture.

I also like frame 32. What complicated relationships between the faces! How did Heyman see fast enough to find this positioning? The little boy's face fits in with the fish peddler's, and the brim of the other man's cap cradles the mother's chin.

Frame 35 is a simple, beautiful image. While the world is crashing ahead to new inventions (and dilemmas), this island continues in its old ways. The white walls and the soft, white light were there before cameras and photographers were created. But notice again how Heyman's eye captured the dynamic graphic of the background, juxtaposing the soft shapes of the burro and bundles against it.

Heyman, on his short walk through Mykonos, took pictures without touching or changing what lay around him. The islanders never saw him, but he saw them and took them away.

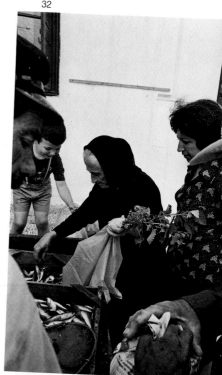

32

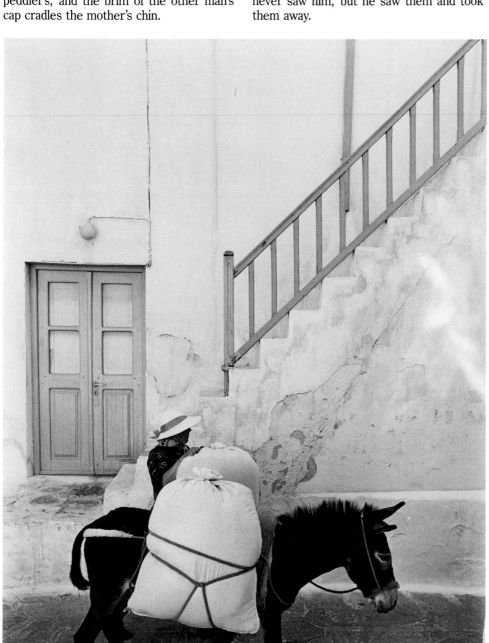

35

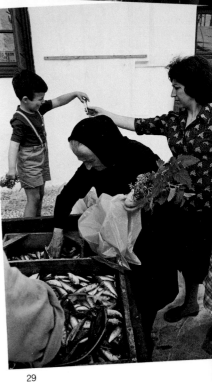

29

43

PARADE POLITICS

The key to good parade photography in any major city is the police press pass. Without it the photographer is limited to a series of bad positions, and has no freedom of movement. The greatest fear in a photographer's mind is to be immobilized by the crowd, and not be able to go where the action is taking place.

How does Heyman use the mobility afforded him by the pass? How does he avoid the clutter of people in his backgrounds? How does he select subjects out of the kaleidoscopic activity around him created by more than 330,000 spectators and marchers?

Bad backgrounds can kill a good subject. The jumble and clutter detract from what is before it. Heyman plans ahead, thinking of the background first and the subject second.

The parade is one of photography's greatest challenges because it teems with action. The eye is numbed by all of it. To isolate the dramatic and meaningful, to eliminate the hokum and distracting static, to extract important interactions—that is the goal.

KEN HEYMAN
I look for what is meaningful, in this instance, something that said in the most desperate way, "Stop Nuclear War." Visual messages are better than written ones, so that's what I try to shoot.

JOHN DURNIAK
Because a parade passes by rather quickly, its messages have to be telegraphed to the watching bystanders. The most effective parts are like television commercials, but convey their messages even faster.

KEN HEYMAN

Certain events have triggered a deep response—President Kennedy's assassination was one such event. Over 300,000 people marching in New York City's 1982 antinuclear rally was another.

I wanted to be part of it. Having had experience with the New York City police, I decided I needed a press pass, so I called a picture editor on a newspaper. I knew he did not have enough photographers to cover the whole event, so I asked if he needed help. He did, and I got a press pass.

The press pass allows the photographer freedom to roam the streets and actually walk past lines into the middle of the parade, to get up close to the marchers, and to have flexibility. Trying to work from inside the crowds is a nightmare. This press pass gave me a freedom I rarely have, since I usually work without one.

When I cover a parade I always shoot the marchers assembling—I find a tuba player talking to a celebrity, or someone holding a flag—and I also do the end of the parade when people sit down. Both these situations are usually more interesting than the parade itself. But this time I wanted to cover the parade as well. I decided the most interesting place would be around the United Nations building, and shot this roll there as the parade went by.

This parade clearly displayed its message. These people had a lot to say. Most parades are all show—bands and color. In the first five frames, these marchers are carrying a block-long, cloth poster of signatures brought from Japan. Frame 5 is the most interesting. I didn't particularly like this shot but it was the best I could do to get the entire poster given the lenses I had with me. I had a light-weight 500mm that I didn't use but carried, a 28mm that I used throughout this contact sheet, and two other lenses, a 50mm and a 135mm.

The next three frames have another message. Because I have traveled a great deal around the world, I know that to see a sign saying, "Tibetans for World Peace" is extraordinary. I have met very few Tibetans. There are just over one million of them living in a half-million square miles of mountainous land in Southern Asia, and they simply don't get around much. How a group of Tibetans could be assembled in New York for a parade just astonished me. So here I was reacting to my own surprise.

In frames 11 to 14, an unusual lady came along the parade route—she had an outfit with writing all over it and was working with

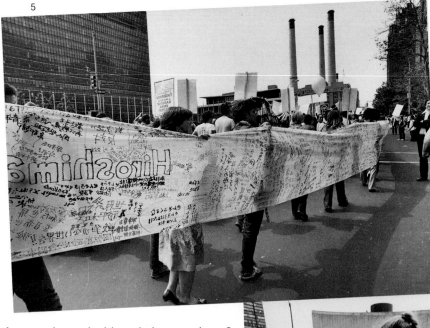

5

photographers, inviting their attention. I changed my detached working style and asked her to pose. Another photographer joined me. We photographed her body as art and information.

On this assignment, I was working for myself as well as for the newspaper. A pro always works with two or more thrusts—one is the assignment and what the editor wants, and the other, what he or she wants as a photographer. In a baseball assignment, the most important job is to get the best picture of the game. At this parade, I was looking for a single photograph that would say what was going on.

I knew there was a photographer from the paper in the helicopter photographing the crowds and another upstairs in a building with an overview shooting the crowds, so I didn't have to worry about those pictures. I did get up on a balcony to take some overall shots; but mainly, my energy was directed toward getting that single image that would tell the story. With that in mind, when a big group of survivors of Nagasaki came marching along, something in me said, "Go for it. This is the picture, this is what you're looking for." As I approached, I saw that they were carrying pictures, which are common in Third World countries, portraits of people who had died in Hiroshima and Nagasaki. I knew this sequence would be the important one so I shot it for eighteen frames, vying for position with other photographers. I figured out how to get around them in frame 17, and I was able to focus on the sign. From frame 18 on, I was shooting and walking backwards—you learn how to do that early in journalism.

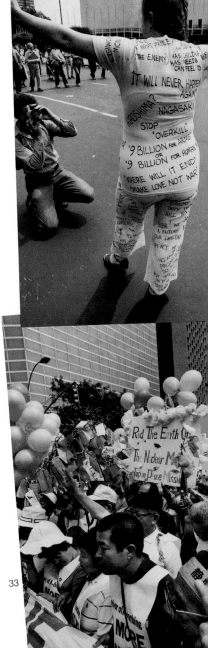

33

In frame 19, I started to get what was important. In frame 20, I was particularly interested in the woman with the black ribbons. I zeroed in on her in frame 21, and took two pictures that are almost identical. Once a photographer knows he's got the image, he takes verticals to match the horizontals. The picture is horizontal, but knowing newspaper work, I automatically shifted my camera to give my editor two verticals. He might have wanted to run it in the one-column format, even though the banner says horizontal, horizontal. I shifted to horizontal in frame 25 and realized it wasn't the right picture, so I went back to the woman. It is unusual for me to leave the prime target, and since I didn't know that I'd nailed it, I went back to it. After eighteen frames I stopped backpeddling.

Frames 33 and 34 are of another group that turned out to be too confusing, and didn't work out. Then I got more interested in the banner with the slogan "Save our Planet" than in the people.

What do I look for during a parade? I look for what is meaningful, in this instance, something that said in the most desperate way, "Stop Nuclear War." Visual messages are better than written ones, so that's what I try to shoot. At a parade, each time I stop, I look down the block for my next target. It

shouldn't be a busy image. People carrying a hundred different-colored balloons photograph badly. I look for a simple, straightforward message. Viet Nam vets hobbling along, against nuclear war, that's the kind of straightforward message I was looking for here. Each group had its own way of expressing itself.

Half of this contact sheet (eighteen frames) is devoted to one such group. A single image of the woman carrying the picture says more than words could. These pictures imply that she had lost a relative in a nuclear disaster, and frame 21 says it far better than any other image on the page. The newspaper used it. Actually, both frames 21 and 22 are pretty good. But I like the paper's choice because the woman looks alert and alive, in contrast to the image on her poster, which implies death.

The right picture could be frame 21 or 22. If you look closely, you can see they are similar. The differentiating factor seems to be the man next to the woman carrying the picture. In frame 22, the man is looking toward her, which makes him important. When he looks away, he is less so. Seeing her alone is more important, so frame 21 becomes the right picture. I don't feel there are any others that match it on this contact sheet.

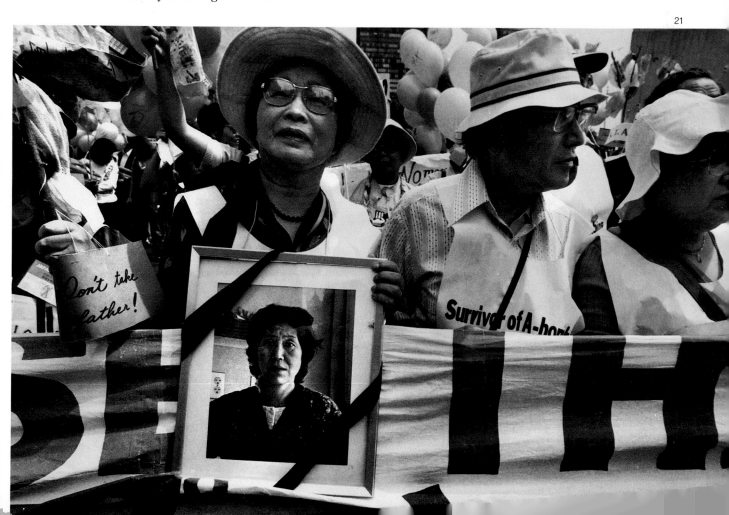

JOHN DURNIAK

Parades are theater. Costumes, signs, music, and even make-up are used to create a desired effect. Marchers are actors. Almost every element of the parade has a director, including those who are independents, who direct themselves.

Because a parade passes by rather quickly, its messages have to be telegraphed to the watching bystanders. The most effective parts are like television commercials, but convey their messages even faster.

How did Key Heyman do at getting this parade's message? Did he find more interesting pictures than the other photographers? First, that he got a picture in the paper is amazing. If four photographers were assigned, each could have shot a minimum of six rolls, which means the editor had a minimum of 864 pictures to look at—not counting Heyman's take. The editor needed only one or two pictures for the front page and four to eight for the inside of the paper. So for Heyman to get a single picture in the paper was no small accomplishment.

Did the newspaper run Heyman's best picture? Going over the sheet, I have initially marked the following frames: 3, 10, 14, 15, 16, 21, 22, 23, and 33. These photographs are a good cross section of people, costumes, messages, and rhythms to the event.

I like frame 3 because of its simplicity and compositional strength. The sign, written in Japanese, and the marching wall of people with bits of American faces are well framed by the photographer, and make an unusual image from a parade. The United Nations building and a balloon are counterpoints.

Before choosing frame 3, I spent a good deal of time trying to crop frame 2. The triangular shape of the banner draped on the marcher's shoulder is strong, but I couldn't tame the background to work with it. Cropping out the photographer at left helped, but the girl with the hand poster looked into the camera lens and undermined the image.

Frame 14 works. The faceless human sign cavorts for the photographer in a surrealistic manner. I like it.

Frame 15 also works by showing the media event—photographers scurrying for position while the Japanese tidal wave of marchers flows toward them. The woman in the center with her face partially obscured is relentless in her body language. The photographer hits with two pictures in a row. Frame 16 also has something. Cropping it across the bottom under the thumb, makes for an offbeat image.

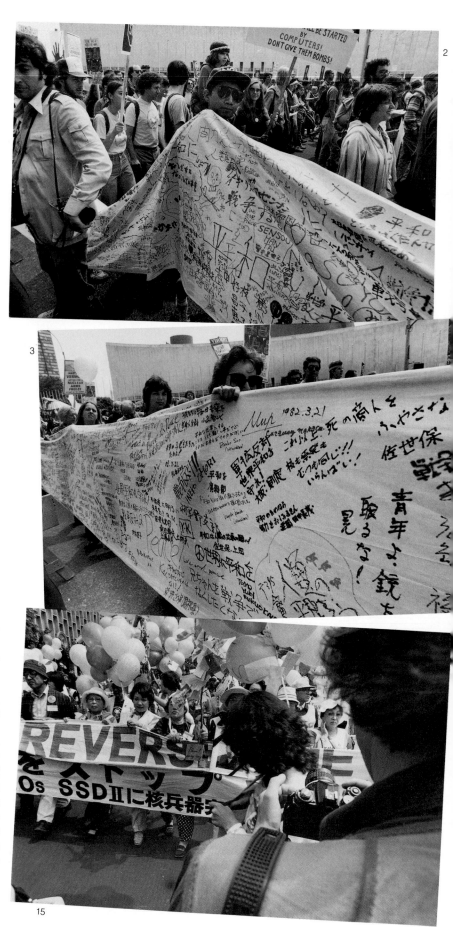

I like frame 23 better than frame 21, because in the latter, the arm coming out of the woman's head is distracting. My pick of the sheet is frame 23 as the right picture.

In frame 33, the seriousness of the faces, the single purpose of the marchers, and the "V" sign in the lower right make this picture work for me.

The photographer scored with a good picture, but his vision wasn't laser sharp. He wasn't critically aware of his backgrounds.

Foreground action wasn't integrated with the background. Using a wide-angle lens forced his eye to scan a large picture area—foreground, middle ground, background and subject—too quickly to make the exposure only when all elements became one. We have seen better work, better timing, and more enthusiasm from Ken Heyman than in this sheet. He was not hungry enough. He was a bit self-conscious, a quality I rarely see in his work.

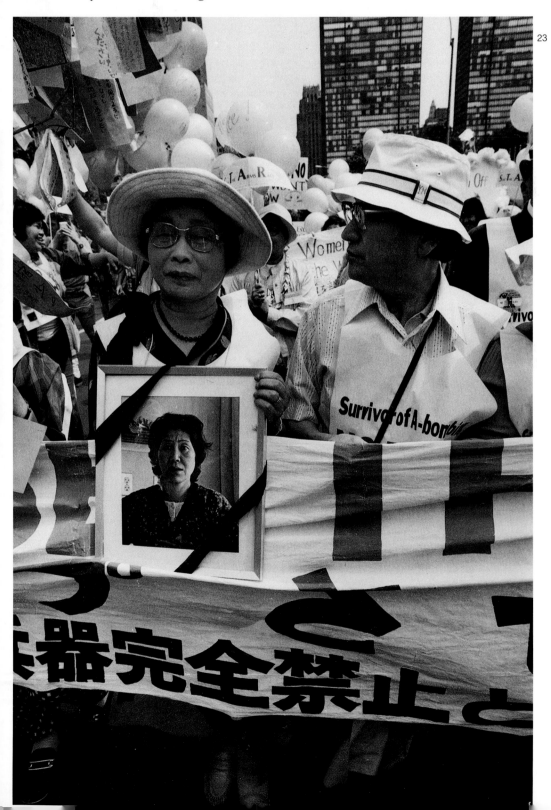

23

→1A →2

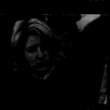
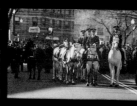
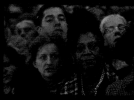

2A →3 →3A →4 →4A →5 →5A →6 →6A →7

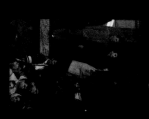
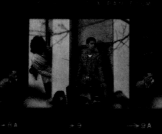
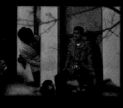
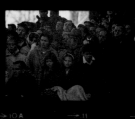

→7A →8 →8A →9 →9A →10 →10A →11 →11A →12

12A →13 →13A →14 →14A →15 →15A →16 →16A →17

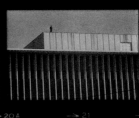

17A →18 →18A →19 →19A →20 →20A →21 →21A →22

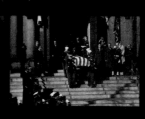
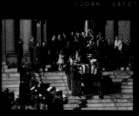
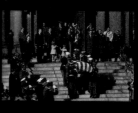

22A →23 →23A →24 →25 →25A →26 →26A →27

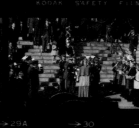

27A →28 →28A →29 →29A →30 →30A →31 →31A →32

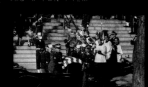
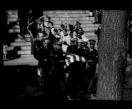
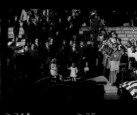
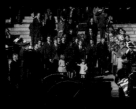

32A →33 →33A →34 →34A →35 →35A →36 →36A

PRESIDENT KENNEDY'S FUNERAL

Photojournalism demands that its reporters inform us of the events of our time; it shows us the good and the bad, the celebrations and the catastrophes. A photojournalist's pictures show us the realities of what we are and how we react to the events of our time.

The shock of President John F. Kennedy's assassination left many Americans wanting "to do something." There was nothing to do.

Ken Heyman had to do something with his cameras, not for a publication, not to make money, but as a gesture of respect to the much admired President. He decided to go to Washington and photograph the funeral. He wore no credentials—he was there as an American, mingling with the people and recording on film one of the greatest tragedies of his life.

Heyman's pictures captured the depths of a family's grief, as well as America's. He could not believe some of the images happening before the camera—young vibrant people dressed in black, their voices once so full of promise, now trembling with pain.

KEN HEYMAN
I was feeling a great deal, but couldn't express it.
I hoped to release some of my feelings through
my visual language, through my photography.

JOHN DURNIAK
This event demands that we test not only the
photographer's accomplishment, but also his
sense of history and commitment to history—
a bigger truth than the journalistic deadline.

KEN HEYMAN

"What should I photograph?" This is one of the questions I've pondered, certainly as much as, and maybe more than most. For newspaper or wedding photographers, this is not a problem. But for a freelance photojournalist, or someone who only takes pictures for himself, it is the most important question.

Once-in-a-lifetime events do occur, and when they do, the photographer has no choice but to go with it. Watching television, I heard, "The President has been shot." The words reached inside me and I reacted from within. When they announced that the funeral would be in Arlington, I knew that I would be there. I didn't care if I had an assignment or not. Too much of my life was tied up in this country, in this President. I was also probably feeling some of the drive that's in journalists—when there's news we must be there.

It would have been easy to get an assignment for that day but I didn't try. I remember flying down and being relieved that none of the other journalists that I knew were on the plane. I was feeling a great deal, but couldn't express it. I hoped to release some of my feelings through my visual language, through my photography.

Arriving in Washington, I went to Pennsylvania Avenue. This was the kind of event that I was trained for, and because of my size, I can get through crowds and get pictures. So there I was without the most basic tool, the press credential. The police, however, were not with it that day. The country was in a state of shock, people were numb. Throughout the entire day no one asked me for a press pass as I moved through lines, crowds, and police barriers.

7

52

As I walked along Pennsylvania Avenue and saw tears on faces in the crowds, I thought of that famous Eisenstadt photograph of a black accordionist crying at Franklin D. Roosevelt's funeral. But I didn't photograph this idea because I wanted to catch up with the casket. In frames 3, 4, and 5 you can see that the cortege hadn't yet started.

I had three cameras. I knew there would be a lot of walking and running around, so to stay mobile, I took no lights. My camera was a heavy Asahi Pentax, the first SLR to accept interchangeable lenses. I had my favorite long lens, an old 180mm Sonnar that was not automatic and gave me lots of problems as well as great, sharp pictures. This style of shooting is very different from what I do with a wide-angle lens on a Leica, which lets me flow with the action and concentrate on body language. Using a telephoto, I am a hunter shooting at long-distance targets, which makes sequential photography difficult. But I hoped to be positioned well, and in spite of my limitations that day, to take a series when the Kennedy family came out of the church toward me.

One of my prejudices is against the motorized camera. I think it hurts photographers because it can flatten the decisive moment, that key moment when either graphically and/or emotionally the photographer catches the peak of the action. Now, I don't know why, but some photographers trust motors more than their own vision. Unlike Cartier-Bresson, a master who chose his moments after his subjects appeared in the right place, some photographers believe that the motor drive can capture the right moment, that the *ratatatat* of the motor will hit on the moment. My job as a photographer is to convey my discovered moments to the reader, to select, to find the moment, and not to rely on the machine. It is a mistake to count on the motor.

As I walked along, I tried with this telephoto lens to shoot the expression of sadness. When I shifted to the cortege in frame 5, my exposure was off, but the cortege was waiting. I went back and did more people, who were waiting and watching with different postures. Overall, there was a slouched sadness. Frame 7 is the right picture of these mourners, the most moving photograph of the day until later on, when the body was put on the cortege.

I worked myself into the press stands, between frame 19 (family going into the church) and frame 23 (family coming out of the church), maneuvering for an hour without taking pictures to get into the right spot.

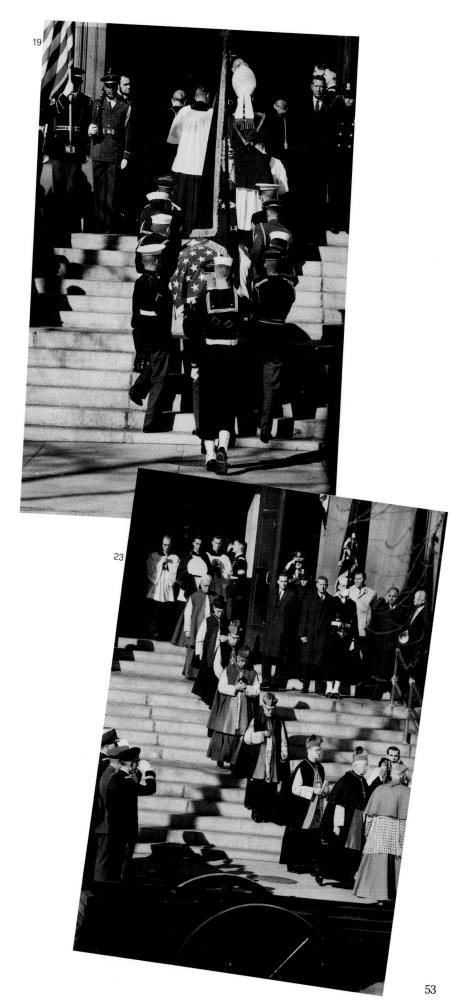

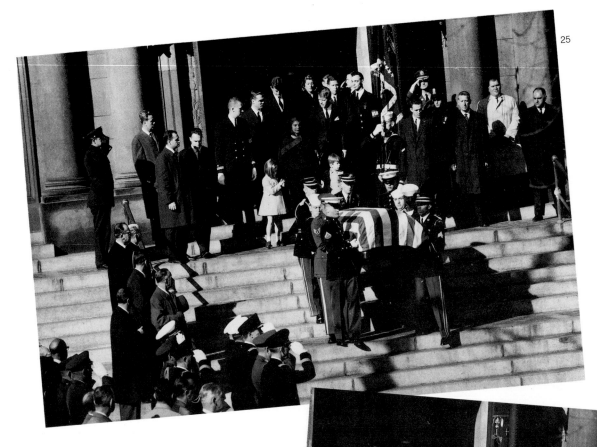

25

29

Out came the coffin. I didn't know what to expect, except that America was somehow identifying with Jackie, Caroline, and John John, so I was pushing the shutter release fairly quickly. Frame 25 is a good image of Caroline leaning on her mother. I changed to a vertical position for frame 27 and made a nice picture showing a "military funeral," but it doesn't have the strength and emotion of frame 28, even though John John is obscured there. In frame 28, there is something interesting about Jackie and Caroline taking a step. Frame 29 is the best vertical. A sense of great sadness surrounds Jackie. The Cardinal blessed the casket, and you can see I was kind of torn between a vertical and a horizontal. Frame 19 is much better than 30.

As they were about to put the casket in the wagon, I was more interested in Jackie than in the coffin. Without expectations, I allowed myself to feel America's concern with the grieving family. And then finally, I nailed the right picture—frame 36A, where it says it all in one frame. A moment later and John John would have been obscured, so this is the right picture. In my enlargement of it, I cropped the distracting elements of the left side and the top. I cropped so that the person standing next to Teddy forms the edge of the picture, pulling you back to the relationship of the woman in black to the two children.

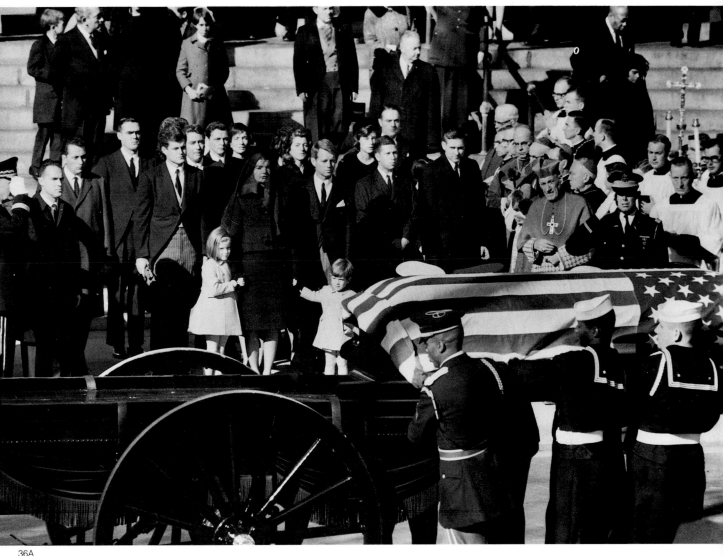

36A

JOHN DURNIAK

The Kennedy assassination and funeral became a super television event. Networks threw away the rule books and let the story roll morning, noon, afternoon and evening. The coverage even included Jack Ruby's shooting of Oswald on live TV. America stopped in its tracks for four days. Those who did not have the story running around the clock on their television sets carried portable radios. Many newspaper stands sold out immediately because customers not only had a hunger for information, but they wanted to save the papers as historical documents.

This event demands that we test not only the photographer's accomplishment, but also his commitment to history—a bigger truth than the journalistic deadline.

How did this one photographer do against the world press that now included television, the most formidable player, as well as the picture magazines, wire services, international newspapers and thousands of amateurs with their cameras? From the looks of this one sheet—very well.

Maybe there is a sense of history flowing through Ken Heyman's brain when he does an assignment (a self-assignment is as important as an assignment given by the editors of the world's leading magazine) like this. Here is a lean take. He knows a great picture when he sees it. He can make on the spot decisions about what is and will be important in his images.

He decided that what he felt in Washington was shock. America and the people lined up on the sidewalk did not believe President Kennedy was dead. Most felt it was a nightmare that in the morning would be a bad memory with no ill effects.

The first nine frames register the shock on America's faces. Frames 4 and 7 show no tears flowing, but these people had just witnessed a terrible event and weren't crying because their minds would not accept what had happened. The viewer can hear the silence in the crowd. The sound of the camera's shutter was probably heard—which it rarely is—as the photographer made his pictures.

Picture editing is the ultimate in Monday morning quarterbacking. It does serve a purpose—it is one of the few teaching tools inside professional photojournalism. At its best it helps fine tune the photographer, editor, and publication for the next assignment. It can also, in the debate, bring out picture possibilities that might have been missed. But, the litany of "you should have, you could have, why didn't you, how come . . ." if improperly used can destroy a visual mind, something I keep in mind as I roll through this sheet.

I would have liked more pictures of the crowds. The photographer was *on* that day. He was seeing beautifully. I almost feel from this single sheet that he was too lean. He

21

was going after pictures one at a time, and I would like to have more clusters than single images before me. Except for the seven images of the coffin being carried into the church, the photographer conserved his film, energy, vision and sensitivity.

To have one image like frame 35 or 36A—just one of these on a sheet—is success. An editor would be pleased with either one.

But this is not any story, this is a big piece of history being covered. Future generations will be able to study these images as visual history and perhaps discover more in them than we have found.

I like frame 6, and I also like frame 9—people stretching, reaching to see more or even to see anything. Good reaction picture. I want to know more about the crowds—what were they carrying in their hands? Lunches? Newspapers? Flags? I am impressed by the number of children that were there. Frame 12 is excellent, showing a squatting, mesmerized young girl in the front row. Look at the faces of the children in frame 11 and the tightly pressed lips of the grownups in the same frame. The photographer is seeing and getting what he sees, which whets my appetite for more history. I want to read everything I can get my hands on.

Perhaps the most unusual shot is frame 21, the lone police officer on top of a building, far removed from the activity on the street. The photographer found this image in his viewfinder, and made the decision—yes, a lone speck atop a roof was also a witness to the event, yes, he belongs on this roll even though he is not street-involved. Good seeing.

I have tried to dismiss the blank frame 20 from playing a part in this analysis, but I can't. On such a dramatic occasion, the mind has to ask, what could have been on this piece of film? Could it have been used for an even better crowd shot? The photographer is so careful throughout most of the roll to get us *the picture* with each exposure, that on that day the blank could have been one of the best shots.

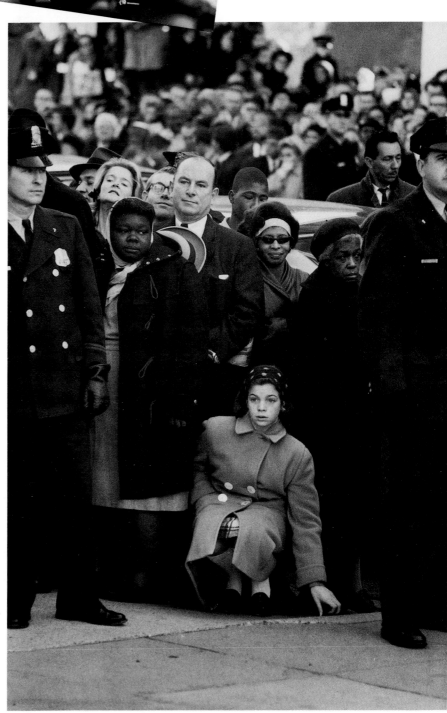

It is hard to relive the trip down the cathedral steps of the President and his family. To watch Bobby Kennedy's face emerge first, the veiled Jackie to his right concealed by shadows as well as her mourning hat, opens memory vaults that lead to sadness.

How the photographer could have predicted that all this would be happening so clearly from his vantage point is uncanny. But wait. He did pre-test his position somewhat with the set of pictures of the casket going up the stairs. What goes up will come down within the same area. He was able to compensate for what he didn't like in his first position. Unconsciously, Heyman worked the territory as if he had time and vast resources, when in fact, he had nothing but his wits—no press pass, one small bag of equipment, a body full of nerve, and willpower to wrest something valuable from the day.

Frames 13, 14, and 15 seem to be made with a longer lens than the following four frames. The photographer may have been doing two things at once here: taking pictures and selecting the lens to be used when the family came out of the church. The same telephoto lens was not used for the pictures going into the church as for those coming out of the church.

A different lens was used on frames 35 and 36A—the right pictures—than was used for the shots of the family coming down the stairs. I believe there was a good deal of lens switching being done here to get the

closest picture and tightest composition.

In frame 35, the photographer caught an expression on the faces of Jackie and Caroline and in the body language of John John, who grips a book under his arm, which has merit. I want to see this frame enlarged. I read that the three are alone now. The children hang on to the only thing they have left, the mother. She does not have the luxury of bearing her sorrow in private, but before a public that expects her to be beyond ordinary human strength. The ambiguity in this image works better than hard-core detail would.

I wonder if frame 35 is sharp enough to take enlargement. The photographer was not using a tripod, but was hand-holding a long lens. The longer the lens, the greater

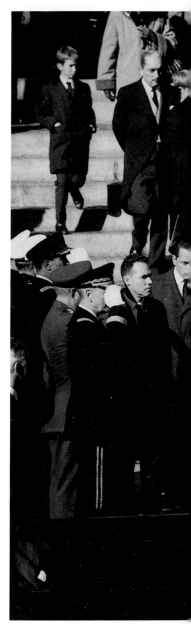

27

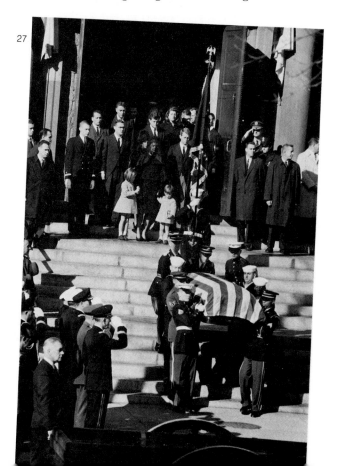

the possibility that there will be camera movement in the finished picture. I do want to see an enlargement of this.

Starting again at the beginning, I look over all the frames. I discover more and more. A layout of four or more *Life* magazine-style images could be made from this sheet alone. The photographer can be proud of himself and his sense of discipline. Frame 36A is without a doubt the right picture, which would have been impossible to predict from the way the roll began. That this image would be on a sheet that starts with crowds on the street—it is hard to believe that there could be such a complete change of position and story.

Frame 19 is well composed, an excellent picture in the sequence of what happened that day. Frame 23, showing the princes of the Church, is overexposed but well composed. Frame 27 is a contender with its livelier body action. In frame 33, had the photographer moved his camera to the right, he would have had a very different picture from the rest of those on this roll. Jackie and the two children would have been isolated in the upper left hand corner while the casket would have dominated the lower right corner. It's close. In frame 34, he made the same mistake, pushing his camera to the right and getting a tree trunk instead of the three Kennedys.

When all is said and done, I choose frame 35 as the best picture. All we need is a touch of the casket to remind us of the tragedy. The big story is really the people left behind.

35

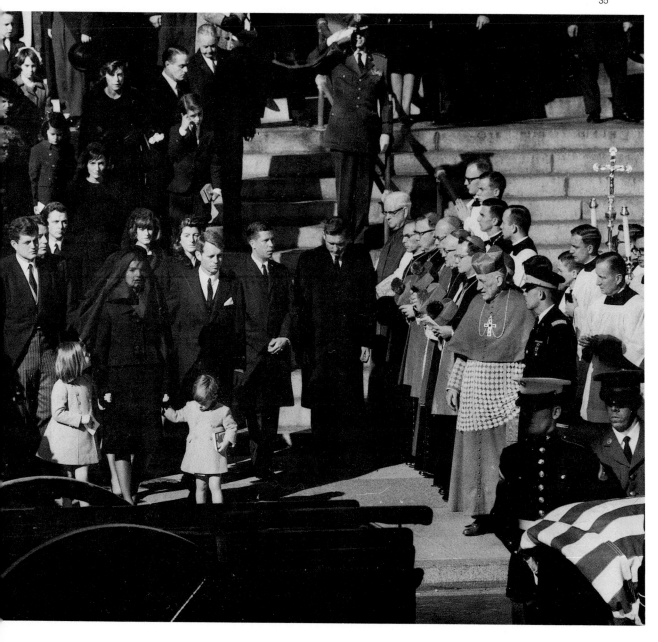

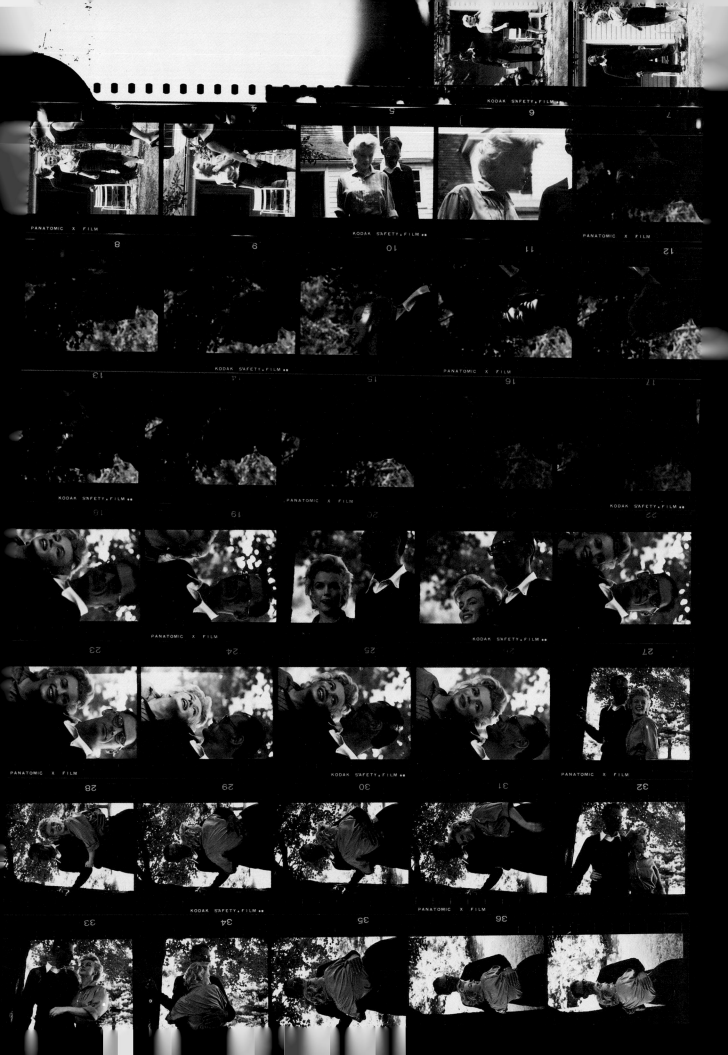

THE PHOTO OPPORTUNITY

The photo opportunity, that classic event staged by press agents and public relations personnel, can be (and often is) a photographer's nightmare. Used to guarantee extensive and, above all, favorable press coverage of the subjects involved, this type of assignment is one of the toughest shooting problems in the business. Television cameras, reporters, and photographers are crowded into a confined space and given a limited amount of time to get the coverage their editors demand. Under these circumstances, a photographer has to shoot fast, be sure of his exposure, and ask questions later. Whether the situation is a meeting of two heads of state, a rebuttal of charges by a scandalized politician, or a personal appearance by a famous entertainer, the requirements are the same: bring back the pictures, not excuses.

This assignment illustrates a photo opportunity of rare proportions. Marilyn Monroe, at the height of her career as America's sex symbol, was expected to announce her marriage to the Pulitzer prize-winning playwright Arthur Miller. It was the coupling of the beauty and the brain, and the world press was invited to Miller's farm in Connecticut to witness the event.

KEN HEYMAN
The scene was almost silly—here was the press, a mob on one side of a tiny white picket fence, an empty lawn, and a closed front door in the middle of nowhere. I had a 90mm lens on my camera and as I lifted my eyes up from checking the f-stop, out walked Monroe, looking beautiful and charming.

JOHN DURNIAK
Given the situation, Heyman got what his editors wanted—one good picture of the two. The shoot, under grueling conditions, was a success. It easily might have been a disaster. . . . Photo opportunities often turn out that way.

KEN HEYMAN

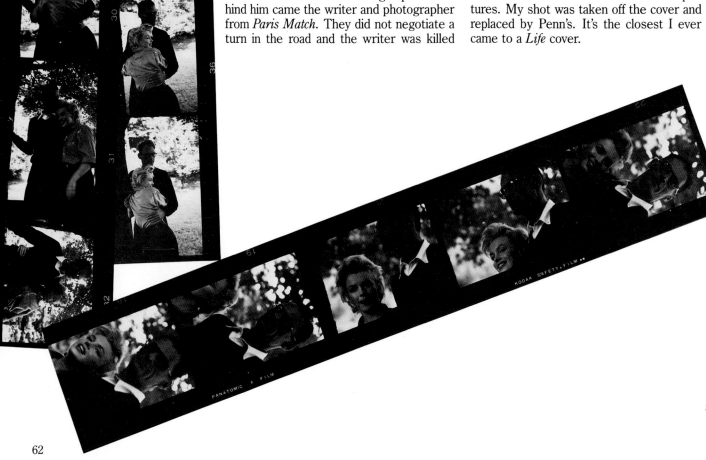

There was a press conference called by Arthur Miller, the playwright, for 10 A.M. Saturday morning. I was working for *Life* and got the assignment. Being good journalists, the reporter and I got there shortly after 9 A.M. By ten o'clock, I had counted 145 members of the press standing in front of the gates of a small house in Connecticut. Three no-food, no-water hours later we all were wondering why we had been called. Was it a wild-goose chase, or were the rumors true that Miller and Marilyn Monroe were about to announce that they had married?

Monroe had a notorious reputation for being late—hours late—for appointments. Was this a typical Marilyn scene? Suddenly, with a screeching of brakes, a car pulled up to the gate. There were screams about a terrible accident, and the occupants of the car, including Monroe and Miller, dashed into the house to call the police and the hospital. One of the members of the press shouted, "It's just down the road. Let's go," and the press moved like a pack of seals going into the ocean.

What had happened was that Monroe and Miller were staying at a neighbor's house. A *Paris Match* photographer managed to sneak into the house through the kitchen window and began taking pictures of the famous couple. Miller became furious and sped off toward his home. He knew the winding, small roads and traveled them at high speed. Behind him came the writer and photographer from *Paris Match*. They did not negotiate a turn in the road and the writer was killed

when the car hit a tree. Apparently Monroe had gone to the scene of the accident and stood there horrified.

We returned to the house, but the couple was still inside. The world was waiting for the announcement, and so were we. The scene was almost silly—here was the press, a mob on one side of a tiny white picket fence, an empty lawn, and a closed front door in the middle of nowhere.

I had a 90mm lens on my camera and as I lifted my eyes up from checking the *f*-stop, out walked Monroe, looking beautiful and charming. I have to admit, I was nervous. And the excitement of actually being that close to Marilyn Monroe is the only explanation I have to offer for neglecting to change my exposure when the couple moved to the area under the tree.

I feel the best shot is frame 25. Other shots may have different merits, but this one is my favorite. Aside from showing two very famous people, I think this is a very good *portrait* of a couple in love. It's a shot that could be framed and placed on the piano in the living room, or it could appear on the cover of a magazine, which, in fact, it almost did—this is the photograph that *Life* selected for that week's cover. It remained the cover shot until a few hours before deadline, when Irving Penn called and told the editors that the couple would get married a second time and he would have the exclusive pictures. My shot was taken off the cover and replaced by Penn's. It's the closest I ever came to a *Life* cover.

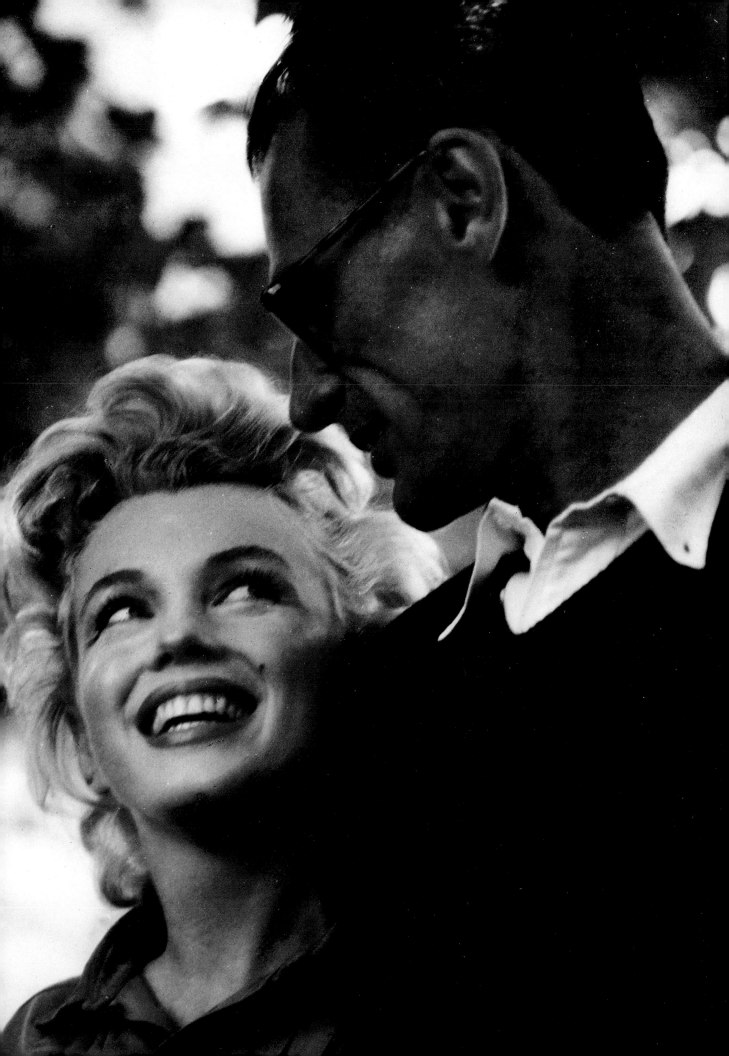

JOHN DURNIAK

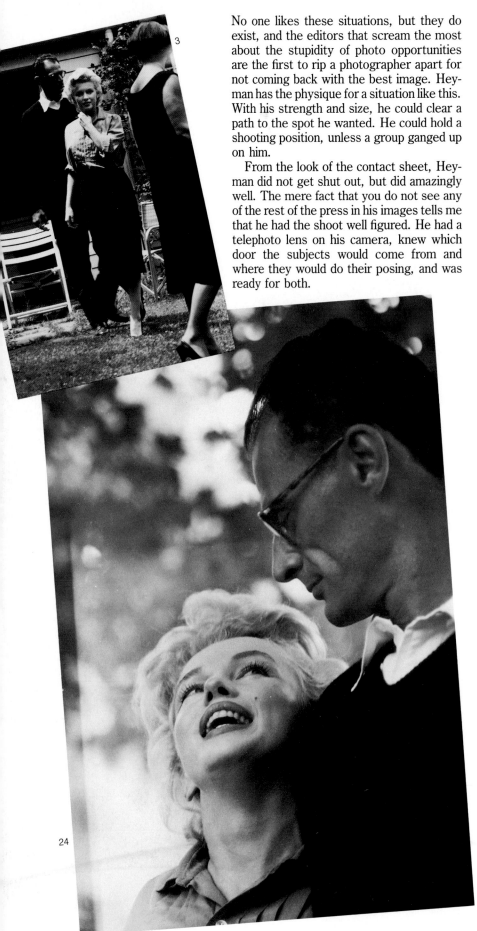

No one likes these situations, but they do exist, and the editors that scream the most about the stupidity of photo opportunities are the first to rip a photographer apart for not coming back with the best image. Heyman has the physique for a situation like this. With his strength and size, he could clear a path to the spot he wanted. He could hold a shooting position, unless a group ganged up on him.

From the look of the contact sheet, Heyman did not get shut out, but did amazingly well. The mere fact that you do not see any of the rest of the press in his images tells me that he had the shoot well figured. He had a telephoto lens on his camera, knew which door the subjects would come from and where they would do their posing, and was ready for both.

Heyman was nervous. For starters, he did not wind through enough frames at the beginning of his roll, making two frames with light streaks in them. In the first six frames, Heyman shot pictures just to have images of some kind. It was not "Heyman-the-hunter" who can get the kill with one bullet, who can say the whole thing with one frame. Of these, I like frame 3 because of its honesty. This was not a situation where Marilyn and Arthur were alone. There was intrusion and the woman at the right is the symbol of that intrusion, a symbol of the audience and a symbol of the American public that would be seeing pictures from this event on their front pages in the morning.

The failure here is in frames 7 through 17—close-ups of Monroe and Miller—which were far too underexposed to be of any value. From my analysis, he went from a brightly lit situation to shadows and simply forgot to change his exposure. When he discovered his error in exposure he came to his senses and began to get pictures. Tight, energetic, expressive pictures.

The best frame on the sheet is number 28. Monroe and Miller were together, yet their eyes said that they were apart. Here were strangers as well as lovers caught by the photographer, Miller was ill at ease and did not know what to do with his right hand, so he touched the tree. Monroe, the actress-model, was trying her best to pull off a good picture, acting for the photographers.

Frame 24 has a magnetic Monroe and a commanding Miller as contrasting subjects. A good, sharp image—this too is a front-runner.

Frame 30 is good journalism. We don't have to see Monroe to know her. Face almost hidden, her body language says it all. Heyman concentrated on her man, and in this frame Miller's right hand does not look awkward.

Heyman got what his editors wanted—one good picture of the two. The shoot, under grueling conditions, was a success. It easily might have been a disaster, with no good picture produced. Photo opportunities often turn out that way.

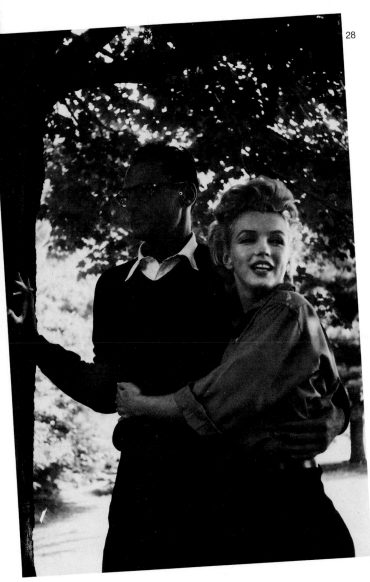

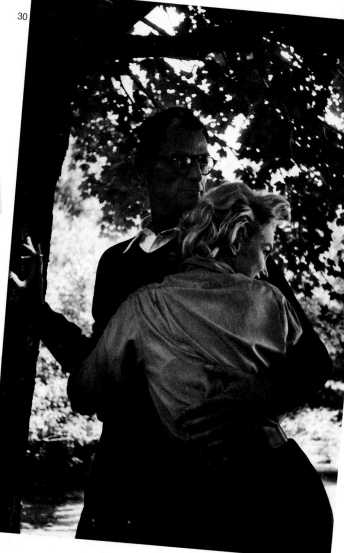

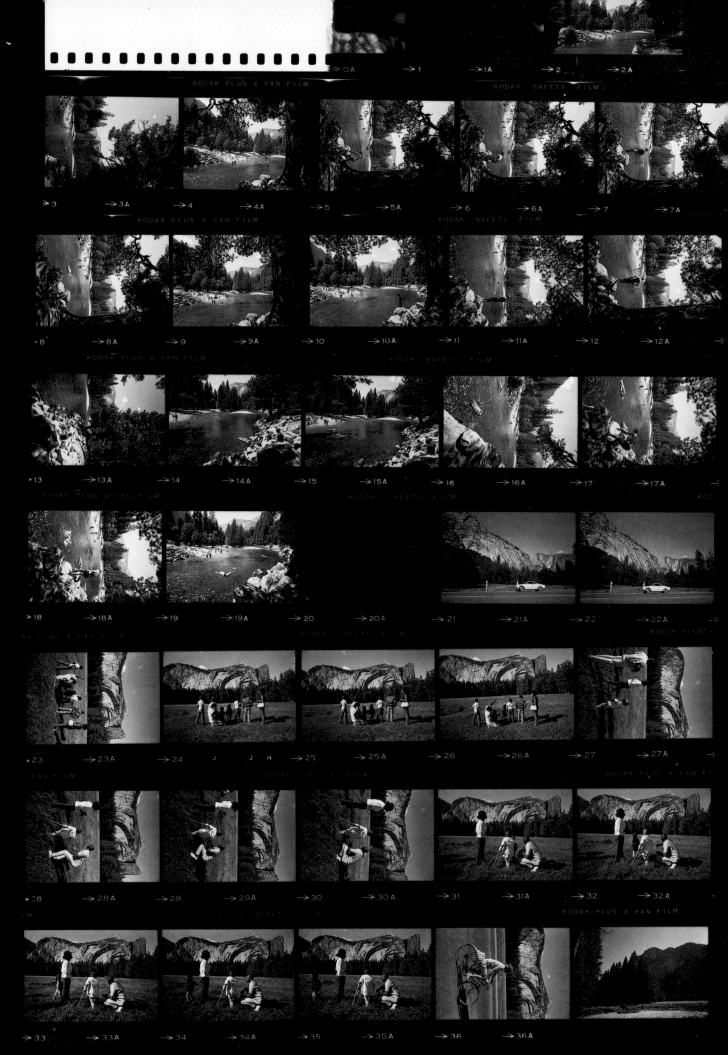

YOSEMITE

Yosemite National Park in California is one of the most popular photographic sites in the world. Just as with such man-made landmarks as the Eiffel Tower or the Taj Mahal, vacationers and professional photographers alike attempt to capture the natural beauty of Yosemite's familiar, yet awe-inspiring vistas on film.

Ansel Adams' documentation of Yosemite encompasses many of this century's most famous photographs and it is more than likely that memories of his "Moon and Half Dome" rest in a number of photographers' minds as they raise camera to eye.

It is a great struggle for serious photographers—especially those who are professionals—to meet the challenge of seeing such familiar subjects with a fresh eye. To create a photograph that is not reminiscent of previous work is difficult under these circumstances and in some cases the photographer may want to use this familiarity to add to a new composition.

When working on assignment, the professional faces one task: to bring back a good photograph taken within certain guidelines. Whether this photograph encompasses some part of another photographer's vision may be less important than whether or not it fulfills the requirements of the assignment.

KEN HEYMAN
Many photographers won't take a shot if they think somebody has already done something similar, but I don't let that stop me. Even if I have doubts about an image, I'll always take the shot. I can decide later whether or not to enlarge it.

JOHN DURNIAK
I cannot get excited about the other situations on this contact sheet. . . . these are not a new way of seeing. . . .

KEN HEYMAN

The text for President Lyndon Johnson's book, *This America*, came from his speeches. I was given key phrases and passages to illustrate. "Our Great Land" was the statement I was assigned to capture on this contact sheet, and for me, *grandeur* was the word that came to mind. I often use a word to visualize the slogan or the energy behind an assignment.

I have looked at great landscapes all over the world, but Yosemite National Park is the single most beautiful spot I have ever seen. There are more beautiful places in this small area than anywhere else in the world.

I started driving around Yosemite and discovered a crystal clear stream. I left the car and found people swimming. First I took the usual, basic tree picture—the tree is in the foreground framing the people in the background.

Then, like magic, a young man prepared to dive into the stream, and I had my foreground interest. After taking frames 5 and 6—nice, placid pictures—I moved in closer to concentrate on the diver. I knew I had a good picture in frame 7A. It was one of those days when the air is pure and the water is crystal clear and the sky is almost cloudless. I found myself wishing I didn't have to take pictures, so that I could just appreciate the beauty of the moment. But I had found a gold mine—the diving stone, a place where young men compete. I shot around the rock, trying vertical and horizontal framing. After going upstream, I returned to the diving rock. This time a diver launched his body way out into the stream, and I got it. I knew I had the right picture in frame 19A, so I stopped shooting.

Then, as I was driving along, I saw a family in an open field, a black family including a boy on crutches. I took four pictures of them—frames 23A to 26A—before asking their permission. Then they started to pose themselves, so I said, "No, please just keep doing what you were doing, look at the scenery."

There was something unusual about seeing a black family in a setting like this. We tend to think of black families as urban families. This was the only black family I saw in the park. And there was something touching about a boy on crutches in this beautiful landscape. Why was it meaningful? Why would a boy on crutches be more meaningful than one without crutches? Perhaps because there was a sense of great freedom in the land, but little freedom for the boy. He couldn't take advantage of the trails, the rocks, or climbing the mountains.

Looking through the viewfinder, I knew frame 30A was a poster, a traditional kind of picture that sells well. I know that sentimental photographs are popular, and while this frame is not necessarily to my taste, it is a cliché that works. Many photographers won't take a shot if they think somebody has already done something similar, but I don't let that stop me. Even if I have doubts about an image, I'll always take the shot. I can decide later whether or not to enlarge it, but at least I haven't missed the opportunity for a good photograph.

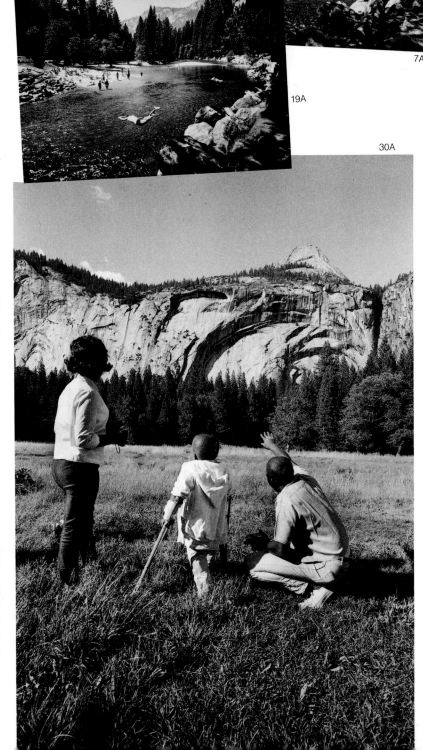

7A

19A

30A

JOHN DURNIAK

There's one right picture on this sheet. It is frame 21A. No one could have posed this picture. It is real, and it talks about the people's relationships and the beauty of the park.

The mother's attitude (she is standing close and touching the car, making it a vehicle with two legs and four wheels) and that incredibly long distance between Ken Heyman and his subject make this a Norman Rockwell piece of seeing in a photographic print. I love the moment.

The photographer probably did not think this shot would get into the book. After all, it is real, simple and direct—the hardest kind of picture to get published. The mountain line is high, the road line is low and the car happens to be just below the gap in the mountains. This composition works well. Here is a rare landscape, a moment with scenic scope and human gentleness—two women alone with their car, stopping to take some of Yosemite back to their friends. Here is scale, small people against the great terrain. Their bright dress and white car separate them from the ruggedness of the mountains.

The car's intrusion in the picture image should be noted because it looks wrong here,

which is a good piece of reporting by the photographer. The park's visitors should ultimately be wearing backpacks and hiking boots, but this pair toured the park from the road, which was daring enough for them.

I cannot get excited about the other situations on this contact sheet. I've seen many other pictures of boys diving from rocks, and these are not a new way of seeing them.

I am sorry not to see the boy on crutches alone against the mountains of Yosemite, which was a good situation that Heyman overlooked. The picture I want is somewhere between frames 34 and 35. The father is not part of the mood in frame 34, and there is a bad shadow on his chin in frame 35. The motion of one boy leaving the frame makes the immobile boy on crutches more sympathetic.

Truly great pictures, in which the point of view follows the light, do not come easily at Yosemite. It can often take days of study to find the right light. Ansel Adams took months to make one picture, waiting for the perfect conditions. Landscape photography of this caliber is measured by the calendar, not by shutter speeds. Time was not on this photographer's side. I congratulate him for catching frame 21A—the right picture.

34

35

21A

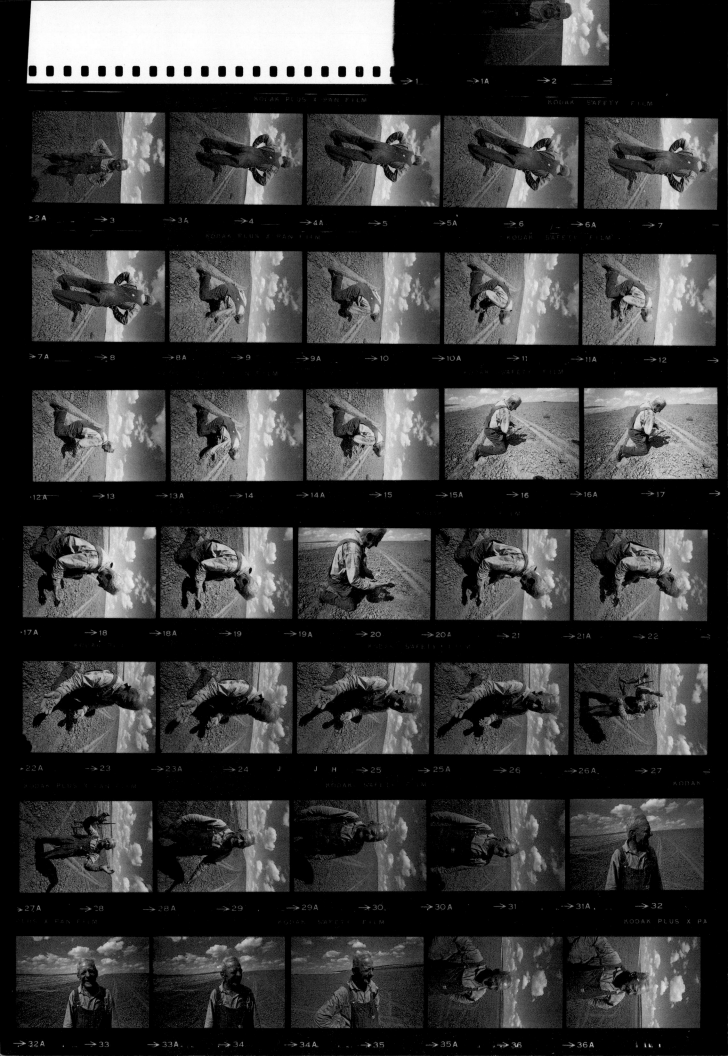

THE PRESIDENT'S FARMER

Ken Heyman was given six months to photograph America, a subject fit for a lifetime of work. The toughest assignments are those that must be completed in the least amount of time, and therefore allow the least freedom. Without time, a photographer cannot function at full capacity. Without it, compromise is the rule of the day—whatever light is available must be used, even though it may not be the right light.

These pictures were shot under a glaring sun, which made capturing facial detail quite a challenge. The photographer waited for clouds to soften the high contrast, and found a way to turn it to his advantage, working with the stark simplicity it provided, rather than against it.

KEN HEYMAN
All I wanted was a simple portrait—no words, no orders, no gimmicks. The only thing I said to the farmer was, "Let's walk out into the field."

JOHN DURNIAK
I wonder if Heyman liked this farmer's face. He does not spend time here trying for a tight head shot and he deals with the face in less than one-third of the pictures.

KEN HEYMAN

There was so much going on in my mind as I prepared to make these photographs for President Johnson's book, *This America*. I knew about the desperate economic plight of the American farmer from stories I had previously done—young people leaving the land, low farm prices, and farm failures. On this day, in this part of the country, drought was the problem.

The farmer I was assigned to photograph asked that his father, who used to run the farm, be allowed to take his place as my subject. I did not object. The older man had a good face—weather-beaten like the earth itself.

The fields were crumbling from lack of rain, and reminded me of the landscape dealt with by the photographers of the Farm Security Administration in the 1930s. No question about it—on this day I was being influenced by Roy Stryker and his FSA photographers, by my knowledge of them and their pictures. Maybe I had Arthur Rothstein's famous dust bowl picture in my mind's eye, or I could have been seeing Dorothea Lange's migrant workers, and feeling her influence. When I was younger, Dorothea Lange was one of the three photographers whose work I wanted to do. That's a funny way to put it, but accurate. The other two were Henri Cartier-Bresson and W. Eugene Smith. I believe I emulated them because their purpose in photography was so much akin to my own.

I thought of Dorothea, for whom I had a deep affection, while I stood getting ready to photograph this farmer. I remember her as she lay dying. She reached out with her two skeletal hands and held my hand in hers. "Ken, you have to photograph America," she said. "You *must* photograph America." I think she was hoping I would do another FSA program.

And then later, there I was, photographing America for the President of the United States, saying to myself, "Here is a man and here is the land." All I wanted was a simple portrait—no words, no orders, no gimmicks. The only thing I said to the farmer was, "Let's walk out into the field."

I've discovered single words to guide me in situations like this. The word for this assignment was *land*. My feelings become the adjectives for these single words. My images define these single words.

Clouds had moved in across the sky and the super contrast from the hot sunlight dropped off to a softer light, but not soft enough. That was okay, because it helped create the atmosphere of dryness.

I arrived at this farm without a lot of equipment and made these pictures without technical gymnastics. When I photograph, the whole technical part of photography is reduced to a single drive—get that picture. I don't think in technical terms at all. I expect and assume that the technical part of photography is operating correctly. I can't tell you how a camera works. I expect of my camera what I expect of my car—I expect both to work. I expect the flash to go off when I press the shutter release. I make mistakes, but they don't matter, because I get the pictures—that's what counts.

What I'm doing on this farm is probably illustration. I'm illustrating in my photojournalistic style the relationship between man and the soil. And when I took these pictures I thanked God for providing those clouds overhead, because another piece of equipment that I don't carry is a filter.

I used a corny idea. Even though frame 26 is the right picture, I have to be honest with myself and say, "Why would this man be showing me a handful of dried-up mud?" The hands have been grossly distorted because I was using a wide-angle lens—the one near the camera is gigantic, and the other is tiny. He is posing like a model. A model? He probably had been photographed only twice before in his life, when he was graduated

72

from school and on his wedding day, and here he was being photographed for a book by the President.

I took my straightforward portrait, and then I pulled back because I knew it was a boring shot. He turned around and looked at his land, and I used the tire tracks that we had just made with the pickup truck to make a line going off into the horizon. I'm very aware of the horizon and the way it affects the picture by where I position it in the frame.

The only person with us was the farmer's grandson, and every once in a while the farmer was distracted by the boy. There was no one distracting me, no writer whispering in my ear.

Frame 16 is the best picture, but I can't say it is the ultimate picture. I like the triangular shape made by the tracks, and the positioning of the farmer at the apex of the triangle. In frame 18, I moved in closer. He was talking to me about the soil. What did he see in it? I was delighted with his interest in the soil.

By this time in the shoot, I knew I had a picture, but I decided to try one last idea, so I shot him telling a joke and laughing as he told it. I was able to experiment, because I knew I had frame 16 and was comfortable with myself.

I can't really compare the *This America* project to the FSA because my assignment was too involved with industry, Wall Street, and movie stars. It was too fast to be FSA. I never worked so hard in my life. A day of rest was going to the office and planning the next six weeks of the project. Who would be called next? How would the assignments fit together? I didn't take a single day off—until it was over, I worked every day. A lot of it was timing—I scheduled one thing in the morning to fit with something in the afternoon.

I didn't look at my pictures and compare them to the FSA's, although I see relationships now, and could edit my pictures down for a comparison. But my project was too rushed, too frantic, and too exhausting. I could find a handful of pictures that might compare favorably with the FSA's, but I'm not sure that frame 16 would be one of those pictures.

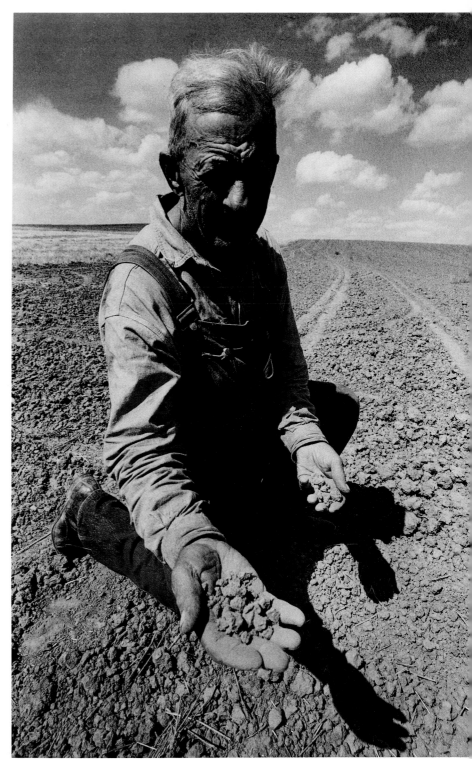

26

JOHN DURNIAK

My first thoughts while looking at this contact sheet went something like this: the first Americans were farmers . . . they opened the land and gave industry an environment to prosper in . . . the farmer turned America into the biggest producer of food anywhere . . . he should be a hero today . . . but instead the farmer is an endangered species.

I really feel for the man in these pictures. He has probably put all his life into this farm, and he does not look like a Rockefeller for all that work. He's got an old shirt, an old pair of overalls, and a grandson to show for it. I'm not sure he's a happy man.

For a contact sheet where nothing is happening—there is so much happening.

The best picture on the sheet may be frame 2. The position of the horizon is right—high up in the frame. (Never put the horizon across the center of the frame; it takes all the tension out of a scene.) The clouds are right, almost as if a painter chose their position and their relationship to the subject. The land is old and dry. The farmer's once strong hands hang by his side. Neither hand is producing much anymore.

The simplicity of this picture lets the viewer's mind wander off to Willie Nelson's recent Farm Aid project, to think about stories of family farms being auctioned right out from under the feet of people who can trace back generations of family farm life—not too bad for a photograph.

I also like frame 7—there is ambiguity in it. And I've spent a lot of time on frame 27. Don't ask me what it means, but I'm attracted to it. The boy must be throwing up clumps of soil to see if he could hit them with a shot from his BB gun. Whatever the farmer is doing is mystical. A rain prayer? I would like to have an 11 x 14 print of it and live with it for awhile.

The sun is hot and bright. At times clouds cut down the glare (as in the first frame). The photographer was concerned with the great contrast range and positioned himself carefully in frames 16 and 17. I looked at their shadows (I always go to the shadows to see where the light is coming from and ask why) and saw that there was sidelighting. The horizon is in good position, well off-center in both frames, and I like them both.

I like to see eyes in portraits. If I can't see the eyes, the picture is a failure for me. Expression in the eyes is the most potent expression one can find. Sometimes it is difficult to see eyes in a contact sheet. I backlit this sheet and looked closely into the eyes of frame 1, and I believe you can see both pupils—they can be printed.

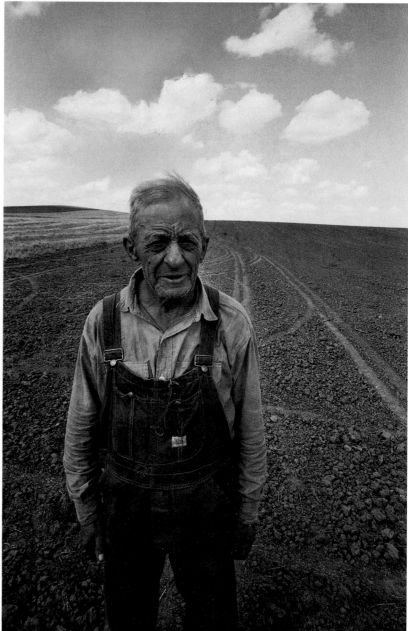

2

One thing I've learned is that a print or a contact sheet can be looked at as a transparency. You'd be surprised at the detail you can find in shadow areas by looking at a picture in this way. And that detail should be in the final print. This is not easy to achieve but being able to do it separates the great photographers from the also-rans.

I wonder if Heyman liked this farmer's face. He does not spend time here trying for a tight headshot, and he deals with the face in less than one-third of the pictures. I remember farmers who had great, selected-for-the-role faces, handsome faces. In these pictures, here is your everyday farmer face. It wasn't chosen, but it was available.

The body language is important in these pictures, and I like frame 7 with the hands on the hips, and the fingers of the right hand

showing. One foot is forward. There is so much resignation in the stance, but also strength in the body, the shoulders. A farmer stands like this and he thinks of his dry land. My imagination flies to find thoughts to put in his head. What would I be thinking in his place?

Frames 16 and 17 have something, although I've tried not to deal with them because there's something theatrical about the pose. Theatrical or not the composition works, the body works, and the pictures work.

If I had to do a layout with these pictures, I would use frame 2 and frame 16. They are both good and both different. Which would run in the magazine? I believe it would be frame 16. It is graphically more compelling and it also may be easier to think about.

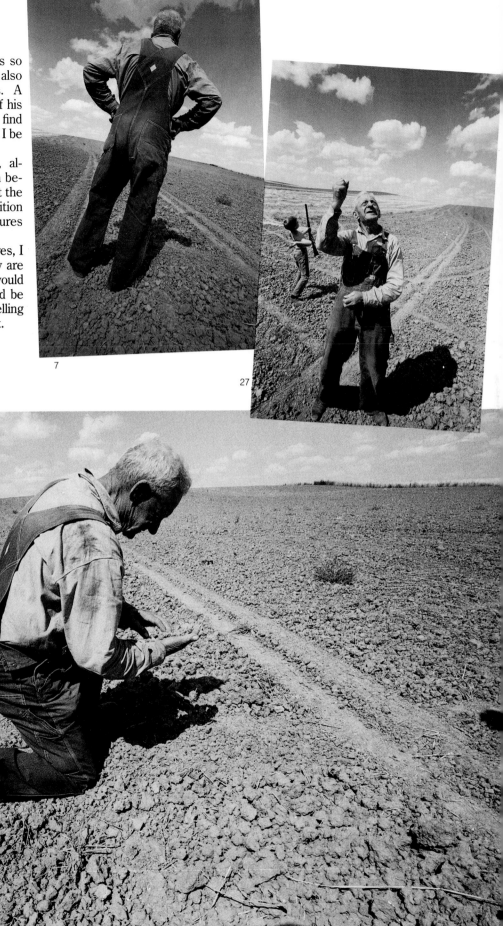

7

27

16

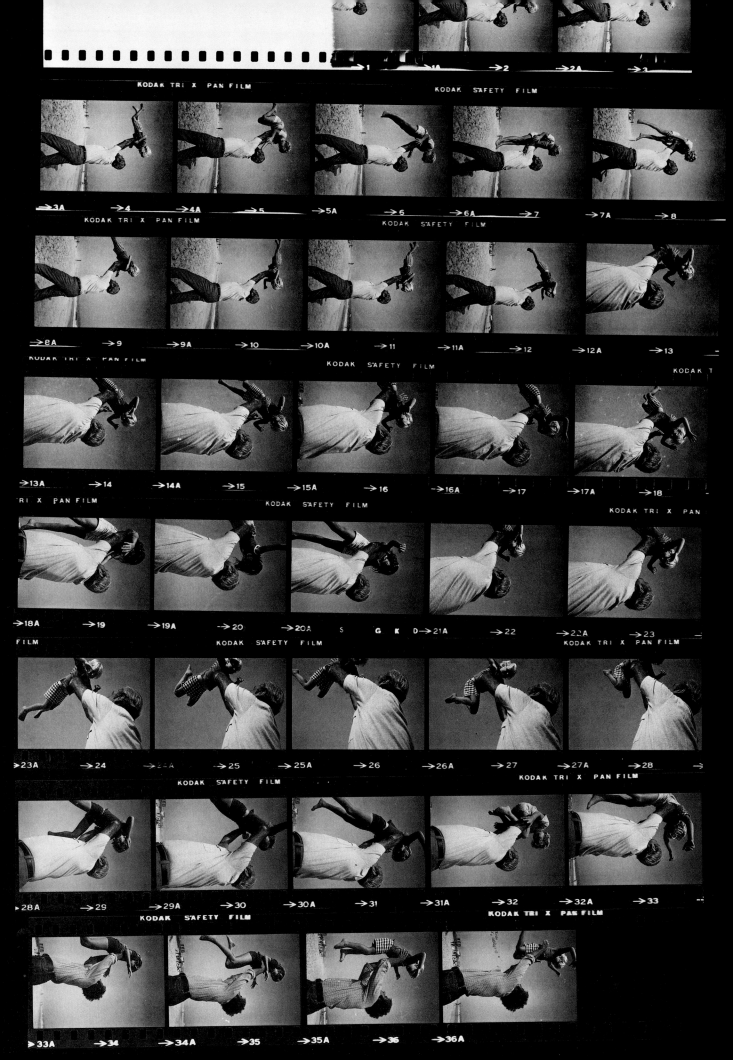

FREE FLIGHT

Advertising photographers are used to working from an art director's layout. They know that they have to leave relatively blank space in specific portions of the frame to allow for the placement of headlines and other text copy. On the other hand, a photojournalist normally works only from an editor's broad guidelines. The photographs are meant to accompany a story on a specific subject, written from a specific point of view.

However, once in a while, an assignment comes along that transcends the fine line between advertising and editorial photography. The request to photograph a poster for the American Tuberculosis Association depicting the campaign "For Life and Breath" seemed fairly simple to execute. Ken Heyman had to take a child's picture for the poster and, since he has five children, all of them had a chance to "audition" for the job.

The photographer decided to make everything as simple as possible—the equipment, the action, and the idea behind the poster shot. There was no special lighting, no special lenses, and no background setups. The action was the point—and it was easy to understand.

KEN HEYMAN
I photographed all the children hoping that one would be more interesting than the rest, and I knew the right spot where they needed to be for the right composition. I knew where the copy would be.

JOHN DURNIAK
This entire contact sheet should have been on the best child, with the photographer perfecting the feeling of flight.

Jason, age four, frames 1–4, 9–18, 22–28, 36, 36A.
Chris, age seven, frames 5–8, 32, 33.
Tim, age nine, frames 29–31, 34, 35.
Jenny, age eleven, frames 19–21.

KEN HEYMAN

"As you live and breathe"—that's the line I had to illustrate for the American Tuberculosis Association. I was given the art director's poster layout showing a man throwing a child into the air, and asked to follow it. Fortunately, I had five good-looking children, and at times like this, I am able to use them as models.

That summer we had rented a cottage on Fire Island. The implication of the poster was fresh air. Fire Island had what I wanted, simplicity, open skies, and fifteen miles of beautiful beaches. When I was out there and the weather was good, I shot the kids. I rarely do advertising or do photographs from layouts, but it seemed easy enough to show a man throwing a child in the air.

I shot three or four rolls. The father in the picture was our next door neighbor, Mr. Siler. As the children ran toward him, he grabbed them and threw them in the air in one motion. He's an athletic man with muscles.

In frames 7 and 8, Chris is not so thrilled to be thrown in the air. Jenny, then 11, also wasn't sure this was fun. She didn't feel good about letting go of Mr. Siler. Frames 10, 11, and 12 are of Jason flying and enjoying it. It was easiest to throw Jason up in the air because he was the lightest. He also seemed to truly enjoy his "flight," and spread his arms out like wings, giving a sense of flight to his motion.

Mr. Siler and I agreed Jason was best. The designers chose frame 18 as the right picture because of its feeling of free flight. The idea of air—fresh, healthy air—is brought out in this frame. The child's hands have energy, and the father-model becomes an arrow pointing up at the child flying. Jason's bright blond hair adds to the airiness of the picture.

What I was doing was illustration, with an added element from sports photography. A sports photographer has to be literally on the ball, he has to know where the ball is and where it is going because that is where the action will be.

I did what Henri Cartier-Bresson did as he hunted for decisive moments, something that goes beyond sports photography. Now, I had most of a good picture already set up. Like Cartier-Bresson I watched for the subject—the child—to cross through the picture. I photographed all the children hoping that one would be more interesting than the rest, and I knew the right spot where they needed to be for the right composition. I knew where the copy would be. I was also aware of the wonders of the airbrush in advertising and how sky can be added if necessary. I directed my team of people to duplicate the image in the layout—Mr. Siler planted his feet, and the children learned how fast to run until they hit the spot where Mr. Siler lifted them into flight. We worked like one big sports machine. By frame 18 I had discovered the point where the children looked as if they were flying.

18

JOHN DURNIAK

Ken Heyman got his picture, but he did it the hard way. Each time the action occurred, he had only one chance to make a picture.

Sports photographers try for better odds. It would not be unusual for the sports shooter to set up three cameras on tripods in different positions around the flyer and catcher—one camera low under the pair, another low to their left, and a third on their right—with maybe even a fill-in-flash to open shadows in the flyer's face. Given that he may not have had all the equipment necessary for the set up I've described, the photographer did pretty well.

My choice for the picture is probably frame 14, and I've picked this image because of the man's hands. Because they are separated from the boy's body and thus definitely not touching him, I get more of a sense that this boy is from the sky and is coming in for a landing. The most important element for me is the boy's airborne quality.

I realize the photographer had a political problem on his hands because he was using all his own children. I would have encouraged him to make a deal beforehand so that each was guaranteed something for his effort, thereby removing any competition for one prize. Thus, he could have narrowed the action to one or two children. This entire contact sheet should have been on the best child, with the photographer perfecting the feeling of flight.

I also wonder if the "father" could not have been fitted with a remote camera on his chest. What a picture it might have been if it were taken right up through his arms as the boy came in for a landing!

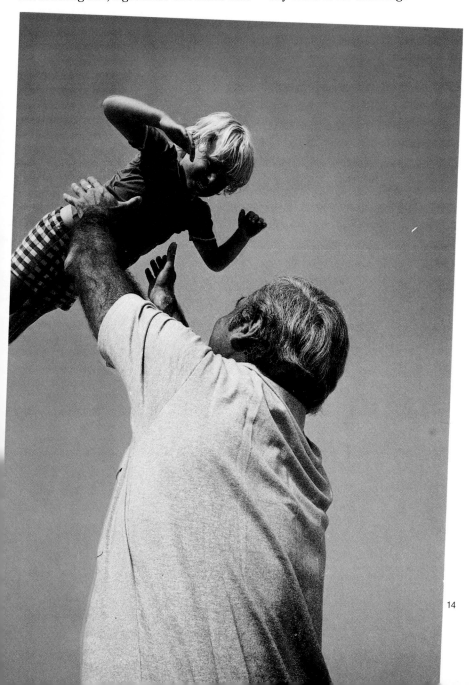

14

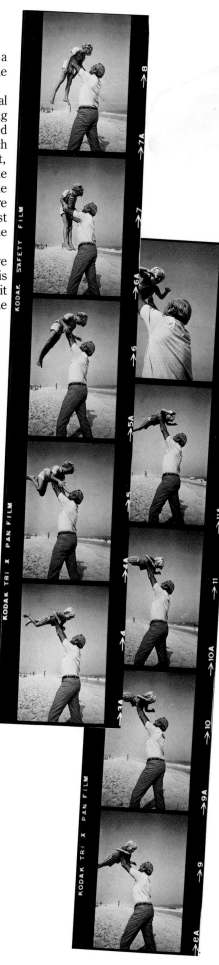

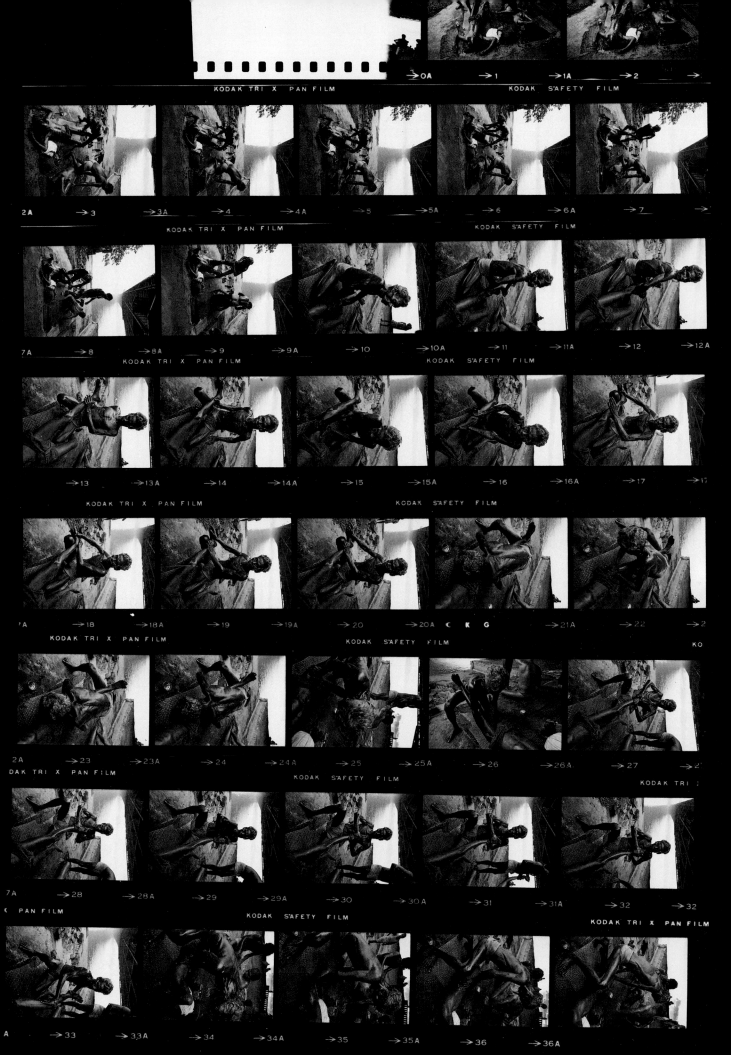

THE MASSAGE MAN

This massage man took great pride in what he did beside the sacred Ganges river in Calcutta, India. If he wasn't the best at his craft, he was close to it. His trade was in his hands, and his shop could be set up wherever he laid his blanket.

Rising before dawn when it was cool, he worked until the sun began creeping in under the bridge, destroying the refreshing shade for his customers. Part masseur, part chiropractor, he twisted, pushed and pulled muscles, and made muscles snap and pop and bodies groan. He was thrilled by the attention Ken Heyman gave him. The more Heyman shot, the harder the massage man worked.

Any traveller with a camera would have photographed this exotic scene had he or she come upon it. But this photographer saw the opportunity to make a stronger statement with the image. Working with the subject and his surroundings, as well as the unusual light that he found, Heyman created a series of photographs filled with an air of mystery.

KEN HEYMAN
The shadow of the bridge is a strong element compositionally. It pulls the top of the bridge structure down to the bodies working and bending beneath it.

JOHN DURNIAK
What strange happening is this? Who are these people? The heavens are made of steel, and the men on earth are trying to look like steel.

KEN HEYMAN

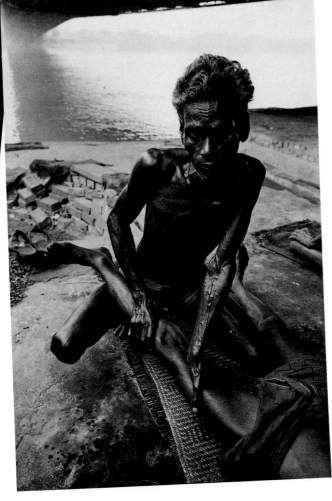

I have an interest in the body as sculpture. I like photographing people when they do not look like people but rather like lumps, rocks, and nonhuman shapes—when they are bending over or when one person intertwines with another. Such subjects please me—I do them for myself and surprisingly they are exhibited. So when I came upon this man, who had oiled his body and looked like a lean machine, I had to take his picture. What a body!

The day before I shot these photographs of the local chiropractor in action, I walked through this area of Calcutta next to the Ganges in the late afternoon and saw little activity. The massage men were finishing their day, and I was told to come back early—very early—the next morning. These pictures were taken shortly after dawn.

When a photographer like myself travels I think of the day as the time for working and of the night as the time for resting. But often you have to rise hours before dawn to shoot some special activity that doesn't go on during the day.

In this situation the light under the bridge streamed through an early morning fog and it was hot, over 80 degrees. What was helping me here was that the massage man had already had his massage, and his body, muscles exaggerated, shone. Frame 12 is not a great photograph, but look at those shoulder muscles. There was no room for fat—not an ounce of fat on his body—and he was so energetic. I had asked him if I could photograph him. He said it would be all right, as long as he could continue doing his work.

Beginning with frame 3, I was showing two masseurs working on two customers. It was a completely nonsexual activity, but I find that any person manipulating the seminude body of another implies sexuality, and am not adverse to showing this in order to make a more meaningful photograph.

In frame 10, I moved on to the masseur who interested me the most. I was particularly aware of his anatomical qualities—his arms remind me of Michelangelo's drawing of muscles. He was distracted by my interpreter. Even though India is to a large degree an English-speaking country, this man spoke no English.

By frame 13 I returned to photographic composition. The massage man had accepted me and I began using his body as the main part of the picture.

Ernst Haas once said to me that there is a time of day when the earth gives back part of the light it has received during the day. It is a beautiful time. Although the masseur seemed to give off light, he was really reflecting back the light of the day, making for a visual excitement—dark skin and muscles glowing—that I had never before encountered.

Frame 13 is well composed. In frame 14, he had finished his exercising and was in an exciting pose—perhaps this is the right picture, this supernatural skeletal body. I'm choosing frame 14. In one of my books, however, I used frame 16.

16

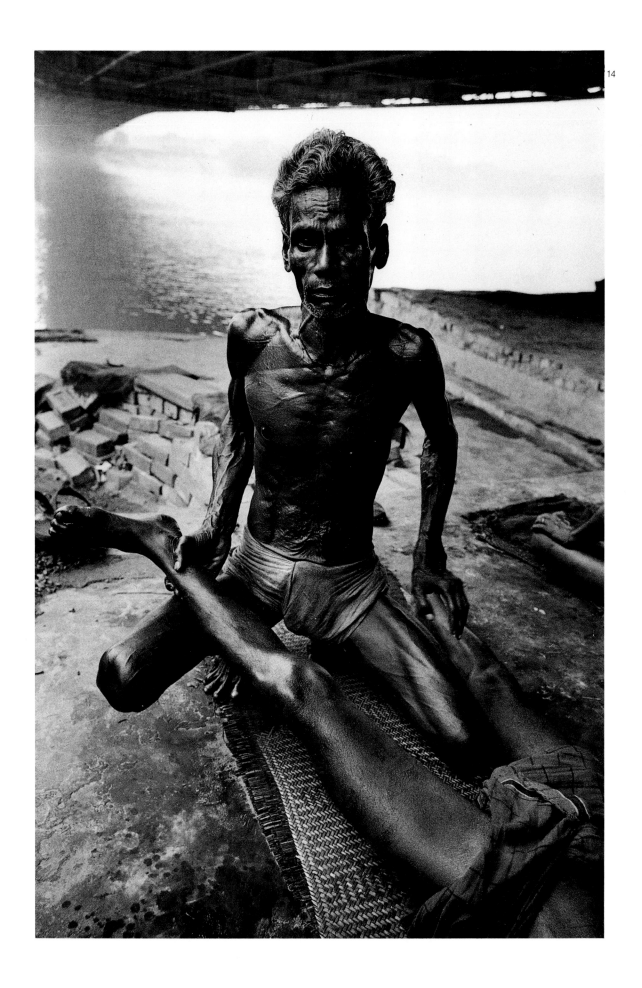

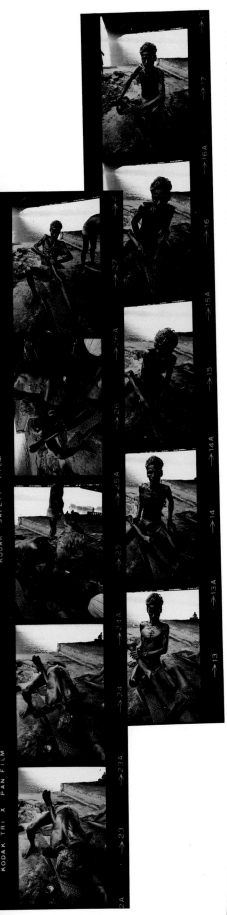

Let's compare three frames that are almost the same—14, 16, and 17. In frame 14, the composition is fine, and his body is wonderfully defined. In frame 16, there is more energy. But compositionally it's bad. Frame 17 is better composed because the leg gives his body more support and has sexual overtones. This is the frame that I have printed and exhibited. I wasn't aware that morning of the haze connecting the famous bridge looming overhead to the people below. The shadow of the bridge is a strong element compositionally. It pulls the top of the bridge structure down to the bodies working and bending beneath it.

Frames 22, 23, and 24 are a continuation of the same idea. Frame 24 is the most interesting because you can't figure out who is where. I changed my position to take frames 27 and 28—I moved away. With a wide-angle lens, his leg becomes elongated.

The light had a lot to do with the way the bodies glow. I had arrived early and had been working several hours. The bridge caused a pleasant, bright-shaded area around us. The exposure there was 1/250 sec. at f/3.5.

It was a lovely light, a shaded light with its own marvelous quality—it was like using a scrim in movie work. (The scrim is a fishnet-like material that diffuses direct sunlight, making it a soft light.) The humidity must have been about a hundred percent, and it kept their oily bodies shiny from the moisture of their own perspiration.

24

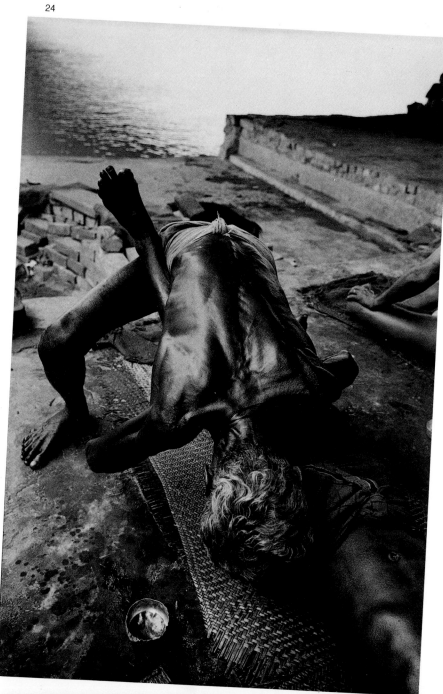

84

JOHN DURNIAK

For the price of an airline ticket, a photographer can change his world from the commonplace to the surrealistic. But can he handle the new world photographically?

Some photographers, like Ken Heyman, thrive on the exotic and mysterious, using the camera to explain the ways of unknown societies. Other photographers gape through their viewfinders, producing images that turn the obscure into the commonplace.

It is uncommon in many countries for a person to lie down in public and have his arms, legs, head, shoulders, and back twisted and massaged. Not so in India, especially next to the holy river Ganges. Heyman was not driven away by this semi-mystical massage. Instead he turned it to his advantage, creating well-composed, intriguing pictures.

He sought to make his photographs as tactile as possible. The viewer can feel the strong hands of the massage man play on the muscles—the back, shoulders, arms, legs, head, neck, hands, and feet. The body forms are like Greek and Roman sculpture—bodies wrestling without combat, rejuvenating each other.

Frame 8—with the bridge like a spaceship above, coming from a foreign place—is at the same time ambiguous, dynamic, real, and unbelievable. The composition is masterful. What strange happening is this? Who are these people? The heavens are made of steel and the men on earth are trying to look like steel. Muscles and beams—this is a portrait of muscles trying to be beams, of men trying to make themselves into steel.

The strength of its composition makes frame 11 a contender, and makes frame 25—a human chain of muscle—an eye stopper. Frame 36 is another fine image. But what is the right picture?

It is frame 8 because of its many levels of information—about the people, about the place, about relationships, and about their culture. However, this image asks as much as it tells. Between telling and asking, this is the right image.

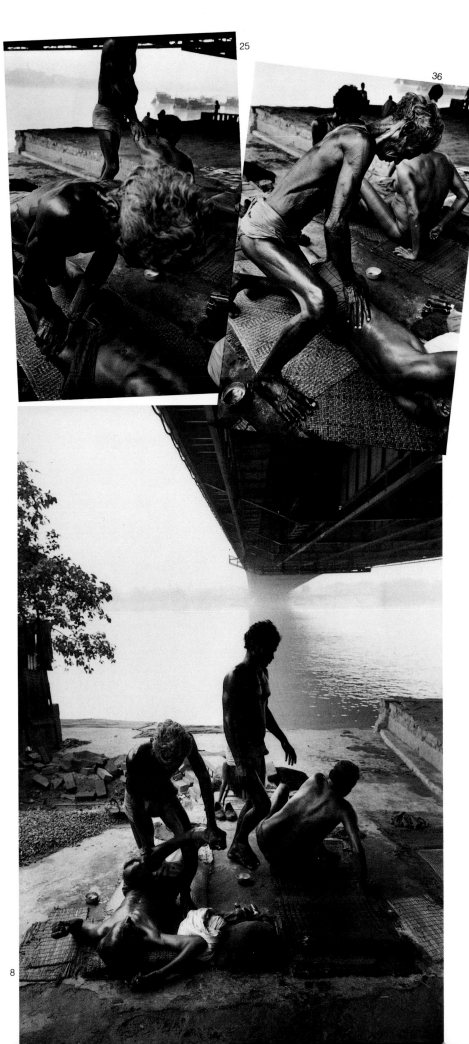

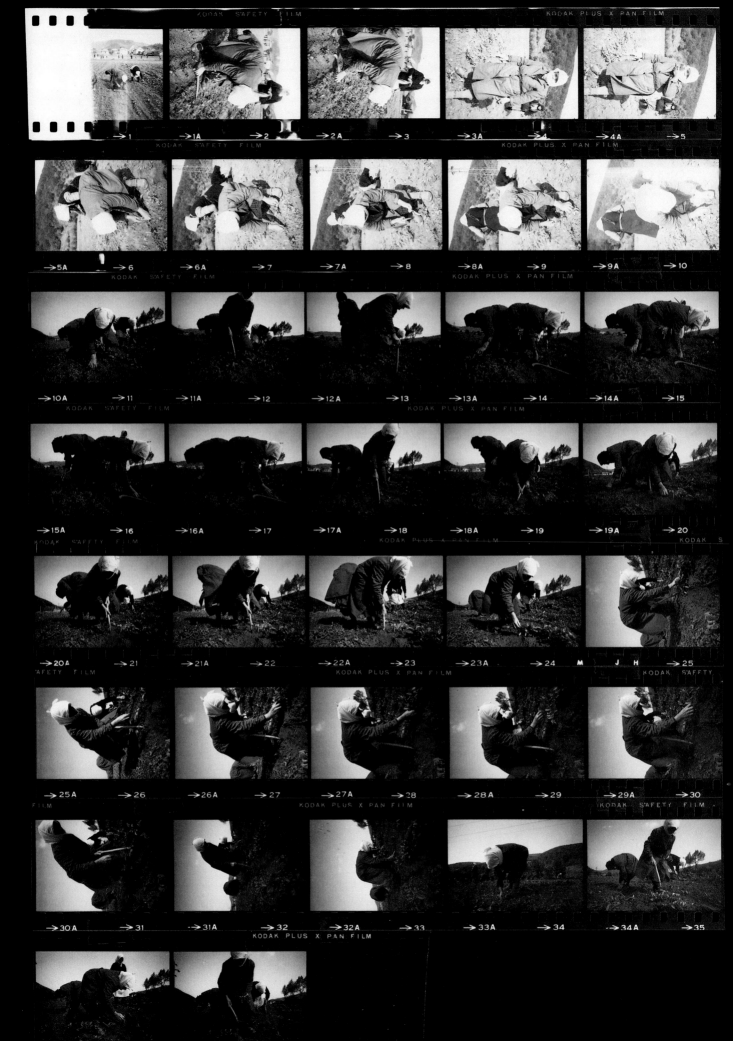

DOWN ON THE FARM IN BULGARIA

It did not take Ken Heyman long to find out that in Bulgaria, the women work harder than the men, and it became imperative for him to show this in his pictures. In Russia, he was surprised to see garbage women instead of garbage men. But in Bulgaria he found women in the countryside doing the hard field work, with a male boss sitting by, smoking a pipe and monitoring their labor.

Heyman was driven to a farm, and with his interpreter met a group of women planting. How does someone who does not understand the language communicate with his subjects? He had to win the confidence of his subjects with only his manners, body language, and demeanor.

The fields were mud-luscious, and the translator, wearing her newest clothing, declined to follow Heyman into the mud. She stood at the edge of the field, beyond speaking distance.

Obviously, the workers thought Heyman had to be someone special. How many people do they see chauffeured to a farm with a government translator in tow? Their work took on more earnestness as he made pictures. But with one wrong move he could have lost them, they could have waved him off. The angle he needed was a low one. How did he get it without scaring them off, making them think he was some kind of crazy man?

KEN HEYMAN
In my kind of photography, I have to go where the action is. It may mean I have to climb up on a ladder, or on top of a car, or lie down. Moving to a low level or high level is something you can use to measure how well you are working.

JOHN DURNIAK
It suddenly dawns on me—this guy must be sitting in a trench to get pictures from this level. What in blazes is he doing, lying in the field? To actually see the plants going into the ground and be surrounded by farm women—this is a new sensation.

KEN HEYMAN

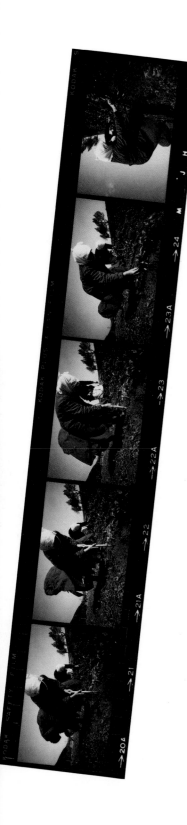

I was doing a book called *World Enough* with Margaret Mead. Part of my work had to be done in Eastern Europe, and I decided that since I was already behind the Iron Curtain, I might as well stay and keep shooting this little-known area. Language was a barrier because I do not speak Bulgarian and most Bulgarians do not speak English. And it is difficult for an outsider to work in communist countries. Bulgaria was no exception.

In America, we see farmers as men. They go to the fields and women work at home. Not so under communism. In Bulgaria, women work in the fields too. In these pictures, they are using sticks to make holes in the earth before transplanting seedlings. To protect themselves from the sun, they wear long kerchiefs on their heads and wrap the ends around their necks and lower faces. These are short and squat people, and their stocky shapes reminded me of elephants. On this roll, they interested me as sculptural bodies, as bending, working sculptures. They hid their faces from me with their scarves but that was okay, because I was after the unusual shapes they made and not their portraits.

For these women farmers it had to be strange seeing me, a 240-pound man with a camera, sprawled flat on my back in the dirt, taking pictures. But they accepted what I was doing without reacting.

In the first frames, I was not yet on the ground. I chose the woman with the white head scarf as my subject and she didn't mind me photographing her. In the action of transplanting, the center of interest lies between her hands and the ground. Because she was short, I had to get on the ground to shoot frame 11.

When on the ground, a new problem developed—lack of mobility. As the farm woman planted, she moved away from me and I had to crawl in the dirt to keep up. Fearing for my cameras and lenses, I cut short the low-angle shooting.

Frame 13 is a good picture, but not quite the right picture.

Frame 21 is the right picture. It is also the shot that was used in the *Time-Life Library of Photography* series as an example of fine picture making. The planting stick in frame 21 looks like a cane, adding to the interest of the picture.

Frame 22 is almost as good as 20A except

that the woman at the left turned and changed her shape. The rest of the picture is better than frame 20A.

This is a horizontal situation all the way. Why did I change to a vertical? I do it without thinking. When I know I have an exciting picture in one format, I automatically turn the camera to the other position. I want to cover myself for a few frames in the other direction to get the shot in two different shapes, which gives magazine editors more flexibility in layout. This comes from my background with *Life* magazine.

Earlier in my career, I spent some time every evening thinking back over the pictures taken during the day. I would be in the middle of Africa; most people would be asleep, but I would be thinking about my day's work. I would question myself about how well I had worked, starting with the number of rolls of film I had used. A good day's work for me is fifteen rolls. It doesn't make any difference whether the subject is exciting or dull, fifteen rolls a day seems to be my take. I usually give myself a grade, B to B+ for fifteen rolls.

You might ask why I don't shoot twenty-five rolls and give myself an A. More does not mean better. I can't force myself to over-shoot. Forced pictures don't work—it is best to let the shooting happen. But if I've done only five rolls, it was a bad day and I start picking on myself. There are ex-cuses—the car didn't show up, it was rain-ing, or they arrested me—but I don't allow myself excuses. The next day, I try to make up for the shortcomings of the day before. It is important to have standards and stick to them.

Another indication of whether or not I'm working well is how I reach for the photo-graph. Lying down in front of these women brought me to the picture. I give myself an A+ for that, because I got to the right place.

Sometimes after I've been working an hour, I'm shaken to realize that I'm not changing position, that I'm still standing, bringing the camera up to my eye rather than going to where the camera should be. That isn't good. In my kind of photography, I have to go where the action is. It may mean I have to climb up on a ladder, or on top of a car, or lie down. Moving to a low level or high level is something you can use to measure how well you're working.

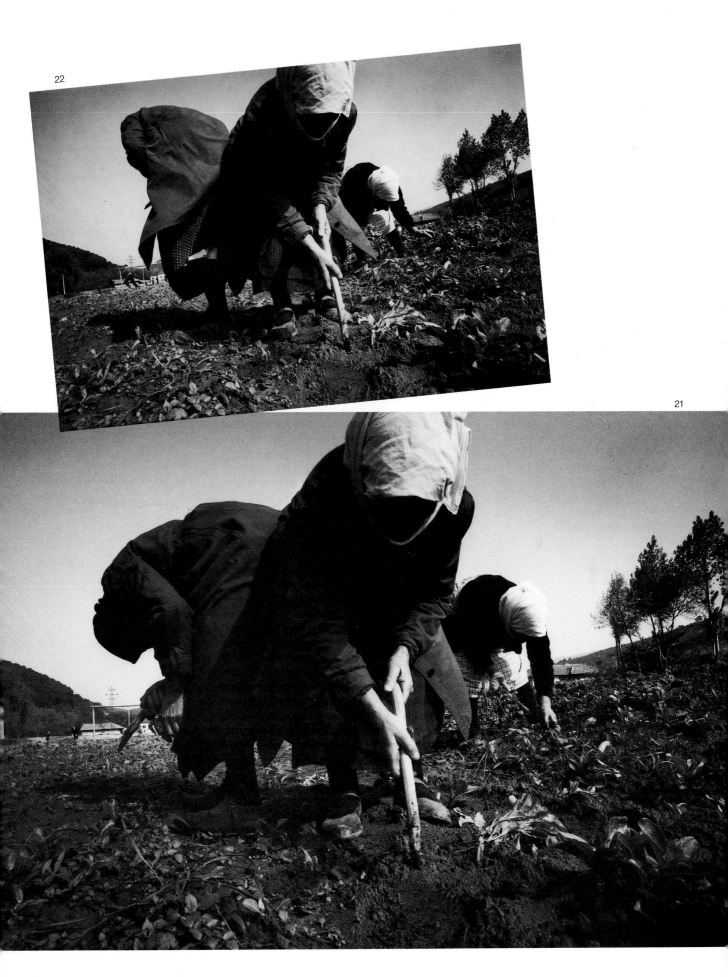

JOHN DURNIAK

One of the most exciting things in photography is to pick up a contact sheet expecting nothing and discover a picture that sings. This is that kind of roll. Looking at the take with the naked eye, I ask myself, "What can any photographer do with three peasant women working in a field?" No single image jumps out with any special content or shape, so I pick up the loup. Starting on the first frame, I work my way forward.

The first frame, partially light struck, has the making of a good situation. Three bent over women work in the foreground while in the background, boys play soccer, on what looks like the same field. This situation is good—it provides a social context, giving us the sense that this field is centrally located, not remote. But Ken Heyman took only one picture, and I'm angry with him for not following through on his discovery. By the second shot he had moved in close on the three women, and threw away the bigger situation including the game.

In the next four frames, 2 to 5, I'm at a loss to explain why he switched his position. These are snapshots, four awkward images ill composed and badly framed. What was he after? In frame 7, my brain lights up—this picture is a brilliant find! So that's it—he was playing the three women off against each other. By frame 11, he hit it. How could this picture be better?

Frame 12 is a flop because the composition is squashed, but the angles in frame 13 open a door to new possibilities. Frame 13 is a hell of a picture. Now it's like watching Heyman start to run toward the finish line, and away from the pack. Frame 15 is excellent, but the head floating alone on the right side foils perfection. The hands and shapes of the two women in the foreground could carry the shot. If there is nothing better, this will be the right picture.

Between frames 16 to 20, it suddenly dawns on me—this guy must have been sitting in a trench to get pictures from this level. What in blazes was he doing, lying in the field? Or was he using a unipod upside down to get the low angle? Whatever he did was the right technique. I can't remember ever seeing planting shot this close. To actually see the plants going into the ground and be surrounded by farm women—this is a new sensation.

In frame 21 he hit it—a terrific image. Could frame 22 be better? No, he had hit his peak and it is downhill from here. Frame 21 is the right picture. But wait, frames 35 and 36A are contenders. The woman on the left in frame 21 is the figure to beat and none of the other frames beat it.

These women do not have personalities; they are like oxen performing their duties without relating to each other. The earth is their job, and gives their lives meaning. Although I'm looking at a still picture, I can see them bobbing like toys, mechanically up and down over the earth.

Back to the first picture—frame 1—it, too, is good, but a terrible loss because of the light streaks. It has something strong, but very different from frame 21. Can you fault a photographer for bringing in a great picture and leaving another great one behind?

By the fifth frame, Heyman had made an observation on how these three women fit together, and nothing could stop his vision until it had pulled that observation into a frameable image. In frame 21, the three women bend out like petals on a dark flower. They are another growing thing in the field.

Here is Millet without paint. Somewhere in the photographer's brain a vague image was stored from a museum trip or art book of Millet's painting of women planting. I cannot prove that the photographer ever saw the painting by Millet, but if he did, what an extraordinary springboard it became. Here is an observation that began with fine painting, germinated, and turned into an exciting piece of journalism.

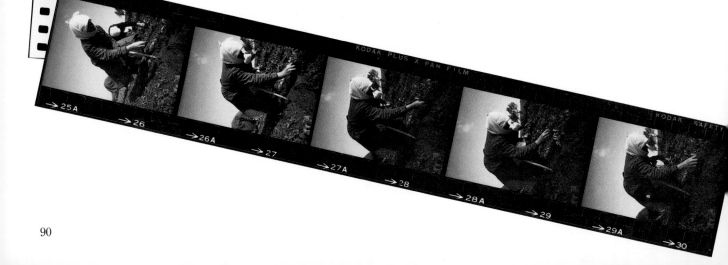

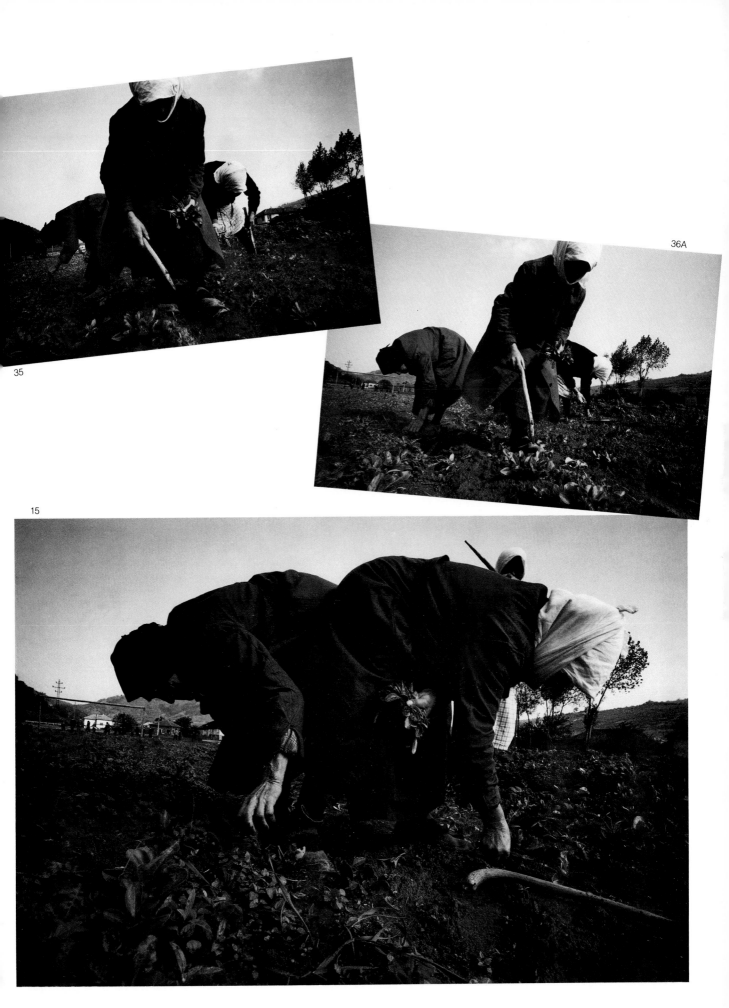

35

36A

15

→2

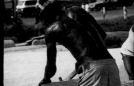

→3 →4 →5 →6 →7

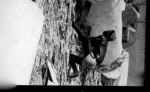
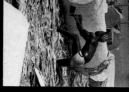

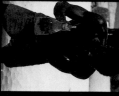

→8 →9 →10 →11 →12

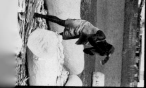
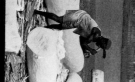
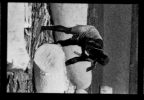
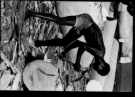
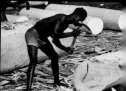

→13 →14 →15 →16 →17

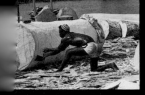
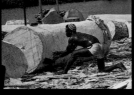
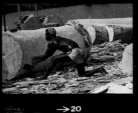
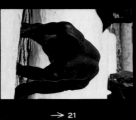
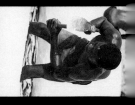

→18 →19 →20 →21 →22

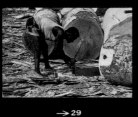
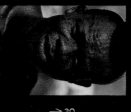

→28 →29 →30 →31 →32

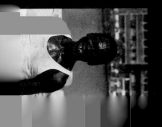

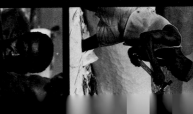

THE LOG SPLITTER

How far does a photographer have to go from his hotel to find a great picture? A hundred miles? Two hundred miles? Three blocks?

It is rare that pictures occur near the hotel where you're staying—the exotic usually seems to happen hours away from the cosmopolitan areas of the city.

However, Margaret Mead once told Ken Heyman that she could figure out the tempo of a country from the traffic in its cities. Since then, he has never ignored the world at his doorstep.

Heyman spied the lumberyard shown in these photographs from the window of his hotel in Lagos, Nigeria. Upon his arrival at the yard, he found natives stripping the bark off trees. Three blocks, that's how far Ken Heyman traveled for this, his most famous photograph, entitled "The Log Splitter."

KEN HEYMAN
Before me were living statues—moving, breathing African sculpture, half-naked against the great white logs. I wanted to capture that look of sculpture. . . .

JOHN DURNIAK
The highlights on the muscles turn the real body into a carefully lit statue in a museum. The texture of the skin, the reflection from the sweat, the physique that comes from daily, strenuous work are all packed in this image.

KEN HEYMAN

Margaret Mead once said to me, during a personal discussion of my psychoanalysis, "If you get over-analyzed, you won't be creative anymore." Stunned by the statement, I asked if she cared to elaborate. "An artist of your stature," she continued, "has to have moments of depression in order to then go into a creative cycle. It is natural and right that there is a down before the creative up."

During the ten days before I took this series of pictures, I had been through hell. I'd been in Africa for more than a month. Because I was new at traveling and living in the continent, I had more than my share of rough experiences. I had been under house arrest in the Belgian Congo, and I was suffering from dysentery, which quickly weakens the body, making any normal movement a great effort.

I was on assignment for *Esquire* magazine to do a study of Nigeria. I had not completed the assignment, but I was beaten by my experiences in Africa. I began to think that I no longer had "it." At this point, I had to make a difficult decision. I was greatly depressed and what I really wanted to do was to go home, back to New York—that's how low I was. Then, something magical happened.

One late Friday afternoon in Kaduna, the new capital of Nigeria, I went to the American consulate office. The two men who ran it were closing up as I walked through the door. Madigan (a marvelous Irishman from Brooklyn, who was married to a charming Philippine woman) saw this sad, lonely photographer wander into his office looking for mail from home. He took one look at me and said, "I have to close this office, but come along with me to our house and we'll have iced tea."

I ended up spending the weekend with this couple. We went to the American Club swimming pool, where I ate an American hamburger and like magic—I was rejuvenated. All it took was talking about my African fiascoes with a fellow American and I had new life breathed into me. The following Monday, I moved on to Lagos, and began taking some of the best pictures of my life.

I had been in Lagos four or five days before I shot these photographs. I was seeing the city differently, and working as well as I ever have. Someone once made the observation that all my pictures are about relationships. That's what I do, and I get most of these pictures with a wide-angle lens—that's how I move in on the relationships. However, these photographs were taken with a 180mm lens so that I could get distance shots, too.

From my hotel window, I shot frames 2 and 3 looking across the bay to Lagos Island. Look closely and you can see other islands in the middle ground—islands of logs. As I watched from my window, I could see the workers in the yard, chipping away at the bark of the logs. The stripped logs were sent to saw mills, and used to make European furniture. For the timber, this was the halfway point between the jungle and shipment to Europe. I left the hotel room after frame 3 with the 180mm lens on the camera. It was a big, heavy hunk of glass.

Unbeknownst to my editors at *Esquire*, I had intended to shoot Nigeria in my own style. I was looking for "stoppers," which is an editor's term that I don't care for. A photographer would call them good photographs. I was playing the game of getting pictures into the photography annuals. I saw myself in competition with photographers all around the world. At the time there were three major annuals: *Popular Photography Annual, U.S. Camera Annual,* and the *British Annual of Photography*. I appeared in them consecutively for six or eight years. I was shooting annual-type pictures—good photographs, storytelling photographs that stood on their own.

When I arrived at the lumberyard, I started shooting the bodies of the workmen, thinking of them as sculpture. I had seen a great deal of African sculpture during my time there and I'm sure that, unconsciously, these sculptures were in my mind.

Before me were living statues—moving, breathing African sculpture, half-naked against the great white logs. I wanted them to look like sculpture and it happened in frame 21—everything worked. Today, this photograph is my best-known image.

2

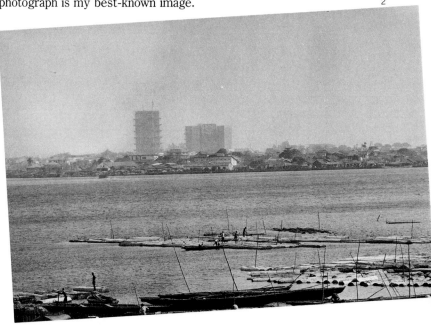

JOHN DURNIAK

When a photographer hands an editor a great picture, the last question that anyone asks is "How many frames did you shoot?"

I have had this picture in my magazine, and on the wall of my office for years, and I always assumed that the photographer must have spent at least a roll and a half exploring the possibilities of the situation. It was a shock when I looked at the contact sheet and saw that only one frame of it existed. Most of the pictures on the sheet are nothing special. The photographer went through the motions, exploring through his viewfinder, but making no discoveries in the other twenty-odd frames.

Heyman learned somewhere to bring back a long, medium, and close-up shot of every scene. In this contact sheet he obliges. There is an overall shot showing the loggers floating on a raft in the middle of the river in frame 2—we have not seen loggers like this before. Then, as if he were listening to the editor's voice in his head saying, "Now, protect us by getting a vertical, too," the photographer shoots frame 3.

Although the photographer discovered the back in frame 4, he didn't realize its potential until frame 6. Then he lost it, and switched over to playing with the contrast between the white logs and the black bodies. Frame 18 is the best of these—the two arms becoming one (the light separating the two arms on the underside is distracting in frames 19 and 20), and the highlight on the shoulder muscle make this a compelling photograph. But the trunks worn by the lumberman are distracting. This is not a pure, broken-down-to-the-essentials image. It is a good one, but not a great one.

Suddenly without warning, the photographer hit the right situation, knew it, shot it, and it was over except for the after shock—another frame, an image without power or vision, a twitch from the finger and brain that

had just been through a devastating encounter.

Frame 21 is one of the most famous pictures in photography. Look at it in comparison to what the photographer saw before and after it was made—it is totally radical. It has a radical point of view, low, very low in comparison, and radical framing—cutting off the hands and feet, making the muscled small-of-the-back the center of interest. It is radical in contrast, almost pure white against pure black. And it is the most abstract image on the sheet.

Much came together in this image—the strength, the force of a strong man, and his emasculation, the cutting off of his extremities. Yet his force and fight survive, faceless—a symbol for millions. This is black versus white—the contrast of prime factors, no in-between tones.

The photographer cropped the frame in the final print, eliminating touches of the bodies of two other men working on top, in each corner of the frame. I wonder if a print of the full frame might be as good, or better?—different for sure. And I try to remember if this is one of the negatives that has disappeared from the photographer's files. If it hasn't I'll ask to see side-by-side prints—cropped and uncropped.

Backlighting adds to the drama. The highlights on the muscles turn the real body into a carefully lit statue in a museum. The texture of the skin, the reflection from the sweat, the physique that comes from daily, strenuous work are all packed into this image.

Knowing he didn't hit the right image in frame 18, the photographer returned to that situation, this time trying to rescue the image with a vertical. It didn't look right and he switched to extreme close-ups. They also don't work, so he ended the role on an indifferent note, knowing that in the center, he had made a truly special picture.

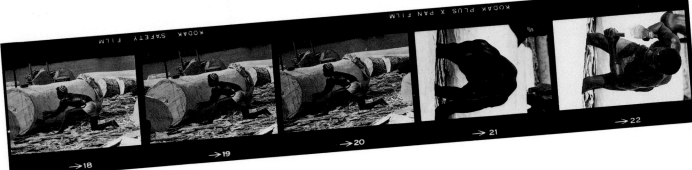

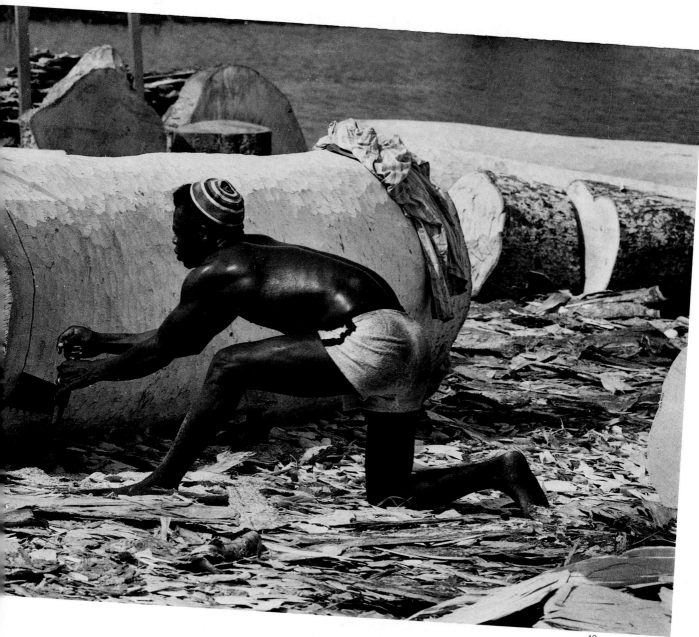

18

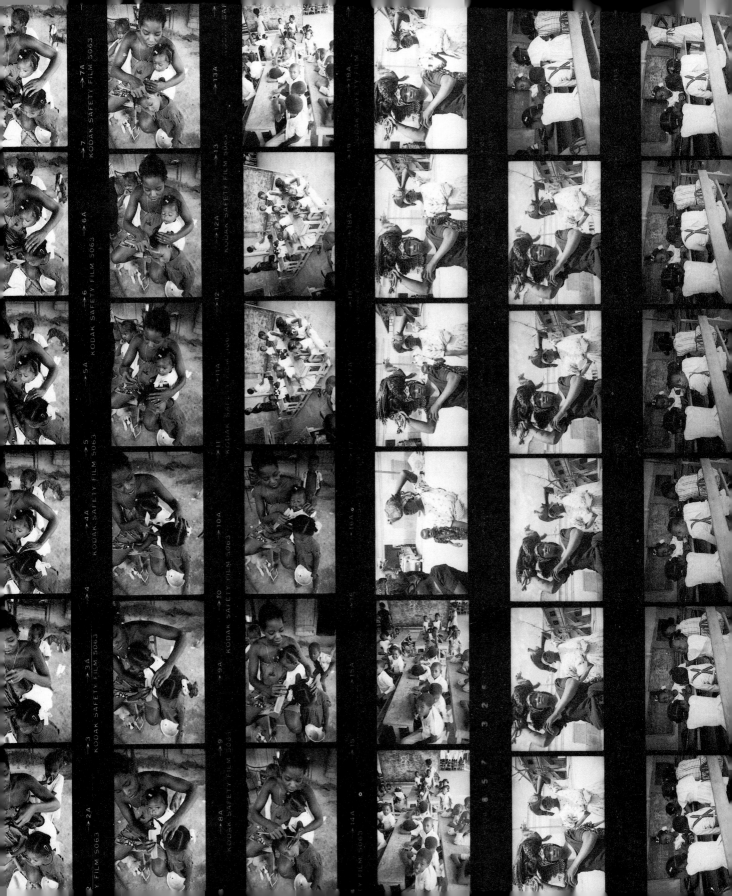

COLOR VERSUS BLACK AND WHITE

What a vast difference between the color and the black-and-white photography Ken Heyman did on the island of Haiti. It looks as if two different photographers made the pictures. He thinks of himself as being a variety of photographers who can be called upon for different assignments. "I'm not schizophrenic," he says, "I just feel what's there. If it's different, I shoot it differently."

Every morning on his way to breakfast at the hotel, he noticed how beautifully the morning light affected the colors of the place, the plants and the uniforms of the employees. But coming back late in the day, he felt the light was not right. One morning, the color overwhelmed him and he shot a small color essay.

All the work was done in less than a half an hour, so he reloaded his cameras with black-and-white film and went off to the village where he was doing his regular assignment shooting people. In color, Heyman's people are objects and color is the subject. In black and white, people are the subject.

Heyman likes black and white better than color, perhaps because black and white has always been his medium. Maybe he considers black and white to be truth and color to be fiction.

KEN HEYMAN
On this particular day, I was purely interested in using people as simple blocks of color, and in abstracting their forms. They were colors against colors.

JOHN DURNIAK
Someone made a rainbow and Ken Heyman found and photographed it.

KEN HEYMAN

A photographer's life is often a contradiction. In Haiti, I was recording poverty with my camera at one moment, and the next I was photographing color on the walls of a luxury hotel. I took my children to Haiti for a vacation. In the morning, I'd go shooting and then I'd return to the hotel to spend the afternoon and evening with them.

Our hotel had brightly colored walls everywhere—blues, greens, salmon—as if a painter had gone wild. The uniforms of the people working there were also brightly colored. Architectural details like windows and railings were painted white. On sunny days the place turned into a Mondrian painting in reverse.

The day I shot these transparencies, I used my 35mm camera with a 50mm lens on it. The 50mm lens produces a different kind of photography for me. I normally use a 28mm lens to get close to people, but the 50mm puts more distance between me and my subject. I just wanted to design pictures by experimenting with these colors and shapes in my viewfinder. It was a radical change for me. For most of my life I've been composing and editing pictures in which the subject matter was my top priority. Here I found myself shooting for design in color, and editing through the viewfinder with design foremost in my mind. Although I had never before thought of my work this way, these pictures led me to accept my strong sense of design.

On this particular day, I was interested in using people merely as blocks of color, and in abstracting their forms. They were colors against colors. I saw a child in a red hat running by, and I asked if I could take her picture. She wasn't sure; she was shy about it. So I asked her if I could take a picture of her back. That seemed interesting to her, so I had her face the wall and I made frame 1. Against the pink wall, the red of her hat and the red door make color, rather than her character, the subject.

In frame 4, the doors are abstracted into pieces of color. I was too involved with the diagonals and the triangles, and I let the image become too busy. In color photography, people and things can quickly lose their identities—a car becomes blue, a child becomes orange, and a fireworks display is a ball of yellow. The magic is incredible.

Frame 10 of the woman in the red dress against the green wall is typical of the photography I've done all my life—a portrait that gives information about the person. (As I took this picture, the thought went through my head that very few people in the world rest by standing on one leg. The most nota-

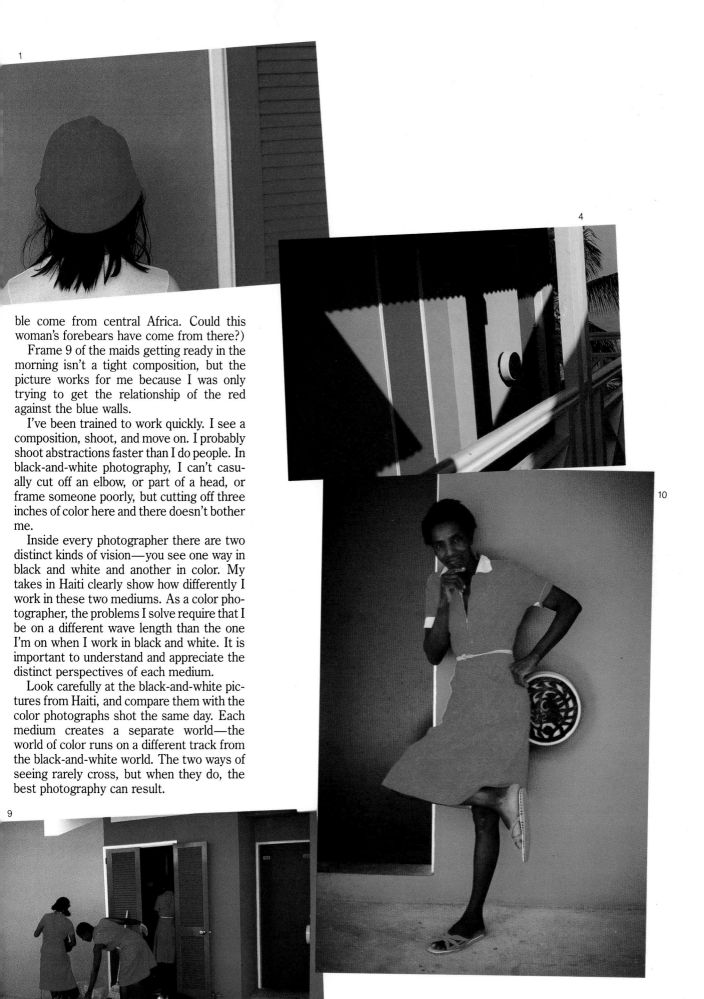

1

4

10

ble come from central Africa. Could this woman's forebears have come from there?)

Frame 9 of the maids getting ready in the morning isn't a tight composition, but the picture works for me because I was only trying to get the relationship of the red against the blue walls.

I've been trained to work quickly. I see a composition, shoot, and move on. I probably shoot abstractions faster than I do people. In black-and-white photography, I can't casually cut off an elbow, or part of a head, or frame someone poorly, but cutting off three inches of color here and there doesn't bother me.

Inside every photographer there are two distinct kinds of vision—you see one way in black and white and another in color. My takes in Haiti clearly show how differently I work in these two mediums. As a color photographer, the problems I solve require that I be on a different wave length than the one I'm on when I work in black and white. It is important to understand and appreciate the distinct perspectives of each medium.

Look carefully at the black-and-white pictures from Haiti, and compare them with the color photographs shot the same day. Each medium creates a separate world—the world of color runs on a different track from the black-and-white world. The two ways of seeing rarely cross, but when they do, the best photography can result.

9

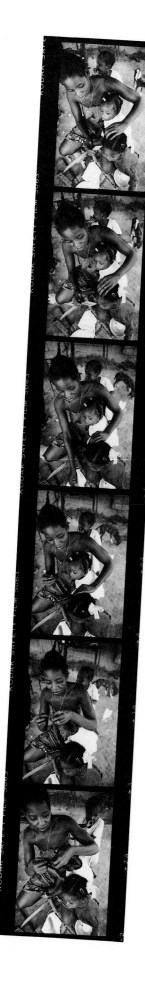

I was finished with my idea for this black-and-white roll by the time I was only a third of the way through it. Sometimes that happens, expecially if I'm disrupted, but usually I finish an idea at the end of the roll. As I took these photographs, I realized that I was getting pictures typical of my style. The first third of this contact sheet shows the kind of pictures I usually do. I pursue relationships—in this case, a mother and two children.

I found a mother sitting in the shade combing her daughter's hair. While she combed, she held the girl on her lap. Working my way into this situation took patience. To photograph them, I had to win their trust and acceptance. I began by moving in slowly without saying a word. I kept a bit of a smile on my face when I wasn't shooting, and I approached them slowly but steadily.

The unusual angle in these pictures was dictated by the light. I was standing and looking down at the mother, who was sitting on a small stool. Normally, I try to be at eye level with my subjects, but in this case, the bright Haitian sun was splashing white light on the back wall. In order to keep the light constant, I had to pick a position where I didn't get mixed light. I am 6′1″ tall—imagine me towering over this tiny woman, and imagine what she thought of me. I was shooting straight down, trying hard to keep my toes out of the picture because I was using a wide-angle lens. I held that angle for fourteen pictures.

I have been asked, "How do you keep your eye on so many things at once and know when they come into proper position?" First, I locate the constant elements; then I shoot for the variables. The mother combing hair is fairly constant; she is doing the same thing over and over again. I framed her, and then began to wait patiently, meanwhile concentrating on the other parts of the picture—what was happening with the children and the dogs. While I was shooting, I was concerned with the dogs walking around in the background. I couldn't control these

dogs, but I was able to move my camera just enough to include or exclude them.

The mother is the main focus of the picture. She is anchored; the variables are a little boy and the dogs. In this outdoor room, I was shooting at about 1/125 sec. After framing her, I turned the camera slightly forwards and backwards to change the background. I could eliminate half a dog or put in a whole child with this maneuver, and since the mother was repeating her action, I was able to concentrate on the background and shoot it the way I wanted it. The right picture is frame 13A.

Getting off a bus later that day, I heard the sound of children coming from a school on the corner. My teenage children were with me, and I wanted them to see this school, so different from any other school they had seen. Uninvited, I quietly walked in and sat down in the back of the class. Some of the kids turned around, probably wondering, "Who is this guy?" These pictures show their reaction to us.

When I left the school, two women walked by carrying turkeys on their heads. I asked if I could photograph their turkeys and they started to take them off their heads. I told them, "No, no, I want the turkeys on your heads."

I had to squat on the ground and shoot up to get this angle. I am surprised to see such extreme angles on this one sheet—from up high on the mother and children, to very low on the women with turkeys. The right picture from this later series is 29A. I had a print of it enlarged and placed in the reception area of my office. Only women were interested in it, probably because they pay more attention to hats, and these turkeys make wild-looking hats.

I went back into the school and took pictures of the class at recess. The best picture here is frame 36A. This last set of images is not up to my best work, because I wasn't concentrating fully on the situation—I was taking care of my kids.

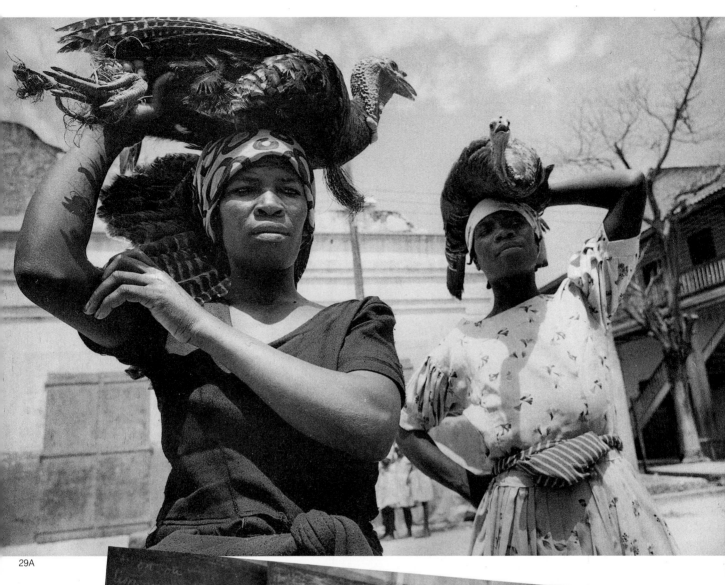

29A

36A

103

JOHN DURNIAK

Sometimes color mugs a photographer, leaving him shocked, surprised and reacting with his reflexes. Haiti was such an experience for this photographer. Flowers, colors in the sky, water, sand, buildings, dress, and radiant sunlight accosted his eye—in self-defense, he whipped out his camera.

Outside his door, cleaning ladies glowed in red. The walls, railings, and fire safety equipment looked as if they had been painted for a fashion session in a photography studio. Haiti's palette is primitive and shocking. The boldness of Haiti's colors has created a legion of primitive painters on the island, and they have an international following. In these color pictures, Ken Heyman attempted a style used by these painters for years, but he was doing his work with a camera. Overpowered, he began to let color call the shots.

The blue and white colors in frames 6 and 7 were easy for this photographer, who usually lives in black and white. He played these colors against each other with energetic results. Simplicity enhances these compositions—white across blue is as strong as white across black. The blue is electric and fights to dominate the white, but never succeeds. Frame 6 minimizes the white, but in frame 7, white dominates the blue.

From looking at these few frames we can see that the photographer was intoxicated with color; he let it take over his mind and movements. The monochromatic picnic in blue becomes a multicolored tour de force in frame 9. The force of violent, primitive color kept pulling him deeper and deeper into more imaginative and abstract color compositions as in frames 11 and 12.

I, too, am carried away by the island's color here. The picture I want for my wall and for my layout is frame 4—it is fascinating, awe-filled, and electric in color and form.

6

7

12

4

11

104

This is a rather amazing black-and-white contact sheet. On one day's walk through the streets of a small town in Haiti, the photographer took an excellent picture of the relationship between a mother and her children, and then probed two other complicated subjects—education and custom. He wasn't on any assignment here, yet he worked as hard as if the shot were to appear with his credit in a magazine the next week. Great photographers don't take casual pictures; they are out for the right picture whenever the camera comes up to the eye.

Without a doubt, the best picture is frame 13A. How many photographers have the will to stand and wait until the elements of a picture come together in a good design, and then take the picture? Not many—that is why we have so few great photographs. Some photographers are lucky to take one great picture in their entire lives. Here is a great picture made in minutes.

At the time this photograph was made, the photographer was shooting about ten rolls of film a day. Doing this amount of work sensitizes the photographer to seeing even the slightest movements within the picture area as he looks through the viewfinder. The camera becomes part of the photographer—seeing the picture and shooting it becomes one and the same.

At the beginning of this series, the children are looking up at the camera, which makes an awkward situation. As they accepted or became bored with the photographer's presence, they began to be themselves. The photographer understood this process, and waited for his subjects to relax.

Unfortunately, the other two situations on this sheet didn't result in high-quality photography. The pictures of the women with the turkeys on their heads don't work for me, because they are snapshots that lack good composition. Yes, the photographer did do well to use a low angle, thereby capturing the sky for background and avoiding the clutter of the street. No, the angle doesn't contribute to a well organized frame. Why wasn't one of the women selected and a portrait made of her alone? Perhaps less would have been more here. In the classroom situation, the photographer obviously needed more time to work without the rest of his family around him. Although I like his idea and the way he probed it, he didn't take the right picture which says, "This is a unique kind of education."

After scoring with a brilliant frame of the mother and children, perhaps the photographer relaxed for the rest of the roll. It is hard to stay high after doing so well.

13A

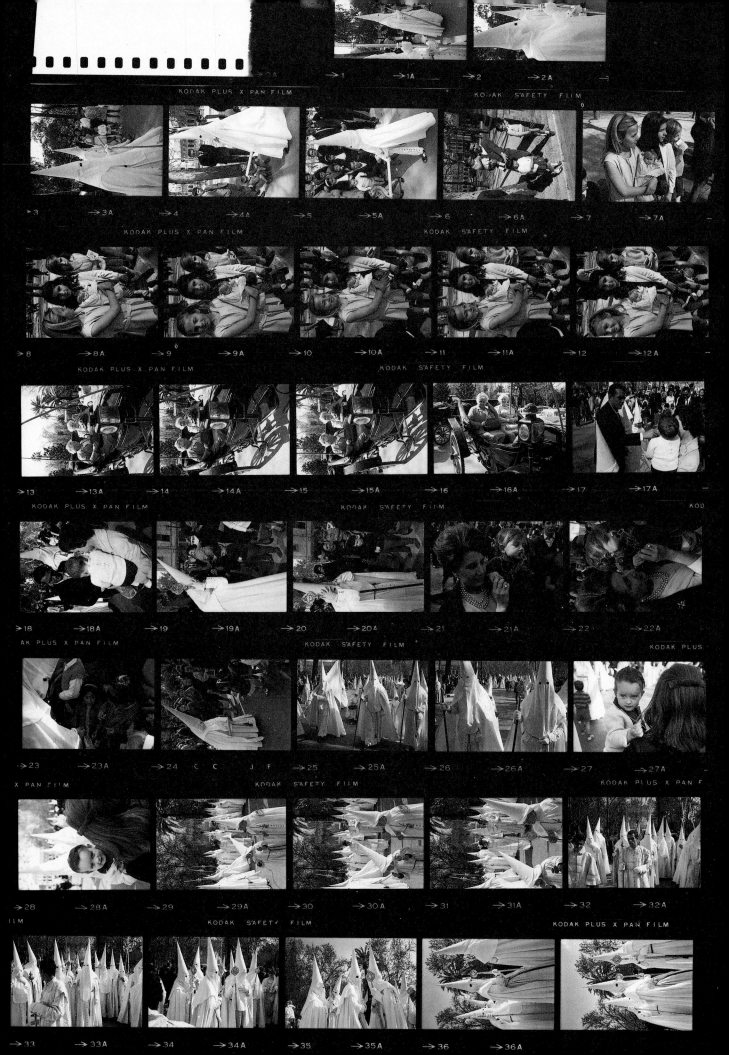

SEMANA SANTA

In most societies, masks are part of life. Anthropologist Edmund Carpenter writes about them eloquently: "Where literate man regarded an alias as deceiving—representing something other than the real self—tribal man often has several names, each a different facet of himself. He may also have several faces, each carefully painted, representing a different corporate self or role."

Photography is often a mirror reflecting what is in the photographer's—and the viewer's—mind. A photographer may tell us little about the reality of a situation because, although it is true that a photograph does not lie, our perception of the subject is shaped by the photographer's point of view.

It is interesting to see the subjects of the pictures on the opposite page photographed both with and without a frame of reference. The photographer has, consciously or unconsciously, taken pictures of a centuries-old tradition of one culture and, with careful cropping, presented a terrifying symbol to another culture.

KEN HEYMAN
*Pictures of people costumed in Inquisition hoods
and robes would be emotional images in America.
How could anyone not think of the KKK?*

JOHN DURNIAK
*In frame 24, the child defuses the image. If this
child is not afraid, how can the viewer be? And
the crowd is smiling. This cannot be an American
picture; this is another world, another time, not
the KKK. The more information contained, the
less intimidating the photograph.*

KEN HEYMAN

Semana Santa, the celebration of the Holy Week before Easter, is Spain's most elaborate festival. In Seville, it is celebrated with more energy than anywhere else. The city has become famous for its colorful pageants, elaborate church services, and sensational food. Tourists from everywhere—especially from western Andalusia—gather to take part in the festivities. I would rate the Easter extravaganza in Seville as one of the ten most memorable events I have ever witnessed.

The churches of Seville take part in a grand procession, for which each parish spends weeks in preparation. Love and care go into making the costumes and *pasos*—wooden platforms with religious figures on them that are used in the parade—because the people believe that what is done for the spectacle is work witnessed by God. The competition is so keen that it sometimes becomes vicious during the procession, when members of rival parishes shout epithets at each other while carrying the images of Jesus and the Virgin Mary. Each parish is represented by a "brotherhood," a team of men who carry a statue of Christ depicting an event from the last week of his life. Members of the brotherhood, who are dressed in the conical masks and long, formal robes reminiscent of the Inquisition, walk at the front and rear of each float. The Spanish believe that if any part of the platform holding the statue touches the sides of a church doorway as it is carried through, there will be bad luck for the parish in the following year. The clearance around the doorway is about one inch.

As can be seen from the black-and-white contact sheet, members of the procession were scattered throughout the crowd before and after the ceremony. Isolated close up, the hooded parishioners look ominous. But pictures taken with family members and neighbors somehow diminished their seeming ferocity. Pictures of people costumed in these hoods and robes would be emotional images in America. How could anyone not think of the KKK?

I shot these pictures as a self-assignment. When I began showing these pictures to editors, they were immediately bought and published. One magazine used the color picture printed here as a cover. Another magazine published a picture story on the procession. A portion of one print was used on a book cover.

This color picture is mysterious and ambiguous. It allows the viewer to make up his own story to go with it. The sharpness of the subject's eyes allows the viewer to look at the person without knowing who he is or what he represents. There are few answers in these images for the viewer, who can guess but not know what they are about, unless he knows something about the *Semana Santa* in Spain.

Because of the loss of other transparencies in the take, the color picture is the right picture because it is the only picture. If my memory serves me right, it was the best picture from the set.

There is a choice, however, in the black and white, and the two best pictures are frame 26A and frame 10A. They are totally different pictures, but both are good and give the feeling of the day.

26A

10A

JOHN DURNIAK

One of the realities in photography is that pictures do get lost. Another is that all black-and-white negatives are saved, while most rejected slides are quickly thrown out to save storage space. This section suffers from both of these "realities."

All the color pictures of these Spanish Easter festivities were either thrown out after an edit, or lost—except for the one slide appearing here. All the black-and-white frames, however, were saved. The one roll shown here is representative. Although not one close-up challenges the strength of the color photo, many are interesting images.

Of the black and white, I like frame 36A. My second choice is frame 24. They represent different ideas at work. Frame 36A is a bad dream, terror about to be unleashed. Ken Heyman shot from a low angle to increase the power of the hooded figures over the viewer, making the shot more terrifying. In frame 24, the child defuses the image. If this child is not afraid, how can the viewer be afraid? And the people in the crowd are smiling. This cannot be an American picture; this is another world, another time, not the KKK. The more information contained, the less intimidating the photograph. When the photographer mixes hooded and unhooded marchers, the pictures are tame, non-threatening.

Frame 1A is one of his best pictures, and he continues working this idea for five frames. I am sorry he stopped. Frame 1A is good, but he did not stay with the concept long enough to develop it.

24

1A

36A

A PORTUGUESE MARKET

Technically, a photographer might think twice before photographing peddlers working in their tents at an outdoor market, as Ken Heyman did with this series taken in Portugal. Many of his subjects were under a tent made of all sorts of cloth strips and canvas, which created an oddly colored light and filtered the sunlight into a weird rainbow.

The impossible color and chance of odd skin tones didn't stop Heyman, who made these pictures because he was more interested in their content than in solving the technical problems involved. Had he been equipped with a color temperature meter, he might have stopped shooting, but the white light bouncing into the makeshift tent from outside was brighter than the colored light filtering through the tent roof.

Heyman thinks that sometimes the best policy is to take pictures and worry about the problems later. That way, he is often rewarded with good photographs, rather than missed opportunities.

KEN HEYMAN
I have been to markets all around the world, and over the years I've seen the peddlers' stock change, sometimes to the photographer's disadvantage. . . . The world is now made of plastic.

JOHN DURNIAK
The plasticware was a rainbow, but he could not resist shooting the people with the pots, giving up on the wild compositions and abstractions that he might have created.

KEN HEYMAN

The boy in the green shirt was selling hard taffy, and was annoyed because he had to mind "the store" instead of being with his friends. Under his arms is the cash box which also contains the candy.

I shot frame 1 first. In frame 2, the boy turned and looked at me. Earlier in my career, I tried hard to get people not to look at me. But when look-at-the-camera came into style, I softened my stance. Now I don't care. Nevertheless, everyone in a picture has to do the same thing. Pictures with some subjects looking at the camera, and others looking away are rarely any good because the photographer should be either seen or not seen.

Compositionally frame 2 is okay, and is the right picture. I don't mind the cropped head, because it makes the viewer more intimate with the boy. I photographed him because I knew the combination of his red hair, green shirt, and the orange box would make a colorful, interesting picture. Unfortunately, he was under the pink canvas tarpaulin, causing a pink light to fall on his face.

In this village, not everyone had a car or a horse. The little man in frames 3 and 4 ran a delivery service taking shoppers and their purchases home in his horse-drawn cart. He charged a few cents for the ride. Of the two photographs, I prefer frame 4 because of its design—the umbrella and truck sandwich the man. I'm not pleased with his expression. Also, if I had photographed him at a different time of day, the green and red on the right would have been deeper tones, which I would have preferred.

I have been to markets all around the world, and over the years I've seen the peddlers and their stock change, sometimes to the photographer's disadvantage. For instance, it was charming to see women in Indonesia carry great banana leaves over their heads like umbrellas—today, when it rains they wear Japanese-made ponchos, much better for them but not as picturesque. The world is now made of plastic. Frames 5 and 6 show the rainbow-hued plastic that has replaced handmade dishes and cookware in the market. I wouldn't photograph this in black and white. Notice the modern look of the vendor—he is wearing jeans and sneakers. I prefer frame 5 because of its composition. It is tighter and more painterly than the journalistic frame 6.

The people in frames 7, 8, and 9 are gypsies, a special people. To me they are among the most interesting groups in the world, one of the only peoples who have preserved a unique style, look, and heritage even though they are spread throughout the western

1 2

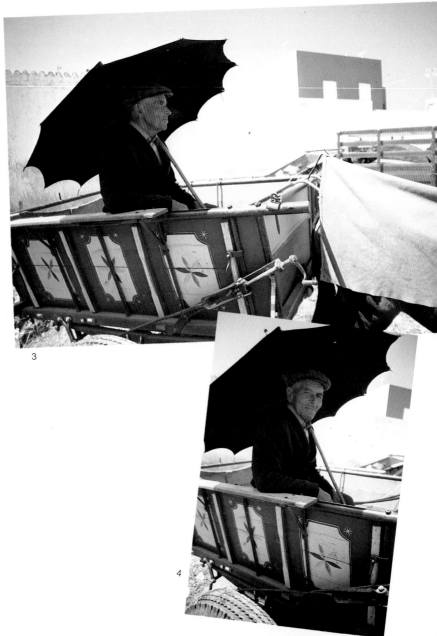

3

4

world. I think these photographs capture their wildly free spirits.

I saw the pile of blue quilting, and moved in on the giggling children, who were a lot of fun—so much fun that the mother watched over them proudly, permitting them to do just what they wanted. The boy was her pride, the man of the house.

Of the three pictures, frame 8 is my favorite, because we share with the mother a fond look at the silliness of childhood. I would prefer having the children's feet in the picture—but it works even without them.

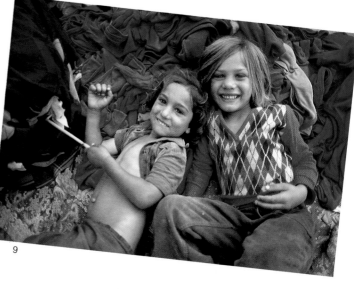

9

7

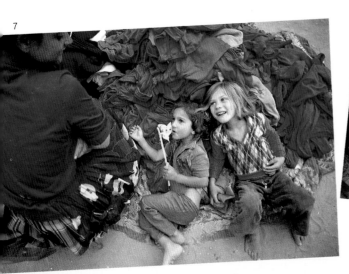

5

JOHN DURNIAK

Once a people photographer, always a people photographer. There were many picture possibilities in this marketplace, but the photographer went after what fascinates him most—people. The plasticware was a rainbow, but he could not resist shooting the people with the pots, giving up on the wild compositions and abstractions that he might have created.

Because he is so good at his specialty, there are two excellent people pictures here—frame 2 and frame 8, both different, both well handled. The taffy peddler tells us with his eyes that he is really a little old man in a boy's body. The gypsy woman lets her children rest on the clothing she is trying to sell—her children are more important to her than her trade. Both images would be fine as black-and-white pictures, too, but the color is an asset. In making these, the photographer combined his black-and-white skills with his sensitivity to color, creating color pictures that have the same depth and power as his black-and-white work.

The rest are ordinary pictures. Faced with photographing a horse cart, he selected the driver. Why not photograph the horse, too? The old man looks as if he is relaxing on a bench. And it was the wrong moment for shooting the peddler with his plastic pots. For once, the photographer was paying more attention to the pots than to the person— rare but he did it. Technically, the color is rich and the exposures are confident—except for the one of the horse cart driver, where the film didn't give Heyman enough range from bright sunlight to shadows under the umbrella.

Frame 8 is memorable and will stay with me for a long time. Imagine how close the photographer had to get for this picture! He is practically standing on top of the kids. That's moving in. Most photojournalists err in the other direction, they try to shoot intimate pictures from too far away with telephoto lenses.

BALINESE DANCERS

When three or more people gather, the photographer has his work cut out for him. Photographing large groups requires that one pair of eyes work like a dozen.

In this situation, photographing the island of Bali's premier dance troupe, the photographer had a number of difficulties with which to contend. He had to be aware of when the troupe was synchronized, and when it wasn't. His subjects were more interesting when they were off balance. And, although the dance mistress commanded the performers, she did not fit in visually. Then there was the fabulous banyan tree in the background. Should the tree-as-theater be allowed equal billing with the dancers?

Dance is a thing of motion, best captured by video and movie cameras. The still photograph slices one moment out of time, a movement, like an orchestra holding a note. The orchestra here is not in the image and cannot be heard in the pictures. Above all, the photographer needed to make a single, frozen image say "dance."

KEN HEYMAN
Being a photographer is marvelous at times like this. There I was with those beautiful people, an orchestra playing, and I was the entire audience. The girls were dancing for my camera.

JOHN DURNIAK
From these pictures we learn that beauty and art come into an individual's life early in Bali, where the human body is a canvas for art.

KEN HEYMAN

Bali is one of the most beautiful places in the world. I feel fortunate that I had Margaret Mead to show it to me. She had lived in Bali for two-and-a-half years while she worked on her famous study of the people. I was twenty-eight years old the first time I went there. I had been in the Army, and had then studied anthropology with her at Columbia University. The one month I spent with her on the island, I learned more than I had in four years studying at college.

She showed and explained to me that Bali—more than any place else on earth—was devoted to culture—dance, music, wood carving, and painting. Of all their arts, they were proudest of their dancing. These little girls are the best dancers in Bali, the "prima" dancers. When a dancer reaches puberty at about the age of thirteen, she leaves the company.

Ten years after my visit to Bali with Dr. Mead, I went there alone. A publisher had asked me to return to do a color essay updating my previous work. Being a photographer is marvelous at times like this. There I was with those beautiful people, an orchestra playing, and I was the only audience. The girls were dancing for my camera.

Under a banyan tree, one of the most beautiful trees in the world, the light is ideal for photography. Banyan trees can be as wide as thirty yards. They provide cool shade on a hot island. The best picture on this page is frame 7—in it you can see the tree and its many trunks as well as the dancing. In frame 8, the dancers are relating to the teacher, which makes this more of a dance-school picture. I didn't do well with the teacher, because this was not a teacher/student situation in the classic, dance-school sense. I was captivated by the beautiful little girls under the great tree. The environment was important—the fact that a teacher was present was not.

8

1 7

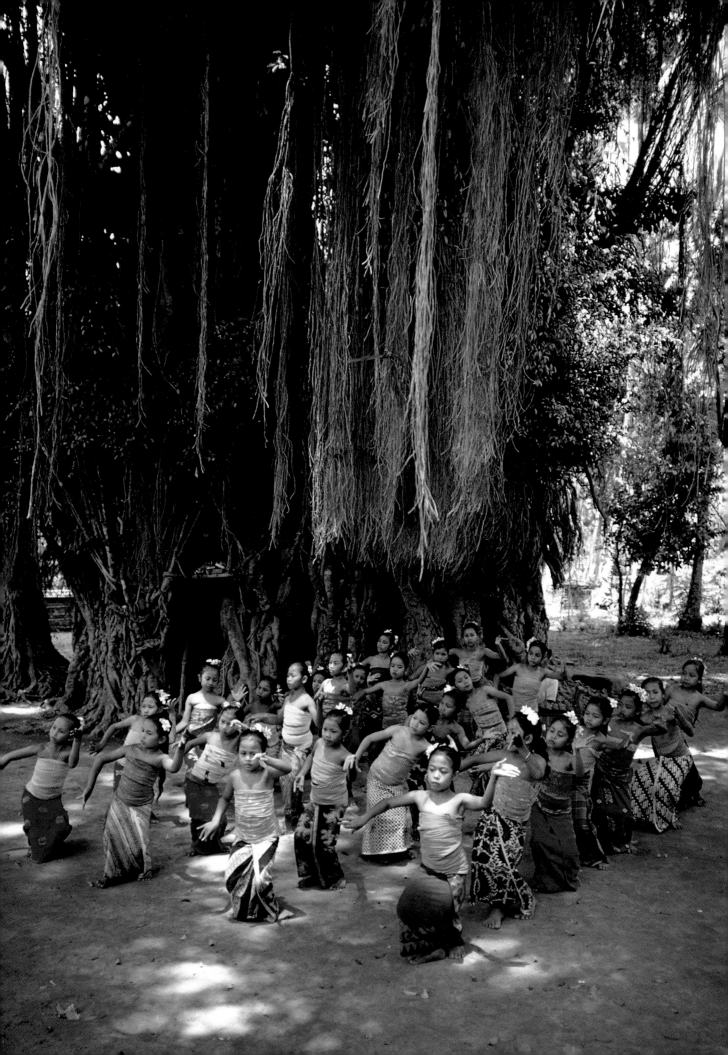

JOHN DURNIAK

This sample of the photographer's take frustrates me. I want to see more of what was shot. The photographer didn't organize his compositions well except for frame 11, where he eliminated the teacher.

Without a doubt, frame 11 is the right picture. It is actually two pictures in one frame. One is a candid moment of an individual—a dancer checking on a neighbor to see if she is dancing correctly. This one little girl is out of step with the rest, and the photographer caught it happening. Her eyes are out of synchronization with all the others. She breaks their regimentation, and the picture works because of it.

This is also a picture of the whole group. The picture frame is filled, yet it is not crowded, allowing the viewer to study the troupe from the wings. Here is a special view of the company, without their instructor, without orchestra, doing their thing. They have forgotten the photographer and are not performing for the camera. The soft, even light under the banyan tree makes the color especially lush. Skin, hair, and clothing all benefit from the indirect light.

How much can we learn of the island from this photography? That it has a calendar with 210 days? That Barong and Rangda—good and evil—constantly struggle against each other in dance form? No. What we learn is that beauty and art come into an individual's life early in Bali, where the human body is a canvas for art. Frame 11 is one small morsel from a gigantic feast.

9

10

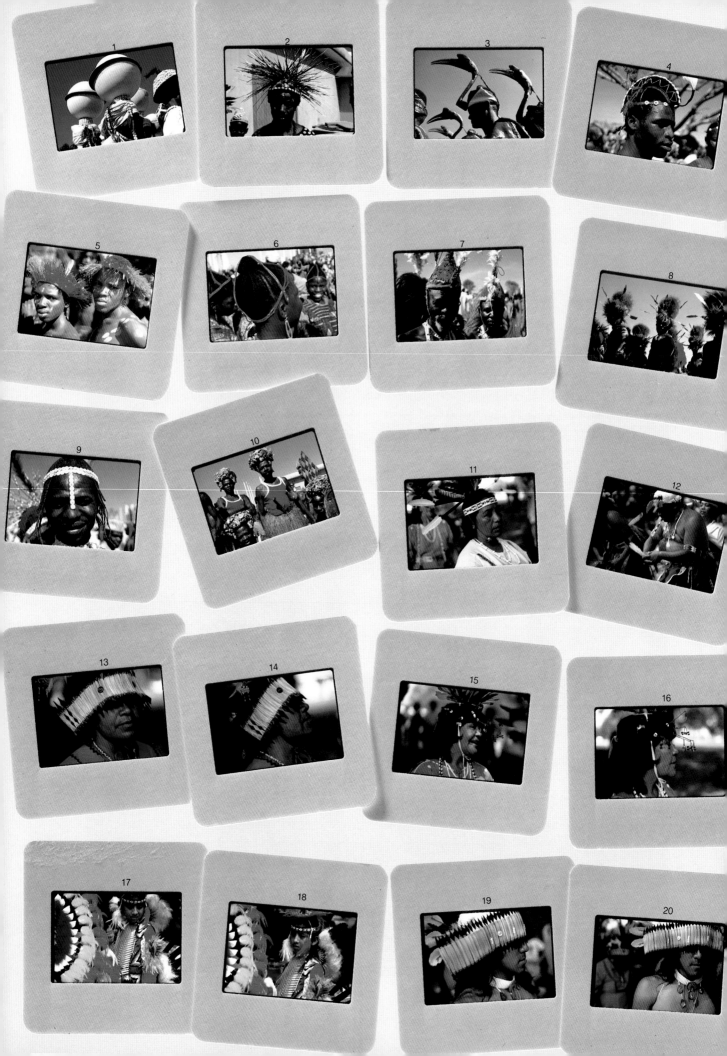

"HATS," AN EDITORIAL FILMSTRIP

"Hats" was a free-form assignment—Ken Heyman could go anywhere in the world to do it, without any editor hanging over his head telling him what to do. An ideal situation? Not quite.

The hats worn by various cultures were to be photographed during his off-hours, the time on his travels that was not spent photographing for a book assignment. Also, all the photographs of the hats had to be in color, while the original assignment was to be taken in black and white.

Every assignment, no matter how loose the guidelines, carries some sort of drawback. Heyman was switching back and forth between two different subjects and two different types of film. In addition, he was left without the choice of shooting vertical frames, while having to worry about the delicate color exposure balance between the hats and the subjects that wore them.

KEN HEYMAN
It was a great way to do photography. I had a black-and-white book and ten color filmstrips to be done on every continent; I could travel wherever I wanted, and I would be the editor on both projects.

JOHN DURNIAK
Shooting only horizontal frames—because filmstrips require that all frames be horizontal—may have been a limiting factor. The photographer likes to move in close, and many of his close-ups are vertical, not horizontal. Consequently, many of these close-ups are not as good because he was barred from his natural response.

KEN HEYMAN

I did more traveling and photography in 1974 than I had ever done before. It was a great year. It started with a contract to work with Margaret Mead on a book entitled *World Enough*. I was to go to countries I had photographed fifteen or twenty years earlier, and rephotograph the same villages and families to show the changes that had taken place.

Knowing that I would be traveling all over the world, I went to *Scholastic* magazine, one of my accounts, and suggested a filmstrip project aimed at fourth and fifth graders that would take advantage of my extra time. We came up with ten filmstrip ideas to be shot on every continent. One idea was "Hats," for which I would photograph interesting headgear worn in different circumstances all over the world. Other subjects included shoes, water, and tools.

It was a great way to do photography. I had a black-and-white book and ten color filmstrips to be done on every continent; I could travel wherever I wanted, and I would be the editor on both projects.

The first series I shot was American Indian headgear (which is what you see here along with the "hats" of African tribesmen). The Navajos were coming from all over the southwest for a powwow on the banks of the Potomac River in Washington, D.C. I knew

that my major shooting problem would be the tourists wandering around, interacting with the Indians. A private festival in the desert would have produced better pictures.

Because of the tourists, I decided to use a 200mm telephoto lens with its narrow angle of view to isolate the Indians and their activities. I made the African pictures with a 50mm lens, because there, without tourists, I could move in closer. In Washington, I switched from Leica to Canon cameras. I love the light weight of the Leica, but I needed the built-in metering and long, fast lenses of the Canon system.

Frame 1 fascinates children because it's so unusual to see a bowl on top of someone's head. This is the way the women carry water from the well. The composition is better here than in frame 2, where it is a little distracting and the expression is not good. I'll pass on that one.

Frame 3 is also terrific for children. Their first reaction is to laugh at the men who want to be birds, and ibis at that. It's fun seeing four birdmen. Frame 4 shows a birdman up close, allowing teachers to encourage discussion of what the decorations in his hat might mean. The tree, which should be an eyesore, somehow becomes part of the photograph.

1

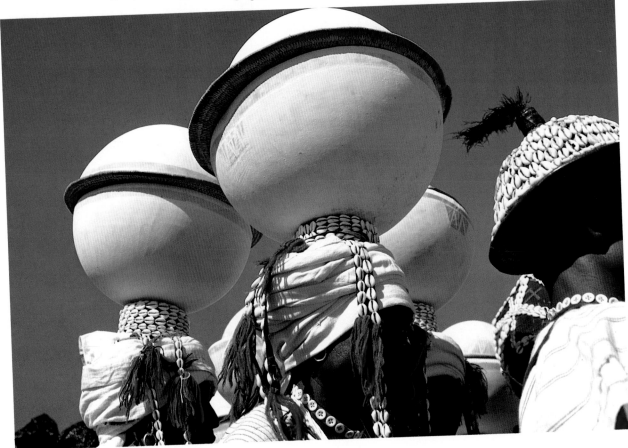

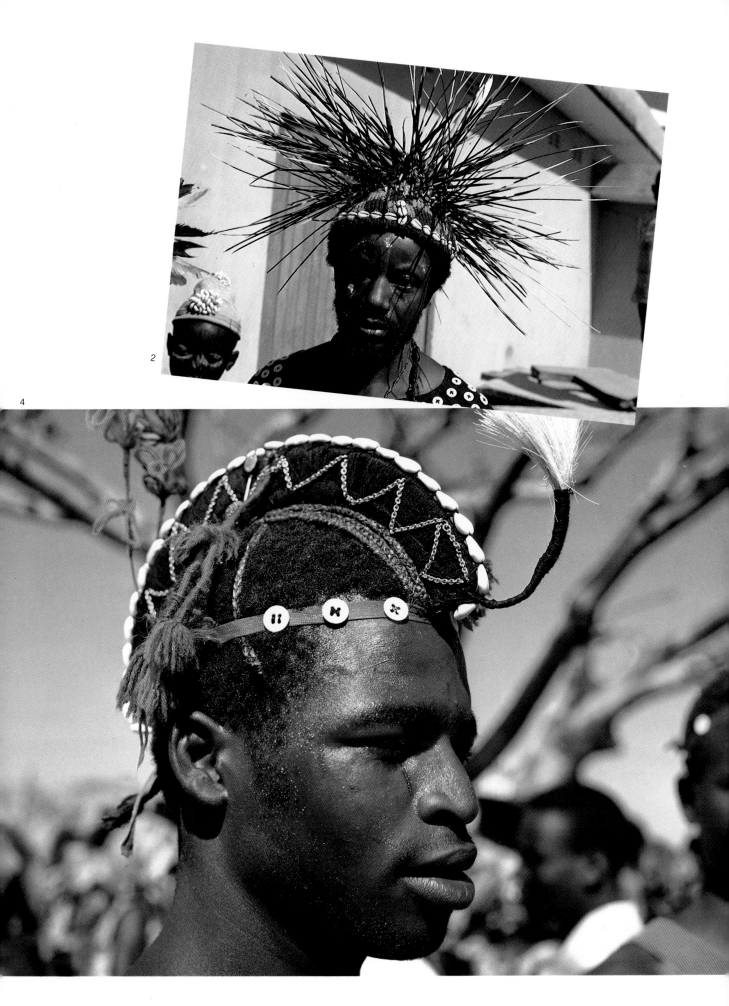

2

4

Frame 5, showing African men in their red and yellow Hawaiian-like hats, is the right picture. Seeing one mysterious man in shadow and the other visible in sunlight is dramatic. They are related and part of the same tribe, but they look very different.

Of the American Indian pictures, the best is frame 17, with its exotic color, although the boy doesn't look happy. I was carried away with the beautiful headdress on the left, and didn't show his "hat" as clearly as possible. Frame 19 is better—the right American Indian hat. The hat shape is good, and I like the covered eyes and the colors on the face. The editor liked the hat, but chose frame 13, possibly because the subject is an Indian woman, who would present a non-stereotypical image of an American Indian.

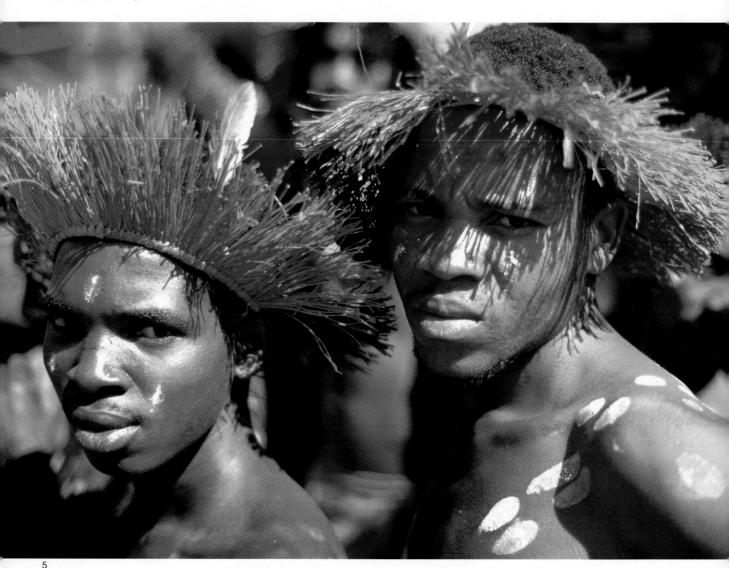

5

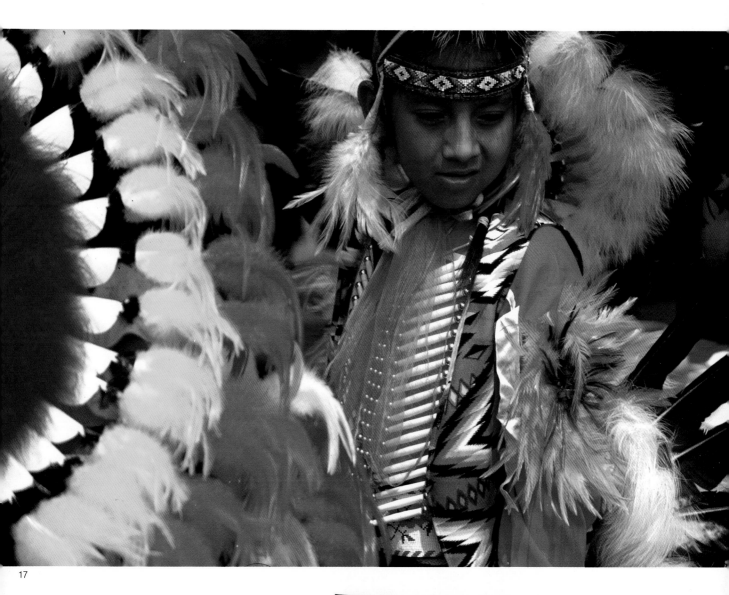

17

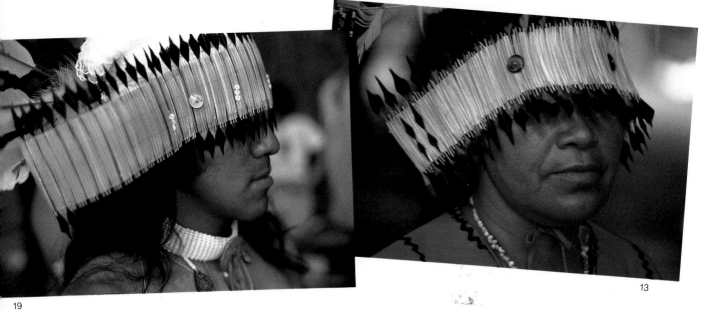

19

13

JOHN DURNIAK

There are two roads to follow in selecting the best picture from this assignment. The first is to go for the most unusual headdress; the second is to choose the best photograph regardless of the headgear. I elect to follow the second path. Therefore, the right pictures for me are frame 14 in the American Indian set, and frame 3 in the African set.

In frame 14, cropped as a vertical, the picture is all design. The Indian woman is part of the design. All the elements work together, and neither the headdress nor the woman dominates. The whole is greater than its parts. This is a single statement, a single thought, a single design. I am not bouncing back and forth, looking first at the headgear and then at the woman.

None of these slides is great photography. I have the feeling that the photographer put on his "children's eyes." The compositions are not as clean as the others in this book—perhaps he was shooting too quickly and not thinking enough. I don't see the involvement of which he is capable and that he demonstrates in most of his pictures.

Shooting only horizontal frames—because filmstrips require that all frames be horizontal—may have been a limiting factor. This photographer likes to move in close, and many of his close-ups are vertical, not horizontal. Consequently, many of these close-ups are unnatural to his style, not as good because he was barred from his natural response.

The photographer spends little time beating around the bush but goes right to the subject—the head gear. The film strip is about what people wear in different cultures, and the photographer gives those images directly. He could have shot down, or from the back, or combined several subjects with their "hats" on. Instead he delivered the simple, colorful, easy-to-study image.

To westerners, the bird-head hat in frame 3 is startling. It is unimportant that the subject's face is in shadow and that the frame tends to be monochromatic. What he is wearing is the story.

It is surprising to me that in Africa, where Heyman had no problems with tourists and had a chance to direct his subjects into the shade, he made all his pictures in bright sunlight which he hates. Despite all his problems in Washington, the Indians are in the shade and the colors are fully saturated. I wonder what kind of pictures would have resulted from the African set if the photographer had asked the subjects to face away from the sun? Backlighting might have been dramatic, and might have produced softer colors and prevented deep shadows on the faces.

I'm sure these pictures made a successful filmstrip for holding children's interest, but as far as being individual pictures for hanging on museum walls, they are not the best. Heyman's attention was directed at something other than making great pictures. Capturing many different hats to keep the kids in their chairs was the goal, not great journalism, art, or anthropology.

3

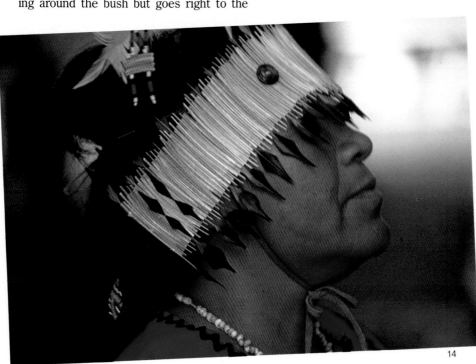

14

130

AT THE MOVIES

From the outside, photographing a Hollywood film production might appear to be the most glamorous of all assignments. The photographer gets to rub shoulders with superstars, great directors, and the movers and shakers of filmmaking. In truth, it may be the most difficult job in professional photography.

Film stars are tough subjects. "No" is their favorite response to a photographer's requests for pictures. They do not get paid extra to work with still photographers, and most actors feel their only work should be before movie cameras. However, if the photographer represents a national magazine, it helps.

Ken Heyman arrived in Rome, on assignment for *The Saturday Evening Post* to cover the making of *The Agony and the Ecstasy* starring Charlton Heston. Photographers become whom they represent—doors open and cooperation is extended to those who work for *Time, Life,* and other super magazines. Heyman's assignment had two goals: shooting the key actors on and off the set, and showing the star within the context of the film. He also was constantly searching for ideas that magazines would buy quickly. The bigger the name, the easier to sell such an idea.

The atmosphere around the set is hostile to most still photographers. Union electricians, make-up people, and stagehands look upon the photographer as an intrusion, and as someone who doesn't work directly for the film and thus makes their lives more complicated. In the United States, unions insist on securing a stand-by union photographer who is paid scale wages without taking pictures when the magazine photographer does his work.

KEN HEYMAN
How can you determine what is real in the movie business, and what is just publicity? To me, that was never a conflict—I produced what I saw as reality.

JOHN DURNIAK
Actors don't often take direction from photographers, but instead "give" a few pictures or poses. They direct themselves.

KEN HEYMAN

Film publicists sometimes hire a hot magazine photographer and pay him more than his usual day rate to take pictures on a movie set. The photographer then owns the pictures and can show them to anyone. This is a way for magazines to get good photographs of important films in the making without paying for them. The film publicist might suggest possible angles for the story, and sometimes an editor guides its slant. Other times, the editor just goes over a take and chooses anything exciting.

How can you determine what is real in the movie business, and what is just publicity? To me, that was never a conflict—I produced what I saw as reality. I've done about twenty motion-picture stories for magazines, and never felt I was being bought. Whatever I shot was used, reused, resold, and repackaged all over the world. Whether I'm paid by a film company or by a magazine makes little difference to me—I still do my own reporting in my own way. I've been on both sides, and in between both sides.

I had my doubts about shooting *The Agony and the Ecstasy* in Rome. I wasn't a fan of Charlton Heston's nor of his epic films. But when I met him, I was immediately impressed. I was on the film for three weeks and I got to know him and his family.

The Sistine Chapel had been re-created at the Cinecita studios. There I was with Charlton Heston up beneath the re-created ceiling, and there was God reaching out and touching Adam three feet away from me. In the role of Michelangelo, Heston posed for me on the scaffolding. From below, the movie company spewed light up all over us, and Heston, wearing a plastic structure in his nose to make it look broken, asked, "What do you want me to do now?" It was something, a big thrill. Those pictures are here in the bottom row.

Frame 16 is the right picture, even though for my taste there is too much light in the picture. But Hollywood did the lighting, not me. I had tried for the pained expression, and got it—against the Sistine Chapel reproduction one hundred feet in the air. Frame 11 was used as the cover of *The Saturday Evening Post*. I like the strength of frame 2.

When you work on a film, you see beyond the set. I remember one day, an Italian photographer came in to shoot Heston and Rex Harrison, who played the Pope in the film. The Italian photographer went up to Harrison and held a light meter in front of his face to take a reading. Harrison pushed his hand aside, and said, "Get out! No one has ever put anything so close to my face before!" The photographer was thrown off the set.

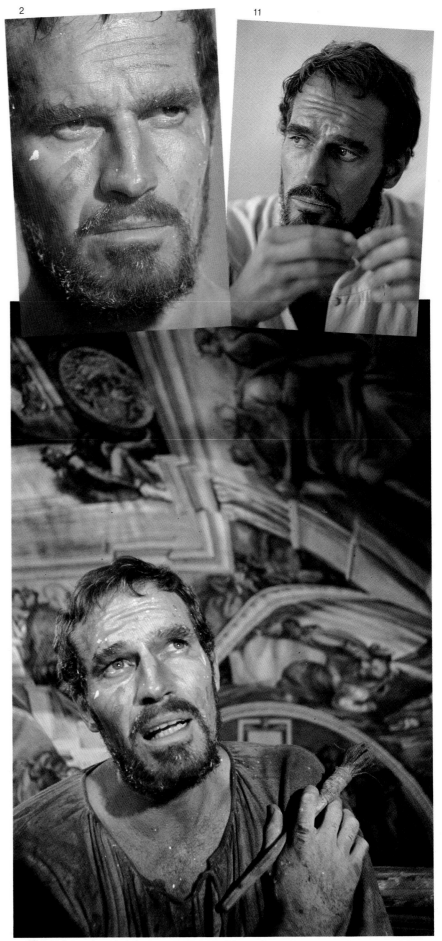

2

11

16

JOHN DURNIAK

The face of a great actor is complex and ever changing. The ego of an actor is even more complicated. In Hollywood, the hierarchy is such that if you're angry, you kick the person below you. Directors think of actors as cattle, and actors think of photographers as dogs. For anyone who hasn't seen a film shot, it's hard to imagine the fire and brimstone the photographer must endure. Even producers are leary of him, because the sound of his shutter could ruin a multimillion dollar scene. And there are hundreds of stories about photographers being kicked off sets by stars.

Sometimes the photographer has to wait for days to schedule a few minutes with a star. These few minutes can turn into "bitch sessions" during which the actor accuses the photographer of all kinds of things, including wasting everyone's time. Under such conditions, photographers have to use their photojournalistic skills to do their jobs quickly without arousing their subjects. Actors don't often take direction from photographers, but instead "give" a few pictures or poses. They direct themselves.

Over the years much thought has evolved on how best to photograph an actor and his relationship to a film or show. There are those who feel actors should play their roles and be photographed in a photojournalistic style. Others feel that actors speaking their lines have unnatural mouth movements that don't look good if caught in still pictures. Having seen my share of contact sheets from Hollywood, I think these critics have a point.

In this case, Ken Heyman was not at war with the star. Otherwise, we would see it in Heston's face. The star cooperated, and the photographer took quite a variety of portraits. The photographer was able to direct Heston into moments that reflect his role in the film. Some of the best shots taken on sets are preconceived during a reading of the script, or by looking in on rehearsals.

Obviously, Heyman had a successful shoot. He seems to have "directed" and shot Heston, capturing expression in the actor's eyes, which is a consolation for not being able to hear his lines. There is tension in his eyes, and the eyes give movement to the pictures. I like the stark look in frame 2. In frame 14, Heston jumps out of the picture with his expression, and the window behind him tags the background as being the Sistine Chapel. Frame 12 is a good confrontation.

But of all the pictures, I pick frame 10 as the right one. There is no obvious acting here. The actor and the part are one. This is Michelangelo—brooding, thoughtful, a mind for the centuries.

I don't like the light in these pictures. But the photographer couldn't control that. He took what was there and did his best with it. It's hard to understand why photographers can't get more cooperation from Hollywood in such situations.

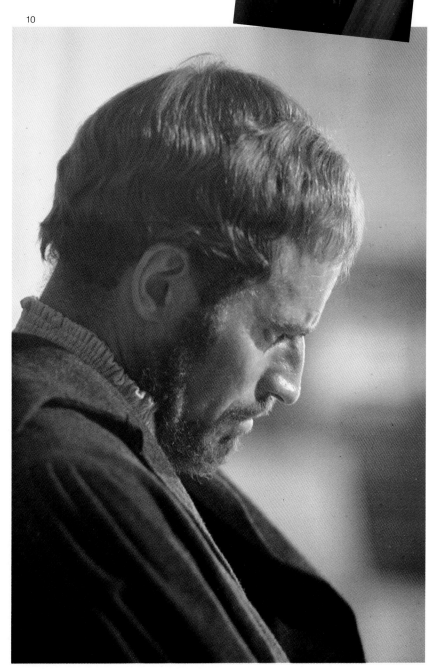

12

10

OFFSTAGE WITH ANTHONY QUINN

An actor can become a different character in seconds. It takes time to search out the right moments and expressions underscoring the spirit of a film, its actor and director. Still photographers need as much time to develop these as do the film crew, but there is never that much time to give still photography.

Photographers assigned to cover movie stars hope to develop relationships with them. Without a star's commitment to doing stills, the assignment is usually doomed to failure. The photographer needs more than the actor's body in a costume, and his face made up—he needs a soul washed, costumed and prepared for the truth.

Anthony Quinn had a reputation for being tough. Arriving in Europe to photograph him, Ken Heyman had butterflies in his stomach. What would he talk to Quinn about? A false move or one stupid remark could kill the assignment. One thing working in Heyman's favor was that Quinn was a long way from Hollywood. In Rome, there was no chauffeur driving up to whisk the actor away to his home or office. In fact, the actor seemed to have some time on his hands.

KEN HEYMAN
Personally, I prefer to observe interesting things, rather than be involved in them. It's difficult to have lunch with a star. With the camera at the table, it's hard to say, "Excuse me," and launch into taking his picture.

JOHN DURNIAK
The interest in these frames lies in their action, the family members' involvement with each other. In the picture of the father and son, the late afternoon sunlight spotlights them sharing something special.

KEN HEYMAN

The chemistry between people is so important that it can mean the difference between the success or failure of an assignment. The photographer who doesn't get along with a subject or the journalist who can't get along with anybody are scenarios for disaster.

LOOK Magazine assigned me to photograph the star and the film, "The Secret of Santa Vittoria," which was being shot in Italy. Anthony Quinn was the star. Mary Simons, one of my favorite editor-writers, was assigned to work with me. Sitting in a parked car near Anthony Quinn's villa, we were both nervously waiting to meet him. We wondered whether to be early, on time or late. There are theories about which is the right etiquette, but I argued that it would be best to be on time.

Each of us had heard separately that Quinn was temperamental and impossible to work with. One of the most difficult of all actors, he was said to be second only to Frank Sinatra. (Sinatra doesn't allow himself to be photographed except when he's onstage. Anyone who tries to shoot his picture offstage has his personal bodyguards to contend with, and they can and will rough up a noncooperating photographer.)

Mary and I went to see Quinn at four-thirty in the afternoon. We had been told we had thirty minutes to do our shooting. However, Mary has a wonderful laugh—an infectious, great big, roaring laugh that is wonderful to hear. And Quinn, like most actors, is a good storyteller. When he told a story and Mary laughed, there was no question about the chemistry between them. We didn't leave until nine o'clock that night. By the end of the evening all three of us were in love with each other. It is unusual for something like that to happen, but this wonderful introduction set the tone for my next three weeks of working with Quinn on the set. During that time, we became friends.

I had just finished a picture book on Leonard Bernstein, the noted conductor, and during the entire shooting process, I was expected to be wallpaper—seen but not heard. He did not want a photographer intruding on anything he did. Quinn was quite the opposite, he wanted me in on everything. He even invited me to have lunch with him.

Quinn was very entertaining, and since he encouraged my participation in his activities, I sometimes had trouble stepping back and being the photographer. Personally, I prefer to observe interesting things, rather than be involved in them. It's difficult to have lunch with a star. With the camera at the table, it's hard to say, "Excuse me," and launch into taking his picture. He may be used to it, but I'm not. It is awkward to be a part of something, then have to step back to take a picture.

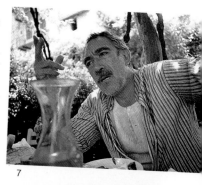

7

I believe Quinn wanted me there more as a companion than as a professional. He seemed lonely, and wanted conversation with real reactions to his thoughts. Highly intelligent and a great conversationalist, he was interested in international and American politics, as well as the arts. I was with Quinn when the news came that Bobby Kennedy had been assassinated. Quinn took it hard, slamming the table violently.

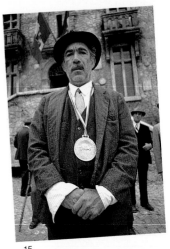

15

In the movie, Quinn played the mayor of a town trying to hide thousands of bottles of valuable wine from the Germans during World War II. He played it as a buffoon. Actors often become their parts while playing them and bring their characters offstage with them into their real lives. I think Quinn practiced his part while he was with me, and it was fun being around that character. I could take pictures freely around Quinn. Part of it was his role—the mayor wouldn't have cared about being photographed, so why should Quinn?

The close-ups of Quinn's face are orange because they were taken late in the day, between five and six o'clock, and reflect the color quality of the sun. I was using a 135mm lens for these few frames, so that I could get close without interrupting the set.

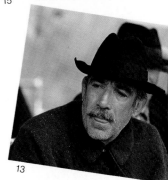

13

Which is the right picture? Frankly, I'm more interested in the whole group of pictures, because they show this man's versatility. He is a man of many moods and expressions. In one picture, he is the movie mayor, a slouchy little man, and then in another you see him with his children with whom he is highly emotional and outgoing. The one I like best is not the one that *LOOK* magazine used—I like frame 5, where Quinn has his hand to his face. *LOOK* used frame 6, the close-up of his straight face.

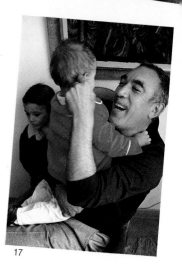

17

5

JOHN DURNIAK

These pictures are a cross section of a photographer's three weeks with one subject. Ken Heyman shot Anthony Quinn with family, Quinn with houseguest Marcel Marceau, Quinn waiting off-set, Quinn by himself, and Quinn in his character's role. The best pictures here are unposed and shot in available light—as close to natural as one can get around a movie set.

In good color photography, the subject dominates the color. That's why the close-up portraits of Quinn are the best pictures here. Frame 5 is the best one, where he has his hand over one eye.

National magazines have special color needs that determine how pictures are edited. They always need a color cover. Would any of these three close-up portraits qualify as a cover? No, because they all lack eye contact with the viewer. Had Quinn been looking into the camera on frame 8 (the close-up with his hat), that picture would have made a good cover. Editors currently believe that magazine sales depend on their headlines and blurbs, so cover pictures are getting smaller and are sometimes buried under piles of type.

8

The photograph of Quinn sitting with his son in the living room, frame 11, is a superb picture, as is frame 1, the picture of his family in an olive grove. The interest in these frames lies in their action, the family members' involvement with each other. In the picture of the father and son, the late sunlight spotlights them sharing something special. In frame 1, the soft, overcast, outdoor light makes a pastel scene out of what could have been cast in harsh, high-contrast color. The moment is right, the light is right, the action is right, and the color is in harmony with the subject.

I wonder how this photographer would adjust to only using color film. Quite well, I believe. Color doesn't interfere with his ability to search out the right moments. In frames 3 and 4 with Marcel Marceau, Quinn's hands are making interesting gestures, and body language is good in both subjects. And the photographer can hold his camera steady at low light levels—note frame 18 where Quinn holds his son, who wears a big, dark sombrero. None of the details in the boy's face have been lost, but I don't like Quinn in the red shirt—it dominates the scene. Without an assistant to hold reflectors, without fill-in lights, and operating just as he would with black and white, Heyman made the harsh sunlight work for him. He shot from the subject's shadow areas and still got good flesh tones. Moreover, he composes just as tightly in color as he would in black and white.

1

11

18

3

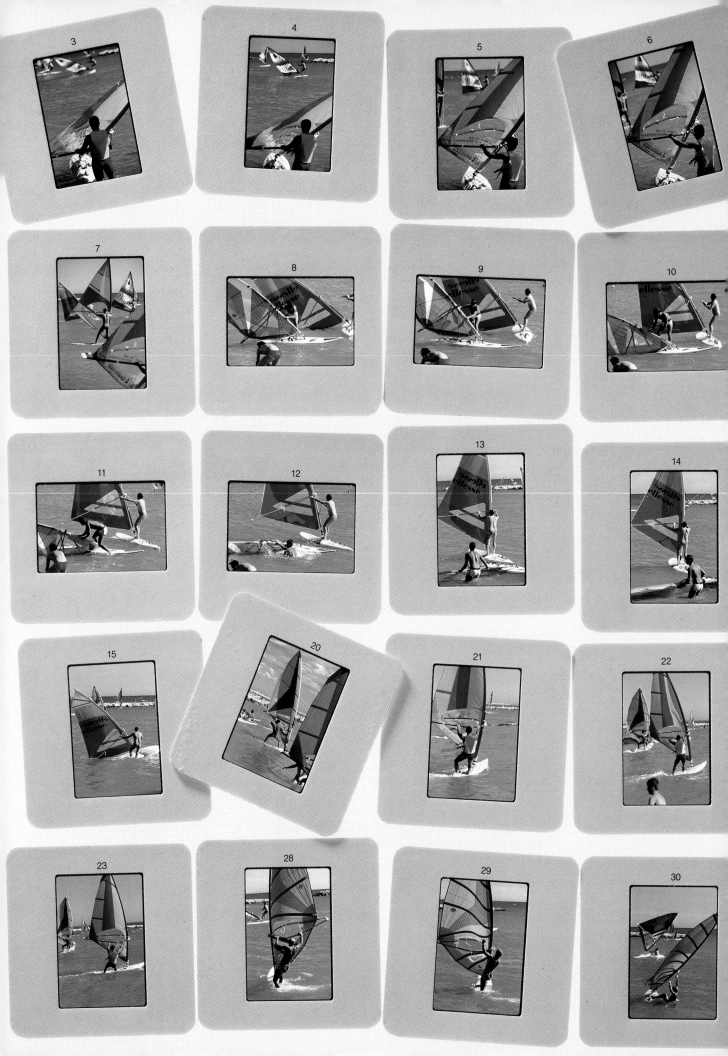

WINDSURFING

How much time does a photographer need? How well does a photographer have to know his equipment? With one eye on his watch and the other on his viewfinder, Ken Heyman shot these pictures of windsurfing, a sport he had never seen, with a camera he had never used, and the camera did the focusing, something he had always done for himself.

Breaking a habit is tough, especially when it involves photographic equipment that fits the hand like a comfortable old glove. The new camera was a challenge. Could Heyman adapt his style to it?

Harsh, direct sunlight reflected off the sand and water. It was not the best time of the day, but like most photojournalists, Heyman's philosophy is: the best time is the time you are there. Knowing he could not come back to reshoot when the light was softer, Heyman searched for the best position on the beach, selected the best lens, and made his pictures.

KEN HEYMAN
This camera proved to have more of a mind of its own than I had anticipated. Everything was happening so fast, and in such an unpredictable way, I wasn't exactly sure what I'd shot each time I pressed the shutter release. I didn't have to worry about winding, just about shooting.

JOHN DURNIAK
Most sensational sports pictures are anticipated, they aren't accidents. Sports photographers plan on being in the right place at the right time. Great windsurfing pictures depend on great surfers being on the right water with the right wind.

KEN HEYMAN

My children and I had arrived at the Nice airport in southern France three hours before flight time on a hot and sunny day. They spotted a beach a short distance away and suggested a swim.

Near the beach there was a bay where about fifteen windsurfers were sailing. The patterns they created were kaleidoscopic. With time on my mind, I put a 135mm lens on my new, fully automatic Minolta Maxxum 7000, hoping to get a roll of interesting colors, shapes, and action that would show something about the way I work. Not knowing how to windsurf, I was simply after pleasant pictures, not a prize-winning explanation of the physics of the sport.

Frames 8 through 14 are part of the same sequence. Of that series, frame 9 is the best because it is about windsurfing. There is a compositional tension between the surfer and the beach and the man trying to pull up his sail that the other pictures don't capture. As the windsurfers moved toward and away from one another, they created new compositions, which I didn't consider to be a sequence. I took them as single shots. Some are better than others, but I am not thrilled with these photographs.

This camera proved to have more of a mind of its own than I had anticipated. Everything was happening so fast, and in such an unpredictable way, I wasn't exactly sure what I'd shot each time I pressed the shutter release. The camera has an automatic wind (not to be confused with an automatic motor) so I didn't have to worry about winding, just about shooting. I was enjoying the sight in the finder, but began to swear at Mr. Minolta and Mr. Maxx when the camera's auto-focusing refused to respond the way I wanted. In frame 13, the two men aren't in good positions. I was concentrating more on the sides of the frame so that all the action would be included, and was hoping the boat would swing toward me into a better composition.

Frame 14 involves the same people, but I had moved aside a step. There is a bad line between the two men, so frame 13 is better. Frame 20 has the kind of body action I was looking for. Everything about the shape and movement of his body says action. My three favorite photographs are frames 6, 9, and 20. The design is interesting in frame 6, but the man in the foreground is not sailing. Frame 9 also has interesting elements, but frame 20 is still the one to beat, because the subject is excitement personified. Everything about him is sexy, and that is one of the things that sells photography.

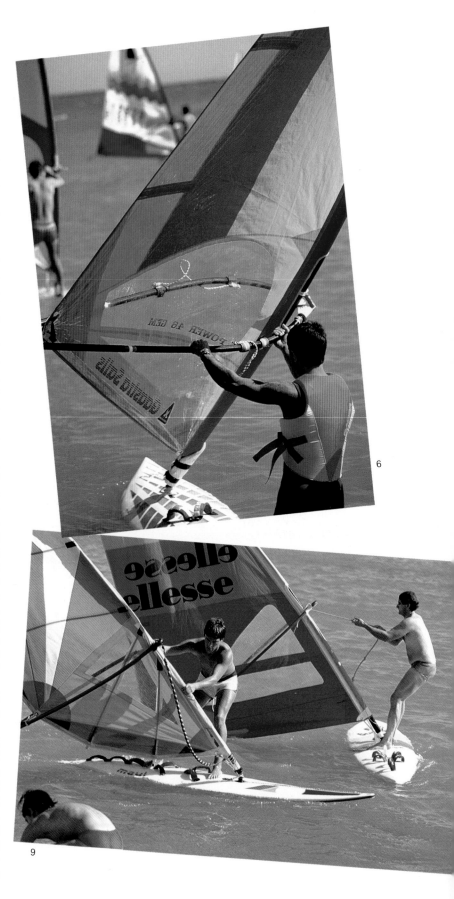

6

9

JOHN DURNIAK

Most sensational sports pictures are anticipated, they aren't accidents. Sports photographers plan on being in the right place at the right time. Great windsurfing pictures depend on great surfers being on the right water with the right wind.

This photographer did well for his first time out. He was on a beach he had never seen before, photographing surfers he knew nothing about, with a camera he had never used for sports, plus he was worried that he would miss his plane.

With all these cards stacked against him, he produced frame 20, which is quite good. Not only has he caught good action, but also the interaction between the woman in the bikini and the surfer. From her body language, she seems to think he's hot stuff.

The rest of the pictures show Heyman has good instincts. Not knowing the sport didn't help him. Frames 8 through 12 are of nonaction situations with the surfers either stopping, or starting out. Frames 6 and 9 are good tries. With a shorter lens and some better action, they might have been fine pictures, because a shorter lens would have added more space in front of the craft, and captured the sail swollen with wind. The right reactions and concepts are all there. Practice and familiarity are the needed elements. But like the first-time fisherman, he can be happy with frame 20—it's a good catch.

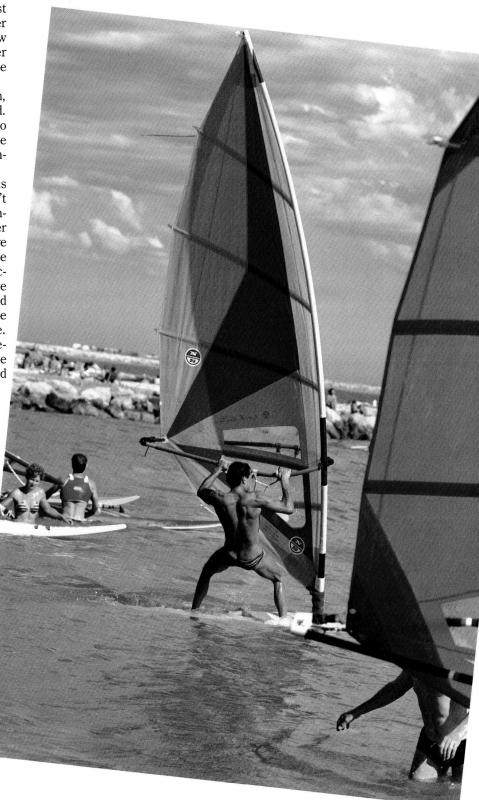

20

INDUSTRIAL DESIGN

A successful abstraction raises more questions than it answers. In a photograph, this is particularly true because we expect photography to be a strict representation of reality. When faced with a photographic abstraction, we react with surprise and immediately begin to try to figure out exactly what it is that we are looking at.

Abstractions can be created in many ways—through juxtaposition of color, composition of shape and form, and by varying the angle of shooting.

In this series of photographs, Ken Heyman has combined abstraction with reality. As the colored girders of a construction site moved and shifted to create a variety of unusual angles, the workers continued at their jobs, seemingly unaware of the incongruity of their realistic position in this surrealistic work place.

KEN HEYMAN
. . . My eyes jumped at the colors of the girders painted yellow and red-orange. I could walk under these while the men were working and watch the colors shift in various arrangements.

JOHN DURNIAK
Shooting straight up or straight down creates radical, dramatic pictures. But in this case, the photographer shot up at an angle. . . . Straight up would have created abstract pictures, but this angle-shooting produced realistic photographs.

KEN HEYMAN

Working behind the Iron Curtain, my first surprise was at the lack of color—it is a colorless, drab world.

So you can understand that when I saw this structure being built at a commune farm outside of Budapest, my eyes jumped at the colors of the girders painted yellow and red-orange. I could walk under these while the men were working and watch the designs shift in various arrangements.

I walked around the construction, using a 50mm lens on my Leica rather than a wide-angle, which would have included too much of the sky. I kept working until I felt I had my picture. Here are twelve frames out of a roll of thirty-six. I've kept a lot of this roll because I think the pictures are interesting. My usual "keep rate" is four or five pictures per roll of color film.

When you are underneath people shooting straight up at them, they don't look like people anymore. Instead, they are legs, or arms and legs. Sometimes these shapes in themselves can be interesting, but in this case they were not, as you can see in the top figure of frame 12. However, I was not primarily concerned with the people, but with the abstractions formed by the girders.

Of all the slides here, I prefer frame 27 and would choose it as the right picture. It's more interesting to me because the three people have their own "compositional" areas in which they are working. My second choice is frame 3. It has more tension in the center, which makes it more dramatic, but I wish the worker standing there were holding something significant, like a rivet gun or machine gun. Runners up are frames 12 and 37. The colors make frame 12 important, but frame 37 is monochromatic and not as successful.

Overall, I must admit that I have seen other photographers do this kind of thing over the years. This is a cliché in industrial photography. I don't take great pride in these pictures, but sometimes a cliché is better than no picture at all.

Two days after shooting this situation, I was called to the police station, not because of these pictures but because I had been photographing in an old section of town. The officer at the desk corrected me when I said, "old section of town."

"Everything here is modern," he told me.

"How about that building across the street?" I asked about a house that was at least three hundred years old.

"Everything here is modern," he repeated and smiled. "We are going to have to ask you to stop taking pictures. You can leave now or wait in your hotel until your plane leaves."

So I was put under house arrest. Fortunately, it was a pretty decent hotel. I was sure that some of the people waiting around the hotel knew who I was, and that their job was to make sure I stayed there.

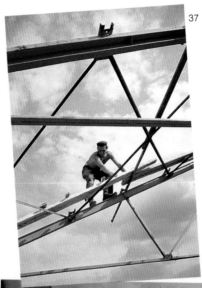

37

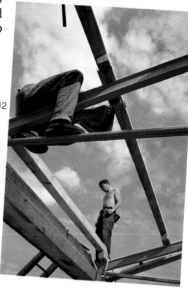

12

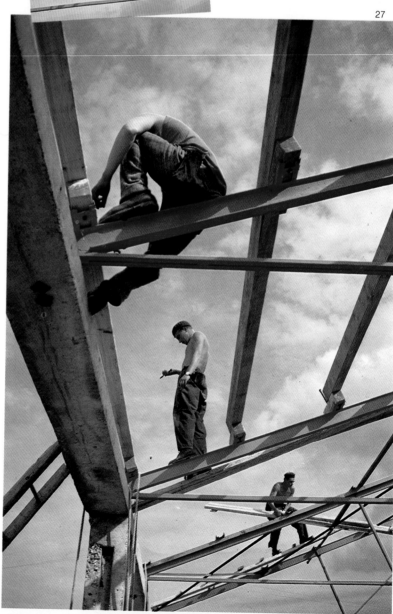

27

JOHN DURNIAK

Shooting straight up or straight down creates radical, dramatic pictures. But in this case, the photographer shot up at an angle, and I don't blame him—the possibility of being hit by a falling tool, bolt, or beam was great.

This slight change in perspective, however, made a world of difference. Straight up would have created abstract pictures, but this angle-shooting produced realistic photographs.

I like the way the photographer worked the scene, and the variety of compositions he created. Where he's missed, he's done so by a hair. Frame 15 would have been a hit if the man's head were back to reveal his eyes. Frame 16 could have been the right picture if the arm and shoulder didn't hide the face. Frame 30 is a great situation but the worker is in a boring position. Frame 37 would have been far better if he had not centered the worker.

For me, the right picture is a toss up between frames 10 and 27. The rope makes frame 10 the most interesting composition and an active piece of journalism. Frame 27 is rigid and less organic, implying that it was posed (even though it wasn't). So, I'll choose frame 10 as the right picture.

The photographer worked it both horizontally and vertically, using combinations of one, two, and three figures. The horizontals are the weakest pictures.

I disregarded the way the pictures were originally shot and turned the frames every which way, looking for the best compositions. I found frame 14 to be improved by viewing it as a vertical with the larger figure on top.

I have also viewed all the transparencies straight up, as if they were hung from the ceiling. If these prints were displayed hanging down from a ceiling, the effect would be thrilling. However, for the pages of a book, I will stick with frame 10.

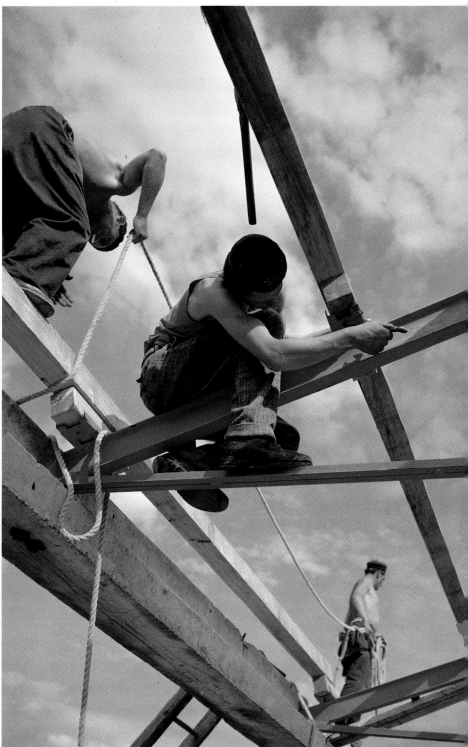

10

149

SWIMSUIT ABSTRACTIONS

How does a photographer turn a sidewalk shop into a photographic studio? Ken Heyman made these abstractions by using a variety of lenses, waiting for the light to create new moods and colors, and moving himself around to create different compositions.

The difference between a frame with color and form well placed within the image, and one that is ill conceived, is the difference between mediocrity and art. Intuition and sensitivity to the elements—balance, line, light, color, and movement—come into play when the photographer finds the right picture. That moment is one of photography's thrills whether it happens while looking into an interesting face, or at a rack of swimsuits at a sidewalk sale.

If the photographer could bring the clothing racks into a studio, control the light, put the camera on a tripod, and carefully arrange the colors against each other, success would be guaranteed, but at the expense of draining all life from the situation. To see and capture the right image from real life quickly and with certainty—that is photography at its best.

KEN HEYMAN
In the last year, I've moved into photography as art, a new kind of photography that I'm doing for myself. One of my battles is about giving up the horizon line. Every editor I've ever worked for wants everything straight, honest, and real—the way things look without interpretation. Distortion is left to art photography.

JOHN DURNIAK
Perhaps it's good that photojournalists think twice before posing or manipulating subjects. In art, manipulation is necessary, but in journalism, the truth is the photographer's responsibility. Being honest in all things is one way to avoid confusing the truth. One photographer's liberty is another photographer's lie.

KEN HEYMAN

I took a new plaything with me to France, the new auto-focusing Minolta Maxxum 7000. It had just come on the market and everyone was talking about it—auto-focus, auto-exposure, auto-flash, auto-wind—so, I decided to try it.

This shoot was a self-assignment. It was the first scene I came upon—a rack of bathing suits in a tourist section of Paris. Out came the Minolta. I took one picture with a wide-angle lens to show the whole scene. The rest of the pictures were made with a 135mm Minolta telephoto lens.

When I looked through the camera at the swimsuits, I saw a splashing and mixing of color—like looking at translucent candy. The sun turned the garments into something more than what they were—a beautiful little discovery.

Half of the pictures were shot horizontally, the rest vertically. Frames 19 and 30 are the two best (with frame 19 being the better of the two), because they retain a strong sense of being bathing suits in sunlight. Moving in closer to the rack did not help preserve this fragile grasp on reality for the viewer.

I like frame 31, although this kind of photograph doesn't make sense of reality—it's color for the sake of color. I would like to see the film removed from some of these slide holders and stripped together, making one large transparency out of nine or twelve frames. The effect created would be like stained glass.

In the last year I've moved into photography as art, a new kind of photography that I'm doing for myself. One of my battles is giving up the horizon line. Every editor I've ever worked for wants everything straight, honest, and real—the way things look, without interpretation. Distortion is left to art photography. These swimsuit pictures have no meaning—they aren't selling bathing suits, they are selling color, beautiful, tacky color. There is beauty in their tackiness, in the hot oranges and hot pinks. I have done an artistic, not journalistic, interpretation of these bathing suits. That afternoon in Paris, these were the brightest colors I saw. The sun shimmering through the cloth brought these colors to life, giving me a new reason for photography.

19

30

JOHN DURNIAK

When it comes to human subjects, this photographer maneuvers well, getting high angles, low angles (even from down on the ground), and intimate close-ups. On this roll he proved to be agile with the inanimate, but not quite as mobile as he is with people. Two pictures were taken, over and over again. The super close-up—taking only two colors and playing with them from a point inches away—is missing here. However, I have projected these slides and found many good compositional possibilities within the frames.

I'm convinced that if the photographer had imagined that the swimsuits were faces, his shooting would have been different. As it was, he was working with a fraction of an idea. Complete, it would have led to a remarkable photograph.

Some photojournalists have a built-in resistance to ever manipulating subjects. But isn't this self-assignment supposed to show the power of color? Shouldn't the photographer have taken some liberties? Since the objective was a graphic blockbuster, why not utilize everything available, such as repositioning the elements and colors for design purposes? An advertising photographer might have rearranged the suits and asked a salesperson to assist with lights.

Perhaps it's good that photojournalists think twice before posing or manipulating subjects. In art, manipulation is necessary, but in journalism the truth is the photographer's responsibility. Being honest in all things is one way to avoid confusing the truth. One photographer's liberty is another photographer's lie.

Frame 23 is my pick for the right picture. I want it cropped at the maroon garment on the left and at the orange suit on the right. This arrangement pleases me. I'm sorry the photographer didn't frame it this way in his finder. A full-frame image of this area would have better image quality.

I assume he used Ektachrome film. I prefer Kodachrome. When color reproduction quality is of major importance, the best film is Kodachrome. Until a better film arrives, why not use it?

Color photography is not forgiving. While black-and-white film takes bumps and bruises and still gives a beautiful print, color is eggshell-delicate. Treat it roughly, and it's gone. These pictures show the photographer's sensitivity to color. However, he didn't let himself go, didn't allow himself to use his full strength. To get full power from his color work, he should have gone the extra yard. Closer would have been better for quality and composition.

23

153

COLOR DOORS

André Kertecz photographed people reading whenever he had the opportunity. Eliott Erwitt made humorous pictures of the dogs he encountered in his travels. Ken Heyman is always interested in some special subject—here, it was doorways.

He traveled all through Latin America, photographing doors in an incredible variety of colors, architecture, and use. Self-assignments like this are a hobby for Heyman. He chose to do the doors in Latin America because of the way people use color there. They are in love with color. North American people do the outsides of their houses in predictable materials and colors that conform to community expectations, but in Latin America home dwellers choose wild, vibrant colors because they love them.

Heyman notes that these colors do not remain the same—weather softens them, the sun mutes them and previous undercoats emerge. Sometimes he felt he was photographing an abstract, folk painting instead of a house exterior.

KEN HEYMAN
In these countries, the rich tend to have white houses with tiled roofs, but the poor proudly decorate their home in bright colors that wear with the weather.

JOHN DURNIAK
This photographer often gets more than he bargains for. If he had been producing an essay on the use of color in the tropics, he ultimately gave us man in the tropics as well.

KEN HEYMAN

I was on assignment for the U.S. Information Agency doing an Alliance for Progress picture essay on Latin America. I was shooting well and, when problems with scheduling developed on the story, I'd use my time to wander and collect images like these. This kind of photography can also serve as exercise for keeping my mind and eye sharp.

How people live with color fascinates me. They put color on themselves with makeup and clothing, and on their houses and cars. Before I started shooting this series, I spent weeks looking at how Latin Americans use color.

The pictures in this set were taken in Brazil, Colombia, and Puerto Rico, and come from many different rolls. In these countries, the rich tend to have white houses with tiled roofs, but the poor proudly decorate their homes in bright colors that wear with the weather. Weatherbeating mellows some tones and burnishes others. Some of the most interesting combinations occurred on and around doorways.

Until now, I have never shown these pictures to anyone. Here are the colors of housefronts in Latin America. I like them—they are soft colors. The pigments used on these houses reminded me of abstract paintings, so I shot them that way under all sorts of lighting conditions.

There are six photographs taken in bright sun, but the rest were shot in overcast light, because I hate the sun. (Not only as a photographer, but as a human being.)

I don't want to see the light in my pictures, I want to see the subject. You have to use light in photography, but it should be invisible; to say "photography is light" is merely to use a photographer's line to himself. Some photographers' work is more about light than about their subject. The photographs that I admire by others are not about light. Outside of advertising photography, I want to look at the ideas and creativity of the photographer, not at his technique.

One could call these photographs a subtle kind of journalism but, to me, they remain more like paintings. Here, I was photographing paintings that I had made out of real life.

It is difficult for me to choose a right picture from this set because I've had the opportunity to edit these photographs from many rolls of film. Each of these is the right picture. If I have to make a choice, frame 10 is my favorite. The arrow in the doorway seems to suggest the man's opinion about the woman. I'm not sure what his opinion might be, but the arrow provides an interesting design element.

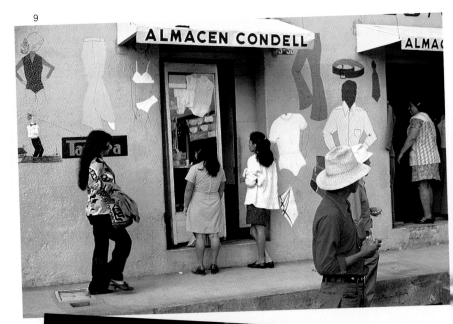

9

13

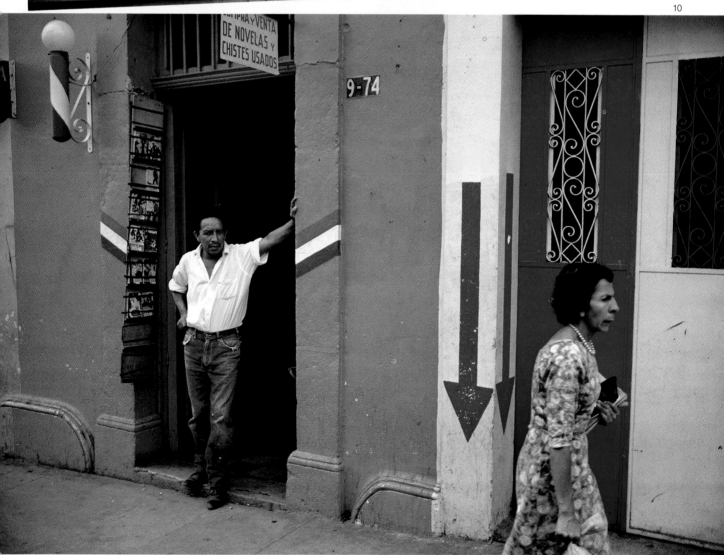

JOHN DURNIAK

The note on this sheet of twenty color transparencies reads, "Doorways to Latin America." The statement is simple but the pictures are complicated. I have seen posters for the "Doors of London," another, "the Doors of Ireland," and even a calendar on the "Doors of New York." But those collections are nothing like the pictures on this sheet. This sheet contains complicated images that include not only doors but people, windows, streets, stores, and decorations.

It is hard for me to accept them as a set, because too many different interests seem to be covered. Frame 5 is the right picture for me. It is ambiguous and well organized, a good moment capturing the subject's eyes in a seeming daydream—all elements of a fine picture.

If people are what they put on their walls, they are also what's on their clotheslines, in their streets, in their hands, and on their backs.

Frame 6 is a good picture. The kids play in the street in front of a grocery store while the mother sits at the door. Two dogs, two kids paralleling each other. "KLIM"—I did a double take on the sign on the doors. It is "Milk" spelled backwards. I thought I had the slide backwards, but the Spanish on it reads correctly. The mother's attention is directed inside the store. The only light that comes into the grocery is from the open doors and the holes in the far wall. Electricity is expensive but sunlight is free. Trousers are in short supply.

Frame 7 is an interesting design, besides being good journalism. The sun freshens the garments, while the kids are guarded by the gate, wondering what the man with the camera is doing.

Frame 8 is superb color, including that in the woman's face. All of the colors and textures here fit together. The touch of rust on the old bedspring underscores how the sun and weather have been rough on man and shelter alike—their skin suffers together.

This photographer often gets more than he bargains for. If he had been producing an essay on the use of color in the tropics, he ultimately gave us man in the tropics as well. These are intimate, slow pictures. We walk with the photographer through tiny towns, the nowheres of the world. Time stands still, and the photographer brings back these long moments for us to feel and scrutinize. He started with color in mind, but ended up capturing anthropology on the walls and the journalism of the street.

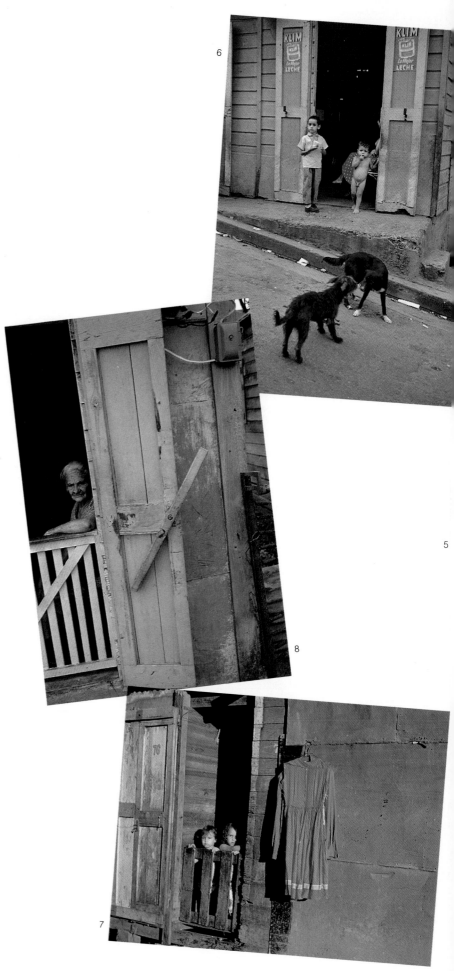

INDEX